MORE Digital Food Photography

Bill Brady

Course Technology PTR

A part of Cengage Learning

COURSE TECHNOLOGY
CENGAGE Learning™

Australia, Brazil, Japan, Korea, Mexico, Singapore, Spain, United Kingdom, United States

COURSE TECHNOLOGY
CENGAGE Learning™

MORE Digital Food Photography
Bill Brady

Publisher and General Manager,
Course Technology PTR:
Stacy L. Hiquet

Associate Director of Marketing:
Sarah Panella

Manager of Editorial Services:
Heather Talbot

Senior Marketing Manager:
Mark Hughes

Acquisitions Editor:
Dan Gasparino

Project Editor/Proofreader:
Karen A. Gill

Technical Reviewer:
Joe Schram

Copy Editor:
Gene Redding

Interior Layout:
Shawn Morningstar

Cover Designer:
Mike Tanamachi

Indexer:
Broccoli Information Management

Printed in the United States of America
1 2 3 4 5 6 7 14 13 12

For product information and technology assistance, contact us at
Cengage Learning Customer & Sales Support, 1-800-354-9706.

For permission to use material from this text or product,
submit all requests online at **cengage.com/permissions.**

Further permissions questions can be emailed to **permissionrequest@cengage.com.**

All trademarks are the property of their respective owners.

All images © Bill Brady unless otherwise noted.

Library of Congress Control Number: 2012934301

ISBN-13: 978-1-4354-5418-7

ISBN-10: 1-4354-5418-9

Course Technology, a part of Cengage Learning
20 Channel Center Street
Boston, MA 02210
USA

Cengage Learning is a leading provider of customized learning solutions with office locations around the globe, including Singapore, the United Kingdom, Australia, Mexico, Brazil, and Japan. Locate your local office at: **international.cengage.com/region.**

Cengage Learning products are represented in Canada by Nelson Education, Ltd.

For your lifelong learning solutions, visit **courseptr.com.**

Visit our corporate Web site at **cengage.com.**

This book is dedicated to my amazing, talented, gorgeous, and phenomenal wife, Sasha. You are my one, my everything, and my best friend.

It also is dedicated to my daughter, Isabella, who brings me joy like no other.

My beautiful girls, I love you both.

Acknowledgments

I would like to thank my friends and colleagues who over the years have supported me both personally and professionally. In many ways, you all helped write this book.

My wife, Sasha, who inspires me daily, loves me without fail, holds me accountable, and rocks my world every day.

My daughter, Isabella, who gives me joy beyond belief.

Brian Preston-Campbell and Laurie Knoop, who make my food look so amazing.

Victor Ribaudo, who has stuck by me for 15 years, and Rich Buyer, my partners in crime. Kevin Ruddy for giving me the opportunity to shoot food. Dani Kaplan, the chairman of the board, John and Claire Brady (my parents), my sister Denise and nephew Paul, the Ribaudo family (Mae, Phil, Santa, and Christian), Sue Knoop, Juniper, Justin, and Mackenzie Lusk and Joseph Harrah who encouraged me to quit my job and follow my dream.

To my good friends and family Reno Bracchi, Mark Giovannini, Darrin Giglio, Dave Gerard, Mike Ardman, Rich Pfeifer, Auggie Isernia, Jon Fields, Josh Morton, Susan Weinthaler, Dave Rosenberger, and Jason Scaramucci, the Cacioppos, Anthony Dimino, Sal Deljudice, and Mark Gable (Flashlight). The Leightons (Andrew, Nancy, Sammy, and Sophie), Michelle Dellisanti, Tony Bracchi, Louise Greenwald, Denise D'Angelo, Sally and Jon Boyer, Martha Ann and Frank Brady, Phillip Brady, Maureen and Joseph Brady, Nancy Dover, Gena Gallinger, Issac Pena, my cousins Bobby and Gloria, Ronnie, Val, Johnny, Christian, Gianna, Frankie, Lauren, Adrienne, Josh, Dominick, Camarie, Marina, and Frank Dellisanti and the Helms family (Carol, Cherie, and Erica).

To my associates Mary Ragonesi, Mark Haurestock, Alan Benjamin, Shaun Smith, Tony Harding, Mike Downey, Sean Aziz, Todd Camhe, Michael Parness, Lisa Skye, Craig Fine, and Chris Crawford.

All of you have inspired me, shared meals with me, and encouraged me along the way. Thank you.

To my good friend, mentor, and second father, Bill Helms. Thank you for sharing so much of yourself not just with me, but with everyone you touched. Your passing was too soon, and we all miss your spirit, good nature, and terrible puns. I only hope that I inspired you as well.

To my grandma Clara, who taught me about food. Because of the old days and Sunday dinners in the basement, you are the reason I am a food photographer.

—Bill

About the Author

Bill Brady can trace his love of food back to early childhood. Surrounded by culinary wonders, his earliest memories of food were formed around the Sunday dinner table in his grandmother's basement in Brooklyn. Sharing a meal was the essence of life, and his world revolved around the endless courses that were laid out week after week. Those experiences created his bond with food that is forever sealed.

Bill has been a professional photographer since 1992 and has concentrated on the food niche since 1999. He has worked with *Fortune* 100 clients as well as household brands such as Ronzoni, Heinz, Sara Lee, Godiva, Absolut, and Boars Head, to name a few.

Contents

3 **Food Styling** **59**

4 **Studio Equipment for Food Photography** **87**

8 The Art of Food Photography 203

Index 219

Introduction

My name is Bill Brady, and I am a professional food and beverage photographer. My work is used all over the world in magazines, print, advertising, package design installations, and on the Web. My images have been seen on the Reuters sign in New York's Times Square and on millions of familiar products. You may not know me, but chances are you have seen my work.

One of the most frequently asked questions I get is, "How did you become a professional food photographer?" To answer that question, I will need to explain who I am. I have taken an unconventional path to arrive at where I am professionally. Photography in general is one profession where talent, hard work, and a bit of luck can allow you to live the life you dream of. It is a challenging field, and there is no specific course you can follow to achieve success, however you define it. It is one of the only professions in which you do not need any formal training to be successful. You just need to pick up the camera and start shooting.

If I had to boil it down to two traits that make a professional photographer successful, aside from talent, I would pick passion and perseverance. There are many genres within the photography field, and merely deciding to be a photographer is only the first in a series of steps. To earn a living as a photographer, you have to rise above the competition. You must be just as good at business as you are at taking pictures. You must work relentlessly to create your point of view, market yourself, and gain the confidence of hardened industry professionals. Above all, you have to deliver the goods.

Becoming a specialist, in my opinion, is required to rise to the top of the profession. There are always exceptions, but establishing a name for yourself professionally takes a sophisticated eye, a dedication to the craft, and the determination to keep at it after multiple failures. Being a food photographer requires a lot of patience and attention to detail. If you are as passionate about food as you are about photography, you will be successful. The payoff can be enormous. My job is challenging, fun, exciting, and downright enjoyable.

I am passionate about many things in life, but food and photography have always been on top of the list. Any great photographer needs to have passion for his subject. If you are going to dedicate your most precious resource—time—to pursuits in life, I have always found that being interested in your subject can make all the difference.

My career developed rapidly when I started photographing food. It came so naturally to me that I quickly evolved. My passion for photography developed at around the same age as my passion for food. When I was eight years old, I picked up my first camera, a Kodak Instamatic. I can still remember the feeling I got when I held it up to my eye. It was like nothing I had ever felt. I remember spending hours and hours poring through the Time-Life books in my dad's library. Rarely interested in the text, I was obsessed with the pictures.

Taking and developing photos was a thrill. I took photography as an afterschool class and soon built my own darkroom. Photography was so satisfying for me because I was able to create something that was totally mine. I was hooked. At the age of 14, I got my first single-lens reflex (SLR) camera, a Canon AE-1. I immersed myself in learning photography by taking a correspondence course offered through the New York Institute of Photography.

Around the same time, I discovered the importance that food played in my life. My mother's side of the family was 100 percent Italian. I can trace my love of food back to my grandmother's basement in Brooklyn, New York. Surrounded by culinary wonders, my earliest memories of food were formed around the Sunday dinner table. The smell of drying peppers in the boiler room, fried meatballs, macaroni and gravy, Easter pies, and ravioli soup left an impact on my soul.

To our family, sharing a meal was the essence of life. Our world revolved around the endless courses that were laid out week after week. Mixed in among the tapestry of the table was life: Laughter, tears, joy, and heartache unfolded around those meals. Those experiences created my bond with food that can never be broken. It would later change the course of my life.

I went to a trade school for photography before pursuing my BA degree. After graduation, I was a bit aimless. I was overwhelmed and took jobs I really had no interest in. I had put my camera down during my college years. As disillusionment grew with my career, I began to do some soul searching for what really inspired me. I picked up my camera as a means to escape. To my surprise, the thrill I had gotten as a child was reignited. I could not wait to take photos. It became my obsession. I began shooting before work and after work, and soon photography consumed all my free time. I was never seen without my camera. A good friend I had gone to photo school with, Joe Harrah, convinced me to pursue photography professionally. He was successful and told me I was wasting my talent. Without his influence, I may have never taken the leap. Once I decided to go for it, there was no clear career path. There was very little information on how to proceed, and the Internet was not yet available.

With a bit of planning, I eventually mustered the courage to walk out on my nine-to-five gig and step into the world of professional photography. Let's just say that my splash into that world was less than spectacular.

I was even more confused. There were so many nuances and specialties in the field that I had a very hard time focusing, and I became extremely frustrated. I kept shooting; in my heart, I knew there was a niche in photography where I could be successful. I had a chance meeting with a producer named Tony Harding. He introduced me to the man who would eventually change my life, my mentor and world-renowned food photographer Bill Helms. We developed a strong relationship quickly.

Congruently, I had gotten my first Mac and started to learn retouching, design, and digital pre-production. Bill and I were strictly in the film world, and much to his credit, he really embraced digital technology. He was easily convinced of the power of digital after I scanned a faded Kodachrome slide of an ad that he had done 50 years earlier and instantly restored the color.

Together, we began to chart a new course as the film and the digital worlds collided. We were making up the rules as we went along, trying to adapt and change with the times and technology. Shooting food was exciting to me. It was what I had been searching for, and I had found my niche. Under Bill's supervision, I started learning my craft.

By combining my two greatest interests into a career, I was able to find a successful formula. I am a food photographer. What makes me great at what I do is my love of food, my appreciation for how a meal is prepared, and the absolute joy it brings me. Being able to translate that into a photograph is my art. My job is to entice you, to lure you, to create longing. I shoot food, eat food, and write about food. I enjoy every aspect of it.

For those who choose to pursue food photography as a career, the road is challenging. For writers, bloggers, and cookbook authors who want to be able to control the content of your craft, this book is for you as well. I will take you through simple techniques at first. Perhaps that's all you need to glean from this text.

The balance of light, composition, and subject is essential to any great photograph. A food image has to possess something extra, though. It has to motivate an emotional response and urge the viewer toward a specific action. Great food photography evokes such a reaction. I call it the *yum factor*. It's what entices the viewer to buy into the fantasy. Even though we know the audience can't taste, smell, or feel it, the visual impact is so overpowering it can stand on its own. It compensates for the absence of other sensory input.

Food photography need not be overwhelming. With some basic knowledge, you will begin to elevate your images to a professional level. With enough practice, you will be turning out phenomenal results. For those who want to shoot food for a living, there is a steeper learning curve. More advanced techniques will be covered later in this book. Whatever your goal is, this book will help you take better food photographs.

What separates a professional from a hobbyist is the ability to get the shot no matter what the circumstances—to be able to envision a photograph in your mind and execute it flawlessly. To take great photographs of food, first you have to take a lot of bad ones. I say this as a source of encouragement. My first attempts were not amazing, but I kept on pushing myself, learning, expanding my point of view, and perfecting my technique. I have taken hundreds of thousands of images in my career. Looking back at my body of work, I can't help but feel proud. I remember what it was like to step into the unknown and be intimidated in the beginning when all I had was a dream. You can become a professional food photographer as well.

Allow me to guide you, share my experience, and teach you how to capture proper food photography.

Enjoy, have fun, and shoot, shoot, and shoot some more.

—Bill Brady, food photographer

Photo Credit Rich Buyer

What You'll Find in This Book

What you will find in this book is how to approach, compose, and light food and drink images. It is known in the industry that shooting food is one of the most challenging subjects you can encounter as a photographer, and that's true. This book is designed as a guide to help elevate and educate you about the process involved in shooting food. It is filled with exercises, tutorials, and a soup-to-nuts crash course on food photography.

You will learn:

- ❖ How to compose, light, and shoot food images
- ❖ How to light food images with natural and artificial light
- ❖ Which tools are required for food photography
- ❖ How food styling works
- ❖ How to photograph drinks
- ❖ How the business of food photography works
- ❖ How to bring your food photography to the next level

Who This Book Is For

This book is for anyone who wants to learn food photography. It is for everyone from the blogger who wants to elevate the level of photographing his dishes to the person who wants to know how to shoot for commercial assignments. It is designed to give the reader a blueprint of how to shoot food.

How This Book Is Organized

Chapter 1, "Digital Evolution and the Food Photography Revolution," briefly describes the transition from a traditional film workflow to a digital workflow. It also covers basic photography concepts.

Chapter 2, "Food Photography: The Basics," describes the necessity of learning the principles of photography as they relate to food photography plus concepts on learning to light food with natural light.

Chapter 3, "Food Styling," discusses food styling as told through the experience of a working food stylist as well as from the perspective of a food photographer.

Chapter 4, "Studio Equipment for Food Photography," acquaints you with the tools of the commercial photographer, particularly lighting and grip equipment.

Chapter 5, "Advanced Lighting for Digital Photography," speaks about advanced lighting for both food and drink photography.

Chapter 6, "Food Photography: The Next Level," discusses how to bring your food images to the next level. It offers tips on taking your food images from good to great. It also introduces basic concepts and theories regarding post-production.

Chapter 7, "The Business of Food Photography," is about the business of food photography as a commercial enterprise. It discusses business formation, marketing, and branding as it pertains to food photography.

Chapter 8, "The Art of Food Photography," discusses the need to stay creative and keep producing personal art for yourself.

CHAPTER 1

Digital Evolution and the Food
Photography Revolution

For many reading this book, the concept of taking a photograph with anything except a digital camera is alien. For others like myself, the evolution of photography from film to digital has been both exciting and frustrating. At times it seemed we would never get there. Once fully embraced by a mainstream audience, the rise of digital imaging technology happened very quickly. I was never a gadget guy; I prefer to get the best use out of my equipment. Playing the pixel game and upgrading your equipment when the latest and greatest technology becomes available can be both expensive and frustrating. Instead, learning how to use the tools you have to get the best result is a much more worthwhile pursuit. Food photography was considered once to be the holy grail of photography. It required a crew of specialists, professional equipment, and the patience of a saint. Today, shooting food has become less challenging with digital equipment. Some of the obstacles once preventing the ordinary shooter from even attempting food photography have been removed. Today, shooting food still requires a fair degree of skill to execute but is now completely approachable with the proper instruction.

A photographer trained well in the correct techniques and fundamentals can quickly improve his food photography skills. If you are serious about taking pictures of food, you have to purchase some essential equipment to achieve the best results. Equipment can be pricey, so we will consider different equipment options that fit most budgets. The two pieces of hardware you must have are a camera with manual settings that supports interchangeable lenses and a good tripod.

Many inexperienced photographers fall short when it comes to food photography. What is the missing ingredient? The fundamental difference between a good photograph and a great photograph is the lighting. Instead of learning how to light properly, photographers will use substandard lighting and manipulate the results in Photoshop or some other image editing software. This ignores a critical part of the photographic process and must be learned along with the other basics of photography. In this book we will explore lighting in depth. We will start with the basics, where a few inexpensive pieces of equipment can get you started. We will then go into more advanced techniques that require more of an investment in time and money.

With the advent of blogs, Web sites like Flickr, and food portal sites like Tastespotting, there has never been more opportunity to show your work. There is a new generation of food photographers who will never shoot professionally. For those select few who want to become professional food photographers, the road is not easy, but it is very satisfying. I have always believed that people who make their living following their bliss are truly blessed. Being a professional food photographer sounds exciting because it is. Seeing my work on billboards, in advertisements, and in magazines still gives me a thrill. I also get to eat all that wonderful food.

Before we delve into food photography as a subject, it's important to recognize how we arrived at this point. What happened to make food photography so popular, and why are people obsessed with shooting food?

When Worlds Collide

One of the first reasons food photography has become so popular is technology. It's amazing to think about how affordable digital photography has become. My first digital camera was an odd little football-shaped Polaroid that I purchased in 1997. Back then, I had abandoned my darkroom in exchange for a computer and immersed myself in Photoshop. I realized that digital output offered so many opportunities that simply did not exist with standard photography methods. I have been outputting my final photos digitally since 1994. The process was vastly improved from a traditional darkroom, but in 1994, it was still cumbersome. You had to scan your film, which was time consuming and expensive. If you went for a less expensive scanning solution like the Kodak Photo-CD, you had to manipulate your images quite a bit to get decent output. You really had to master Photoshop to get a superior print, which was the ultimate goal. Images for the Web were not even close to being the norm. Generally, the end use was a printed piece of some sort.

Photoshop had whetted my appetite. I desperately wanted to get into the newly evolving digital world of photography. Early digital camera systems were very expensive, ranging from $13,000 to the mid five figures. Only elite photographers could afford such systems. After some research, I purchased the Polaroid camera system for $7,000. The camera had interchangeable lenses, and you could sync it to your strobe flash units. It was barely able to capture a two-megabyte file, smaller than most cameras built into today's cell phones, but it was still impressive and very exciting to work with. It featured live preview and other sophisticated features. The draw was that it was totally digital.

My mentor Bill Helms and I hooked up the camera to the computer and cataloged the entire produce library for his large supermarket client. For all of its pitfalls, the little Polaroid performed brilliantly. In just five days, we were able to finish a job that would have taken a month using the film equivalent. By shooting completely digitally, we could speed up the process, increase the number of shots per day, and deliver the job much quicker. The advantages were clear. We were no longer at the mercy of film and its constraints. The ability to view our images instantly was intoxicating. Prior to that, we had to rely on our knowledge and skill and hope we did not miss a critical step along the way. Even when you try to do everything properly, there is always a chance your image will not come out. As a professional, you always have to get the picture.

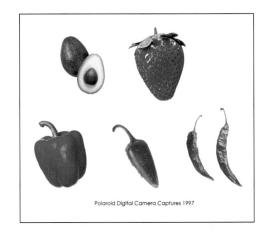

Polaroid Digital Camera Captures 1997

As photographers, we had been witness to many new technologies. Forty years my senior, Bill told me stories about what it was like for him coming of age as a photographer. Ansel Adams introduced Bill to Polaroid film as a tool to test lighting and composition. He was a Navy photographer at the age of 17 and served on the USS *Yorktown*. In the 1950s he worked with emerging color photography technologies such as dye sublimation prints. Needless to say, Bill had an interesting career and was a wealth of knowledge. Photography is mostly on-the-job training. Although you can learn technique, you have to develop your eye, which you can do only through practical experience.

By the time I went to photo school in the mid-1980s, not much had changed. In those days we had to rate the ISO of film. The ISO is a number that corresponds to film's sensitivity to light, and it functions much the same way in the digital world. Since film was not produced through controlled computer techniques, it would come out a little different with each batch. You had to purchase your film in bulk and shoot tests. By analyzing the negatives, you would assign the film its proper ISO. It required certain technical skill to produce professional images, but it required artistic talent to produce exceptional photographs. The point is that it you had to work very hard to produce a properly exposed negative or positive and then work equally hard to produce a high-quality print.

Photography back then was more of a fusion between art and science. You really had to understand how film behaved, know what its limits were, and understand that it was a living organism. You had to work with precision to achieve the desired result. Unlike digital as a medium, film has strict tolerances that have to be observed to get the desired results.

Food photography was challenging because, compounded with all the technical aspects, including proper exposure, focus, and lighting, there was also the fact that food moves and wilts on the set very quickly. Exposing an image to film requires more time, during which many things can go wrong. We would test lighting with Polaroid film and use a stand-in to make sure everything was compositionally and technically perfect.

We shot with cumbersome 4×5 cameras that used sheet film. We could not rush the process or we would miss a vital step. For instance, if we forgot to pull the dark slide (a piece of plastic or metal that protects the film from light), the film would not be exposed, and we would get a box of blank negatives back from the lab. That's hard to explain to a client.

Assuming we did everything technically correct, the food had to hold up long enough to get the shot. Combine that with long exposures, and any movement would render the shot useless. The slightest thing going wrong during any of the many steps required could spell disaster. Once exposed, the film was rushed to the lab for development. If we moved on without checking and there was a mistake, we had to do it all over again.

Back then, cameras didn't have autofocus. Instead, we had to focus the camera manually and use a loupe (a photographic magnifying glass) to check the focus on the ground glass to make sure the view camera was focused properly. Oh yes—the image was also upside down, which added that extra element of fun.

Forget shooting food on 35mm. We used 4×5 and 8×10 large-format cameras, and in later years we used a 6×9 roll film back on the 4×5. 6×9 film came on a roll instead of in sheets. You could load one roll onto a special back (the piece of equipment that holds the film). By that time, the scanning technology had become very good, and you could get away with using the less expensive and easier-to-work-with film. The ultimate goal was to be completely digital one day, but the gap still existed.

As with any fledgling technology, there was a steep learning curve. It took a great deal of effort to get the Polaroid digital camera even to work. It would allow us to print only a very small image before it pixilated. With some persistence we incorporated the Polaroid into our workflow, when applicable. That was 1997. That was not really that long ago, but in the early days it seemed like we would be stuck in the darkroom ages for years to come.

For professionals making their living through photography, being able to take the guesswork out of photography was amazing. We replaced the Polaroid film tests, multiple strobe pops (multiple flashes), and exposure bracketing with live image preview where we could see the results right away. It was a game changer. The reason so many professionals were early adaptors was simple—the results spoke for themselves. You could see your outcome and be confident the photograph was correct. A client could approve a shot instantly. Removing the guesswork from photography was a sheer delight. We could play with our food by experimenting with multiple camera angles without the worry of all the possible things that could go wrong before the food died. It increased our output and made clients very happy. The new technology gave us the ability to create entirely new compositions using the same dish. Shooting digitally afforded us extra time to shoot. This was a very interesting development. The ability to move the camera changed the entire landscape of food photography forever. We were no longer chained to cumbersome 4×5 cameras and were now free to move about the cabin. In 1997, digital photography was in its infancy, and there was a debate whether digital would ever replace film. Film was still king of the world, and companies like Eastman Kodak and Fuji ruled the industry.

Within two years from my purchase of the Polaroid system, the digital photography boom took a quantum leap forward. The introduction of Fuji S1 changed the landscape for us completely. It was the first digital single-lens reflex camera, or DSLR, that was reasonably priced, at under $4,000 for the body. We purchased three lenses, including a 14mm flat wide-angel lens (a lens that did not distort on the ends), a 24–120 zoom, and a 105 macro. Maxing out at around six megapixels, with a few gentle nudges in Photoshop, we could produce 9×12 printed pieces for clients. This was the breakthrough we had been waiting for. We put our 4×5 into the box and never took it out again.

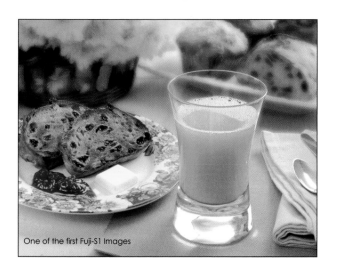

One of the first Fuji-S1 Images

In the beginning, digital photography was accessible only to professionals. The DSLR's first practical application was by photojournalists. Kodak created the first working models in 1991 with the introduction of the Kodak DCS 100. This marked the beginning of a long line of professional Kodak DCS SLR cameras. Built on a Nikon platform, it used a 1.3 megapixel sensor and was priced at $13,000. It was still a bit steep for hobbyists and not quite up to the standards that professional food photographers needed. Our only option was to shoot and scan or spend up to $100,000 on a large-format digital camera, which at the time were highly flawed. You needed special non-flicker bulbs, could not use strobes, and could not shoot anything that moved. Most of us had to operate within the technology gap until it eventually caught up with what could be produced on film.

Today, the entry point for digital photography has become very affordable. You can purchase a DSLR on the low end for $400. This is kind of mind blowing when you consider how expensive the technology was just a decade ago.

As professionals we paved the way, and the rest of the world came along for the ride. With all the digital advances and ease of use, one fact remains constant. Good photography is still challenging. Even with all the bells and whistles, a bad photograph is still a bad photograph.

I have been shooting food professionally on my own for 13 years. Bill Helms retired from commercial photography in 2000 to pursue an art career. He was a true pioneer in the field of food photography and digital workflow.

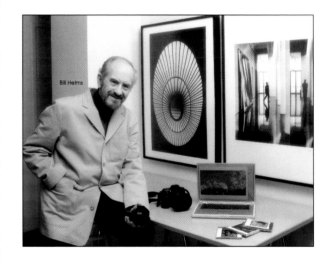

Along with his dear wife, Carol, an art director with impeccable taste and style, they were a collaborative team breaking down all doors in the food photography field long before I ever hit the scene. We spent seven years together, and our relationship was much more than assistant and photographer. Like any great relationship, Bill taught me many things. He was one of the most caring, kind, and giving people I have ever met. Always selfless and willing to teach, I feel it is important that I pass along his legacy as well as mine. His knowledge and wisdom are mixed with my photographic DNA. The result is a food photography knowledge base that is extensive. I can only hope to come close to being the photographer and person he was, but at least I can share what I learned along the way.

Photography as the predominant vehicle to show food in print was not really prevalent until the early 1990s. There was always a demand for food photography, but illustration was still heavily relied upon as the most cost-effective way to show food. The second reason for the dominance of illustration was the cost of printing. Four-color printing was more expensive. Photographs of food look better in color, while illustration could look good in black and white.

It was very expensive to do food photography. During a typical photo shoot today, we create about 8–10 beauty shots. Back then, you were doing well if you finished two shots in a day. The advertising community would commission top photographers, such as Bill Helms, to shoot their images. The process was costly compared to the return on investment. Although top food photographers get paid quite well today, our output is significantly greater, so comparatively it's much less expensive.

It was also laborious and expensive to get photographs prepared for printing. There were many steps involved. Today you can create a PDF, combine the text and images, and be done. Back then, the printing process was in the Stone Age. Press plates had to be made from negatives, and it was costly to print in color.

Desktop publishing moved food photography to center stage. New methods like the Kodak-CD standardized imaging systems and allowed people to share photography much more easily at a much lower cost.

Companies such as Corel offered huge stock libraries of every conceivable genre, including food. Illustrations were no longer in vogue because photography was easily accessible and less expensive. When combined with imaging editing software like Photoshop, it was no contest.

Soon photography took the lead. Professional photographers experienced a bit of a downturn when the marketplace was flooded with cheap food images. It was exciting to see a great food image on your marketing material until you saw your competitor using the same image on its ad pieces. But this quickly reversed due to the increased demand for unique and original photography.

Once photography became the norm, it was a matter of time before demand exceeded output. People became used to seeing color food photography. Television has also done a great deal to bring food photography into the mainstream. Innovative cooking shows helped spark the foodie movement and create a need for more and more food images.

Two major contributing factors gave rise to the explosion of the digital food photography revolution we are experiencing today: the accessibility of the DSLR and Web 2.0 (the ability for people to self-publish their work).

Being able to self-publish and disseminate information at lightning speed has spurred on the food photography revolution. Having digital cameras available to document every culinary experience opened the floodgates.

People quickly started sharing their culinary experiences. Early adapters now make a decent living with their content and traffic monetization models. People who embraced Web 2.0 technologies and beyond are creating amazing work to satisfy the massive information machine ever hungry for content.

Sites like Flickr and WordPress were instrumental in bringing food photography into the hands of anyone who wanted to express himself. No longer a field just for elites, food photography is now available to anyone who wants it. It's still not easy to shoot food, but at least you don't have to go through 10 steps before you take a picture. You can experiment all you want until you get it just right.

The most important thing a food photographer needs to learn, after the basics of photography, is how to develop a point of view. The only way to do that is to shoot thousands upon thousands of photographs.

I was lucky enough to have evolved along with technology at a stage in my career when everything changed. It was a fun and exciting time to usher in the digital food photography era. I have not shot a roll of film in 13 years and don't really miss it. Give me my digital camera any day. I will stress this: I was a photographer before I became a food photographer. I took the time to learn photography, its rules, and its restrictions. Whether shooting film or digital, you still have to learn the basics. Photography is still a challenging pursuit, and food photography is even more so. Let's review some basic concepts of photography as they relate to taking food images.

Photography 101

Before we get into teaching food photography techniques, let's take a few moments to review some very rudimentary photography concepts. Why take this time when you can just point your camera and shoot away? Photography is a skill that needs to be developed. You can learn to play the guitar in a matter of weeks, but it can take a lifetime of practice to master it. These concepts will also tie into my recommendations for food photography equipment. I will explain how to get the best results without having to break the bank. Most hobbyists can't afford the type of equipment we professional food photographers use, but with proper instruction, they can get similar results.

If you are looking to make the leap into professional food photography, don't worry; we will also tackle more advanced techniques later on. The purpose of this book is to speak to both the hobbyist or blogger/writer who shoots photos as well as the shooter who wants to become a professional food photographer. As we progress through the text further, we will demonstrate real tricks of the trade along with more advanced techniques.

Let's start with the basics. I would be remiss if I did not go through a few of the fundamental principles of photography. Whatever medium you choose, there are certain underlying photographic principles that you need to master. Controlling your equipment and using it to your advantage are paramount. You need to learn the rules of photography. Once you learn them you can have fun breaking them, but first learn the principles that all photographers should know.

I will be referring to DSLR cameras in the book. You can use any camera you like, of course, but without the ability to control your camera manually, you are at the mercy of the machine. Critical aspects of food photography can't be achieved without the use of manual controls.

What makes a photographer great is his ability to see the outcome before the shutter is snapped. Once you can translate your mental vision into reality consistently, you can master photography. Until then, your great images are just happy accidents. If you learn from enough happy accidents, you can repeat them at will and develop your own style.

I mentioned earlier that photography is both science and art. Even though a great deal of the science has been simplified, there are still a few fundamentals that need to be discussed.

Let's start with how a camera works. A camera contains a shutter that when released creates an opening that lets light in for a specific amount of time. A properly exposed image achieves the perfect balance of detail between shadows and highlights. Many newbies don't take the time to expose images properly; instead, they rely on post-production to save the day. This is a mistake. Learning the basics of how a camera operates is very rewarding and will yield dividends for the rest of your life.

Fixing images in post-production can be fun and is an art unto itself. If you like manipulating images better than taking photographs, then perhaps being a photo retoucher is a better path for you. Retouching is time consuming. My personal theory is that every 10 minutes spent capturing an image in camera correctly will save you an hour in post-production time. If you are on a deadline and have to correct 50 images, you may end up in the weeds.

Tip

Rather than relying on Photoshop to fix difficult lighting or bad composition after the fact, take an extra minute while shooting to make sure your image is just right. It will save you a lot of time and effort on the back end.

There are three means of controlling an exposure in every camera with manual settings: f-stops, shutter speeds, and ISO. Two work in tandem with each other and form a powerful combination. The way a camera records an exposure is simple. A proper exposure is derived by combining the correct shutter speed with the correct f-stop. Along with the ISO (the chip's sensitivity to light), we can make intelligent choices that affect the final photograph. How we apply the various combinations of f-stop and shutter speed determines the outcome of the photograph. By learning how to manipulate those, you have complete control of the result.

The shutter speed controls the amount of time light records on the image sensor. The aperture setting, also referred to as the f-stop, controls the amount of light that hits the chip. Think of the two working as a team. Circumstances dictate how these two partners need to be used. Creating the proper exposure is often a compromise. There is a fixed range of stops between shadows and highlights that the exposure needs to be within, or one part of the image will suffer.

For example, if the light it takes to record detail in a shadow area is much greater than the highlight, then the highlight in a photograph will be blown out (no detail is recorded) and will not yield an acceptable print. The same holds true for shadows. The same image might have great highlights, but the shadow areas will be muddy or black if there is too much of a gap between what is a good exposure for the highlights and the shadows. Being able to use fill techniques, which will be explained later, is essential in controlling this delicate balance.

Let's discuss how shutter speed works first. There is a curtain in the back of your camera that keeps light away from your sensor. When the shutter is released and a frame is taken, the curtain remains open for a specific amount of time.

| Underexposed 1 stop | Correct exposure | Overexposed 1 stop |

Shutter speeds

bulb | 30sec | 15sec | 8sec | 4 sec | 2sec | 1sec | 1/2 sec | 1/4sec | 1/8sec | 1/15sec

1/30sec | 1/60sec | 1/125sec | 1/250sec | 1/500sec | 1/1000sec | 1/2000sec | 1/4000sec

a shift in shutter speed either halves the amount of time or doubles the amount of time.

Some cameras have slightly different shutter speed ranges, but they all work in the same fashion. Shutter speeds are expressed in fractions of a second, usually ranging from 1/4000 of a second (which is extremely fast) to about 30 seconds on the average shutter speed dial. Most DSLRs also have a bulb setting. This allows the photographer to hold the shutter open for an extended length of time. This is useful when doing night exposures or when shooting fire effects, such as meat being grilled on a barbeque. The faster speed is expressed in the smaller fraction, and as we progress down the scale, the amount of time increases. For instance, a shutter speed of 60 (1/60 of a second) is a longer exposure than 125 (1/125 of a second).

To hand-hold a camera, you need to shoot with a shutter speed no greater than the length of your lens, designated in millimeters (mm). As a reference, the focal length of the human eye is roughly equivalent to a 50mm lens. For example, if you shoot with a 105mm lens, your hand-held shutter speed should be 1/125 of a second or greater. On a sunny day there is not much of a problem, since the light is bright. When the light fades, being able to set your shutter speed becomes more restrictive.

When shooting food, some element in the photograph needs to be crisp. If your shutter speed is too slow while hand-holding the camera, the camera will shake, and the image will be blurry. Even image stabilizing devices are limited in what they can correct. It's best to make sure you are using a fast enough shutter speed to capture the image without blur. When shooting food, use a tripod.

With food photography, often we must use longer exposures. A tripod is always preferred when shooting food photography. It is, after all, a still life. The goal is to blur the image only where you want it to be blurred through the use of a technique called *depth of field*. Depth of field is the distance between the nearest and farthest objects in a scene that appear acceptably sharp in an image. So, for instance, an image with a greater depth of field may be sharp throughout (a mountain landscape), while an image with shallow depth of field may only have one element in the picture sharp while the rest is out of focus (close-up of a strawberry).

Another part of the exposure equation is the aperture, also known as the f-stops. The aperture is an iris. The human eye contains an iris, one that is infinitely more sensitive and reactive than any camera lens can ever be. When the light level is dim, the pupil in your eye adjusts by opening up to allow more light in. If you move into harsh sunlight, the pupil recalibrates and becomes much smaller. This is done automatically, so you are unaware it's happening. It takes a few minutes for your eye to adjust to radical shifts in light—like moving from bright sunlight to a dark room—because the eye does this slowly.

A camera lens uses the same principle. When I was learning the rules of photography, I had a difficult time grasping how f-stops work because of the language that is used. What was most confusing to me was that the larger the opening, the smaller the f-stop number and vice versa. For example, f-2.8 resembles your pupil in low light (wide open), while f-22 resembles your pupil in bright sun. It's practically a pinhole.

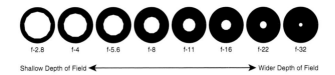

Here is where the eye and the lens part company. The human eye is a perfect machine. No matter what size your pupil's opening is, your eye's focus remains sharp. A camera lens is different. The sharpest part of the lens is in the center. The lens blurs gradually as you move out from the center. If the f-stop is at f-32, most of the photograph is sharp. As we open up the lens and make the f-stop wider (a smaller number on the scale), the sharpness of the lens begins to decrease, and parts of the image start to blur. The middle of the f-stop scale is about f-8.

The lens opens up wider and wider as you move progressively toward the smaller numbers. Each increment on the f-stop dial either cuts in half or doubles the amount of light that the iris is allowing into the camera, depending on which way you turn it. If we say that you should stop the lens down one stop, then you would move the f-stop from f-8 to f-16. If we want to open up the exposure one stop from f-8, we would shift the f-stop to f-5.6.

Assuming the exposure is determined using a light meter, for each move we make on the f-stop we need to make the opposite move on the shutter speed to maintain a balanced exposure. We will discuss this further in a moment.

Manipulating the aperture creates what is called *depth of field*. This concept opens up a myriad of creative choices for the photographer. Conversely, professional jobs sometimes need critical sharpness from the back of an image to the front. If the focus falls off the image, it becomes useless to a client. Being able to understand how f-stops and shutter speeds work in conjunction with each other will ensure you get the results you want.

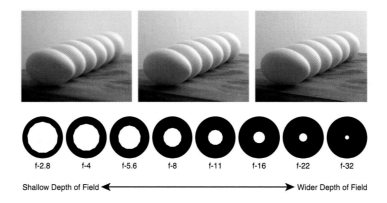

Relying solely on the automatic settings of your camera is easier; you will never be fully free to explore your creativity. Depth of field is critical in food photography and must be mastered. As a good friend and colleague always tells me, fear no button. The beauty of digital photography is that it costs nothing to experiment. Explore the camera and its settings thoroughly. You will be much happier that you took the time to learn your craft when the results of your photos improve dramatically.

Putting the f-stop and shutter speed concepts together is easy. Using the candy image illustrated here, we chose to focus on a few pieces of candy and blur out the rest.

We know we want to create a shallow depth of field. Set up the tripod and compose the image. From our previous discussions, using a more open f-stop will yield the desired effect. We choose f-5.6. Somewhere there is a shutter speed that will allow us to expose the image sensor at f-5.6 and capture a properly exposed frame. Let's say that 1/125 of a second is where our camera meter told us the exposure was good. We shoot the image and achieve a perfectly exposed picture, but the depth of field is not satisfactory. We decide to open up the f-stop to f-2.8. This time we get a very overexposed image. What happened?

The f-stop and shutter speed dials have a direct relationship to one another. If you want to increase the depth of field in an image by stopping down the lens (to a smaller number), you must adjust the shutter speed in the opposite direction. We determined that we wanted to create a more shallow depth of field. We adjusted the f-stop two stops down from f-5.6 to f-2.8.

Note

Some cameras also deal in half stops, which allow greater control. For this discussion we'll stick to the standard f-stop increments.

We changed the f-stop to f-2.8 but neglected to change the shutter speed. Our image is now overexposed (too much light)—two stops to be precise. Each click on the f-stop dial either doubles or cuts in half the amount of light the image sensor receives, depending upon which way we adjust it. The shutter speed works in the same fashion by decreasing the amount of time the image sensor is exposed to light by half or doubling the amount of time, depending on which way you turn the dial. When you move the f-stop up or down, you then have to move the shutter speed in the opposite direction the same number of times. So our image, which was f-5.6 at 1/125 of a second, will now be f-2.8 at 1/500 of a second.

The last piece of the puzzle regarding exposure is the ISO sensitivity. Originally used as a scale to determine film speed, ISO now is used to indicate the image sensor sensitivity to light. ISO settings usually range from 100 to 3,200, depending on the camera. When you are shooting in low light, the ISO may need to be increased get the proper exposure. For example, if the light level starts to wane a bit, we have to adjust the ISO to compensate. We increase our ISO from 100 to 400. The same rule applies to ISO as it does for f-stop and shutter speeds. If you increase the ISO sensitivity, you double the chip's sensitivity and ability to react to light. Image quality begins to suffer as the ISO moves towards the higher spectrum. Similarly to film, the image takes on a grainy quality that can be undesirable in food images. Although cameras are always being developed that produce better images at higher ISOs, I usually prefer to use ISO 100 or slower to maintain the highest image quality.

Our jump from ISO 100 to 400 has now created a two-stop difference from our previous settings. Using the numbers from our example, we have two choices. We can either stop down the lens from f-2.8 to f-5.6 or increase the shutter speed from 1/125 of a second to 1/500 of a second. Previously we determined that maintaining f-2.8 is more critical than maintaining the same shutter speed. If we determined instead that maintaining the shutter speed was more critical to the execution of the photograph, then we would have adjusted the f-stop instead. The balance for exposure must always be maintained. Having a properly exposed image is critical.

Putting it all together is pretty simple. Inside your camera is a light meter. The meter usually works on a plus/minus scale. When the meter is at null (zero), the exposure is correct. If it's on the plus side of the scale, your image is overexposed, and on the minus side of the scale it's underexposed. As a general rule of thumb, it is better to underexpose a digital image than overexpose it. You can never get detail into an overexposed image, but you can pull detail out of an underexposed photo with image editing software.

Light meters are tools. They do not think; they merely measure averages. The meter built into a camera works off reflected light—meaning it measures light as it bounces off the subject. It can easily be fooled into giving you the wrong exposure, so the key is to know when the light meter is giving false results. Light meters used to play an extremely important function in photography because you could not review the results and had to rely on the meter to determine exposure. Since digital cameras now give you the ability to review images on screen right away, using a camera light meter may seem redundant. But using the camera meter to get an exposure reading is still a great jumping-off point when you are using manual settings.

Gearing Up for Food Photography

Here is a brief review of the basic tools you will need to do food photography. Keep in mind that if you are going to go into food photography as a career, there is a significant investment in hardware. It has taken me years to acquire the gear I need to work. Many photographers go broke buying gadgets they don't need. My advice is to purchase only equipment you need to do your job. If you live in a large city, there are rental houses that have all the equipment you need and can be expensed to the job.

The equipment listed is highly recommended for the beginner. Also, when purchasing equipment it is always wise to get the best you can afford. When you outgrow your equipment, you will know it. When I made the leap from a digital SLR to a high-resolution Leaf back attached to a medium-format camera, it was apparent that I could not progress without it. I still use digital SLR cameras when appropriate. There is always a correct tool for each job.

Here are a few recommendations:

- ❖ DSLR (Nikon or Canon if possible) with manual settings and interchangeable lenses.
- ❖ Tripod. Purchase a sturdy tripod with a proper head. There are different types of heads for tripods. I prefer a traditional head vs. a ball head. You can level a traditional tripod head easier. Long exposures for food photography require a very sturdy base to avoid camera shake.
- ❖ Lenses. Get a 24–120 zoom lens and one macro lens if possible (105mm is preferable).
- ❖ Two light stands.
- ❖ Handheld self-standing mirror with one normal side and one magnified side. These can be purchased at any drug store.
- ❖ Two 11×14 white bounce cards and two 11×14 black cards. Cards can be foam core or poster board but need to be stiff.
- ❖ One diffusion panel, a translucent foldable disk that can transform harsh sunlight into soft diffused light.
- ❖ Four heavy gauge spring clamps or A-clamps.
- ❖ Image editing software, preferably Photoshop.

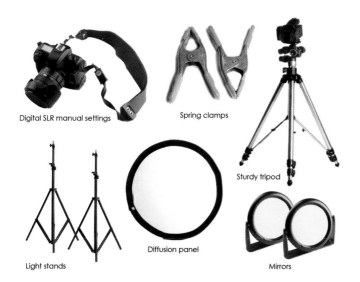

Digital SLR manual settings

Spring clamps

Sturdy tripod

Light stands

Diffusion panel

Mirrors

Note

You can save money by picking up some equipment second-hand, such as tripods and light stands. When purchasing more pricey equipment such as cameras, lenses, and other electronics, be wary of buying used. New equipment will come with a manufacturer warranty, which might be helpful down the line. Without it, you are on the hook for costly repairs.

The Last Word

The last thing I want to stress before we move on is that it has never been a more exciting time to try your hand at food photography. Digital technology has leveled the playing field and has never been more accessible to anyone who chooses to learn this art. This book will serve as a reference for years to come and is designed to teach practical solutions to capturing food images. Do not get discouraged if your images are not magazine worthy yet. Play with your food, and you will get it. Don't be afraid to take bad pictures, learn from your mistakes, and develop your style.

I also recommend to all you fledgling food photographers not to show people your work until it is finished. I repeat: Don't show your work unless it's finished. You have one shot to make a first impression. There are critics out there who will judge you. There are also people who are afraid to hurt your feelings and give you a false sense of accomplishment. Showing your work prematurely can devastate your self-confidence. I urge you to nurture your art and not allow anyone to disrupt your learning process. And by all means have fun!

Photography for Beginners

Food photography is a worthwhile pursuit, but it can be challenging. When I shoot for clients like Sara Lee or Heinz, I employ a team. In its simplest collaborative form, the team consists of me (the photographer) and a food stylist. A food stylist makes food presentable for the camera. Usually they are trained chefs and are highly skilled at making food look good for photography.

In my opinion, it is more productive to work with a team. You can divide the labor. Food photography is complicated enough without adding the element of styling your own food. That just adds another element to an already challenging job.

If you love to cook and are reading this book to learn how to photograph your own stunning food creations, that's not a problem. Hopefully you have a basic understanding of photographic principles. If not, don't worry. I will guide you through the essentials and get you shooting great food in no time.

If you are like me and are merely a photographer, then you might want to consider collaborating with a chef or a person who aspires to be a food stylist and needs support. As a team, you can accomplish a great deal. Developing a reciprocal relationship can be beneficial, and it helps defray the cost of the food, which can be expensive.

When I am not shooting for a client, I often shoot the food I am cooking or I collaborate with my wife to get great results. Professionally styled food has a certain look and is not always the correct choice depending on how you want your end product to look. Food styled by a professional may be too polished for your needs, which may require a more organic look. For example, I write a weekly blog, and I am always in need of images. I often experiment at our house in the country where I use natural light or just one strobe. Often people like to make things more complicated than they have to be. It is important to learn to be free from restriction and not limit yourself by making it too challenging to take out your camera. Often, people get so overwhelmed by the prospect of shooting that they never get going. Do not make this mistake. Even a bad experience can be one you learn from. Just shoot, and worry about the rest later. The more you get used to shooting, the quicker you will become proficient as a food photographer.

Learning photography should be fun. I started taking pictures as a hobby. I progressed at my craft by taking a lot of photographs. I studied what went right and what went wrong and made adjustments. As a digital photographer, you are at a huge advantage because you can accelerate the learning process. How? By shooting, editing, and then analyzing your pictures very quickly.

You should dedicate just as much time toward analyzing your photographs as you do when taking them. To become a master at food photography, you need to critique your images and be brutally honest with yourself. Assess the strengths and weaknesses of your photography. Get rid of the bad images after you have figured out what makes them bad. You can learn a great deal from moving in the wrong direction. Not everything works photographically. You have to develop a memory of what are and are not good photographic choices. In other words, you can't learn if you do not practice. Don't make it impossible to practice.

The wonder of photography is that with every photograph you have a chance to demonstrate your point of view, to share your vision. It all comes down to choice. What props do I use? What food do I photograph? What lighting do I want? What is the mood of the image? You will eventually develop these senses like a muscle memory and make the right choices whenever you pick up the camera. To get there, though, you have to learn the craft of photography. If you can move through the learning phase quickly, soon you will be creating beautiful food images.

I have been shooting for 30 years, half of that time professionally. What I love about food photography is that it is always a challenge. The goal is to create a reaction, to showcase food in a seductive way, to make people want to take a bite. I usually ask myself if I would eat that, if it makes me hungry. If so, I did my job correctly. You can also use photography to repulse people. Whatever your artistic vision, whatever reaction you want to evoke, positive or negative, you accomplish through your photographic choices. If you want to showcase the beauty of salt or discourage people from eating meat, you can do so. It's all a matter of how you choose to frame the debate. I can show the horrors of eating meat by photographing a brain, chicken foot, and organ sandwich or the beauty of meat by shooting a pork chop cooked to perfection. Whatever side of the fence you come down on, you have to make a choice to sell the idea.

Grab something to write on or any device you wish to keep notes on. Choose five of your best photographs—food ideally, but any genre will do for now. Write down the choices you made for each one.

- ❖ What lens did you choose?
- ❖ Why did you choose that particular subject?
- ❖ What distance to the subject did you choose?
- ❖ Why did you choose to take that particular photograph?
- ❖ Why did you choose that particular composition?

The exercise is complete when you can answer all these questions.

The point of this exercise is to learn what makes these photographs interesting, based on the choices you made. Disregard what other people may have said about the photos and hear what is important to you. Listen to your own voice about why you like an image and what makes it resonate with you. The next time you pick up the camera to shoot, think about the choices you have available to you.

When you pick up the camera to shoot, you should ask yourself questions. The choices you make photographically, good and bad, will help you develop and shape your point of view.

Every photographer needs to have a point of view. A point of view is a common element or style that represents your unique vision and personality. If you don't have one at the moment, don't worry. It takes some effort and a good deal of time to develop a strong point of view. People who are familiar with my work can spot what makes my images unique. For example, when I take a photograph, I like to get up close to the food to reveal its amazing textures. Some photographers prefer to showcase the environment along with the food itself. Since no two photographers will take the same photograph exactly the same way, developing a strong point of view will separate you from your peers.

Developing your point of view is partly achieved through your compositional choices. Do you prefer to shoot a macro view of your universe by zooming in close to count the seeds on a strawberry? Do you prefer to shoot an elaborate table setting where the set becomes the main focus and the food is an accoutrement? Only you can make those choices for yourself. It takes a bit of experimentation to develop this. You have to drill down to reveal what your point of view is. It starts with composition.

Composition is the way the elements are arranged, accented, or diminished in a photograph. The choice of lens, distance to the subject, and angle of the camera can radically alter the look and feel of an image. Often the difference between a great photo and one that winds up in the trash is a slight shift—moving the camera up or down or changing the lens.

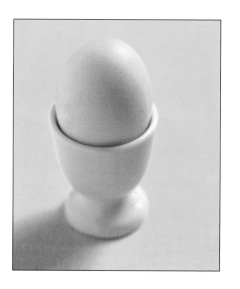

With food photography, you may have everything just the way you like it, except that the plate needs to be rotated to make it perfect. Often we will style a dish only to notice it does not work, or the props are wrong. It is not uncommon to change elements or even restyle a dish if it's not working. Simply changing the plate can make the difference. As a food photographer, you are really a still life photographer. The ability to arrange the elements in your photograph so they are pleasing to the eye is paramount to your success. As a still life photographer, you are the master of your world. Everything in the photograph is yours to decide. Being able to arrange the subject and make it work in the photograph is the challenge. How do we accomplish this? Composition. The first rule of composition is KISS (Keep It Simple, Stupid).

One of the most common mistakes photographers make is trying to force too many items or competing subjects into the photo. Let's take plate choice, for example. A loud pattern on a plate can distract the audience. By choosing a simple white plate instead, we diminish the distraction, and our eye can concentrate on the food. Distracting backgrounds are also image killers. Keep your compositions simple at first by exploring the beauty of shooting one element in a photograph. Tone-on-tone images are good examples of compositional simplicity and beauty, as we can see from the example of the photograph of the egg. Using opposite colors also works well. If you are not familiar with color combinations and opposites, there are many books and Web sites dedicated to color theory. For now be aware of any color clashes that exist in your setup.

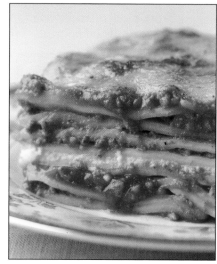

The Rule of Thirds

The rule of thirds represents the off-center placement of your subject. Visualize the photograph in your mind and imagine your picture area divided into thirds both horizontally and vertically. Where your imaginary lines intersect suggests four options for creating a center of interest. Where you place the subject depends upon how you would like the subject to be viewed. The human eye is drawn to one of the quadrants, so it is more pleasing to the eye to have the subject in one of these areas.

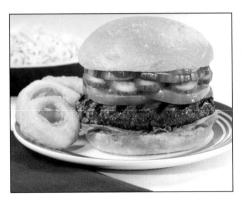
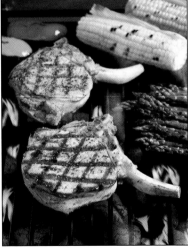
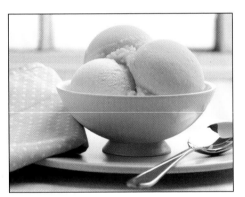

Use of Shapes

Shapes and patterns appear naturally in the world. When we take photographs, whether of food or any other subject, our eye is naturally drawn to such shapes. The following examples are illustrative of shapes you can replicate when composing images.

Diagonal Lines

Another technique is to divide the frame diagonally. Instead of framing the subject vertically or horizontally, draw an imaginary diagonal line. Turn your subject to match the line in your mind. This creates energy, pulling you through the scene.

Circular Patterns

Circular patterns work well to add interest. Creating concentric circles within the photograph gives visual importance to specific areas. This helps hold the viewer's attention and brings attention to the area in focus.

S Shapes

I like to use *S* shapes to keep the action sweeping through a photograph.

Other compositional techniques involve camera placement. You can turn a mediocre composition into an award winner simply by moving the camera in one direction or another. You can use camera angle to emphasize importance or to bring the viewer's eye to a specific area. Using concepts we discussed in the first chapter—such as depth of field—can help to bring the viewer to a specific point of view by guiding him through compositional choices.

Food looks great from many different angles. The safest choices are always straight-on, above, and overhead. Here are illustrations of each form of composition.

Camera Angles

The angle of the camera is an important element to the composition of any photograph. Defining the correct camera angle can spell success or failure in a photo. Where we choose to place our camera affects the over-all tone of the image. We can choose to place the camera anywhere we want, but certain angles work well with food. Here are a few examples of different camera angles.

Straight-On Angle

Placing the camera directly in front of the subject works well for food. It features the subject but also requires a background in the shot. It really works well with selective focus (depth of field).

Above Angle

One of my favorite angles for shooting food is about 45 degrees from above. This angle allows you to look over and into the food. This is a great angle if you do not want to build an entire background set. You can still capture the flavor of a background, but in these instances, the surface also becomes a background. This is a great camera angle for working in smaller spaces.

Overhead Angle

The overhead angle or bird's eye is another great angle when shooting food. The overhead angle is fun to experiment with. There is no depth of field with the bird's eye, but it is a great camera position to create graphic still lifes. When using this angle, keep in mind that you have to place the camera above the set. It's best to put the shooting surface directly on the floor, or you will need a really tall ladder and a tripod that extends fairly high.

Dutch or Tilted Angle

You don't always have to keep the camera straight. You can dutch (tilt) the head of the tripod to create interesting compositions, as illustrated below.

Making strong compositional choices is a great start to becoming an accomplished food photographer. When in doubt, it's better to start with simple compositions. Create visually interesting images by employing these compositional guidelines. Learn the rules, and then by all means apply them inside and outside the box. For example, composing images below the horizon, approaching the subject from below, can create heroic effects. Composing an image with the camera severely tilted can produce dramatic tension. It's all about balance and what makes the photo appealing both to you and to an audience.

These techniques are fun to experiment with.

EXERCISE #2

Using the techniques described previously, get a bowl of apples and see how many of these compositional styles you can apply. Feel free to capture as many images as you can so you can compare the various techniques against each other. Fruit is a great subject to start with as a beginning food photographer. It is easy to work with, and you will be able to handle it all day without it losing its beauty. When you are finished shooting, compare your images to the examples provided and see what you came up with.

Color Temperature and White/Gray Balancing

The lighting spectrum is represented through the use of the Kelvin scale. This means that different types of light have specific color temperatures. You don't need to know the Kelvin scale to understand that the color of a fluorescent light is different from the color temperature of daylight. That's why your image turns green when you shoot under fluorescent lights and orange under tungsten light. The camera has to be told what lighting conditions you are shooting under.

Most likely, you have your camera set to automatic white/gray balance. You can also set your own white/gray balance using a manual setting in the camera. Refer to your camera manual for custom white balance instructions.

The reason we like to create a custom white balance for each session is that the color temperature of lighting situations changes every time you shoot. The white/gray balance simply establishes a neutral tone in the image, so when you output your image, there is no colorcast creating an unpleasant effect in your image. To achieve a custom white/gray balance, you need a gray card. You can purchase one at any photo supply store. Some camera models come with a little gray card.

Place the gray card in the set where the light source is hitting the front of the card. Zoom into the gray card and set the white/gray balance according to your camera's directions. You might have to disable the autofocus feature. Since the lens has nothing to focus on, it gets confused and won't focus. The shutter won't fire unless the focus locks, so disable the focus and adjust the setting manually. When you set your balance, flip the autofocus back on.

Mirror Up

I highly recommend that you determine if your camera has what's called a mirror up function. An SLR camera has a mirror that allows you to look through the viewfinder and see your subject. When the camera fires, the mirror flips up and lets the camera receive the exposure. The mirror also causes vibration, an undesired result. Remember that we are shooting still life, in many cases under macro conditions. The severity of the blur is increased by the length of the lens. The longer the lens, the easier it is to shake the camera, which amplifies the blur. The effect is greater with a macro lens. Camera shake can ruin an image. To defeat this, we lock the mirror up and then fire the shutter. You can't look through the viewfinder when the mirror is up. Instead, compose the image, lock the mirror, and then fire the shutter. Problem solved. You should use a mirror up function every time you take a photograph.

Lighting Made Simple

Now that we understand composition a little better, we can discuss another piece of the food photography puzzle: lighting. Lighting can make or break a photograph. If you learn how to manipulate light correctly, your photography will advance by leaps and bounds.

Lighting food does not have to be complicated. When you get into more advanced studio techniques, your lighting will be much more evolved. When I first started I was a bit overwhelmed about lighting. I am going to show you some very simple methods that you can use immediately to light food.

The key to lighting food is understanding one simple fact: Food does not like to be lit from the front. If you have used your on-camera flash, you understand my point. You prepare to take a photo, and the little flash in your camera pops up. You snap the photo, and it looks terrible. The harsh flash creates ugly shadows and eliminates textures, which are integral to food photography.

Let's examine the photo of the eggs. The image on the left was taken with an on-camera- flash. Notice how unflattering it is to the subject. We took the time to make a nice composition and ruined it with poor lighting.

Rather than front light a food subject, we want to light it from behind or from the side. I know that sounds strange, so bear with me. In the figure on the right, the light is coming from behind, and the camera was mounted on a tripod. I determined what depth of field I wanted and picked a shutter speed that corresponded with that f-stop. The same image was then captured from behind. The results are quite different.

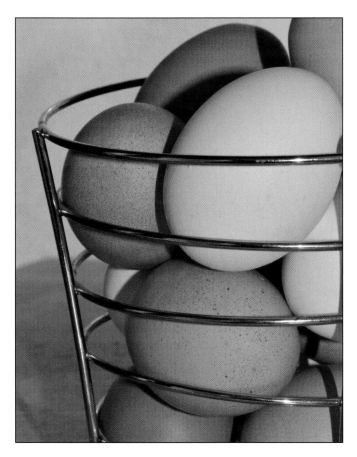
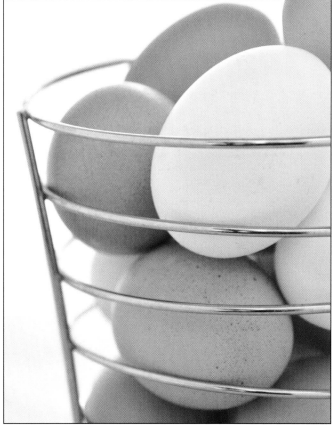

Up at the farmhouse studio I have 43 windows. There is always sunlight coming in to the house. The front and back decks are also available. The advantage to working with natural light is that it's free. You just have to learn how to bend it to your will.

If the light is coming from behind, why does the front seem to be lit? We use reflectors to bounce the light onto the subject.

If you have ever taken a photograph that is lit from behind, you know that the front of the subject is darker. If you change the exposure to make the front of the subject receive the correct exposure, the background blows out (goes totally white). Usually the back or top of the subject gets burned out as well.

To compensate, we use what is called a fill light. In the case of natural light, we are merely reflecting the light streaming in from the window beckoning us back toward the front. This fills the shadows with light. We use white cards to reflect the light onto the front of the subject, in this case the cauliflower (see the next page). You have to catch the light streaming in from the back and bounce it from your white cards to the front of the cauliflower. Depending on the angle of the sun, you might have to adjust the cards a bit to get the desired results.

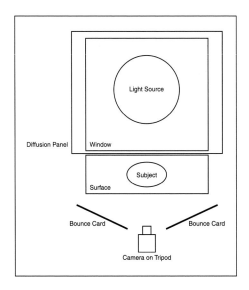

We first identify a proper light source by finding a window where the sunlight is coming in. We like to diffuse the light so that the gap between the rear exposure and the front exposure is not too great. If the day is overcast you do not have to diffuse the light; it is naturally diffused by cloud cover.

When direct sunlight (not obscured by clouds) is coming in, we usually want to soften it. We achieve this with the diffusion panel described in Chapter 1. If you do not have one, hang a white bed sheet or sheers, which are more translucent, on the curtain rod in the window. We use white because we do not want a colorcast in our photograph. You can follow the lighting diagram shown to the left.

Once the light is properly diffused, we place our subject, in this case the cauliflower, on the surface. We set the camera on the tripod and determine our composition. Next we take out our white cards. Use one card at a time to bounce light from the diffused window onto the front of the subject. You will have to experiment to get the best lighting ratio or balance between back light and front light. The closer you place the card to the subject, the brighter the front part of the subject gets and the more fill the shadows receive. If you pull the card farther away, the subject gets darker. This is where our choices come into play. In this case I wanted to make the lighting fairly even from back to front. I also wanted to throw detail into the front shadow so it would not go completely dark. I positioned the cards about six inches away from the subject. Once I liked the lighting ratio, I attached the cards to the stands with the A-clamps. I made a final exposure reading and then took the photo. The result is a beautiful shot. Notice the texture and richness of the image. If we were to shoot this lit from the front, those details would have been lost.

Tip

Here is a quick tip about measuring exposure correctly. Measure the light bouncing from the subject. When using backlight, the light coming in from behind often prevents an accurate reading. Light meters don't think; they simply measure the overall light from a scene and calculate an average. Since the light coming in from behind is stronger than the light reflecting from the subject, you can compensate for the false reading in one of two ways. You can zoom in to the frame until all the ambient light from behind is being blocked out. The meter then will give you the correct reading. If you are not using a zoom, dismount the camera from the tripod and move closer to achieve the same result. Set the f-stop and shutter speed according to your new reading and remount the camera on the tripod. You may have to disable the autofocus feature if the minimum focus distance for your lens won't allow the camera to focus.

If you want the highlight to be more specular (shiny) when bouncing light, use the mirrors instead of white bounce cards.

You should also take more than one exposure. This is called *bracketing*, a technique employed by professional photographers. Bracketing means adjusting the exposure to over- and underexpose the picture intentionally.

When we shot to film this was crucial. It's not as important these days, but it will save you a lot of time in post-production, especially if you calculate the exposure wrong or the display on your camera is not adjusted correctly. Many times you think the photograph looks amazing in the display only to be disappointed when you import the image to the computer. By bracketing exposures, you will get the correct exposure somewhere and not have to do much post-production.

Refer to your camera manual; many of the new models have an auto-bracket feature that will automatically shoot the over- and underexposures for you. If your camera does not, simply adjust the shutter speed to under-expose three frames, shoot the metered (correct) exposure, and then shoot three overexposed frames. Notice I said "shutter speed." If you adjust the f-stop you will change the depth of field. Generally, I adjust the shutter speed unless I am trying to achieve a specific motion or fire effect. Since the camera is on a tripod, you can use long exposures and not worry about camera shake. Reset to your original exposure and underexpose three frames. Somewhere in there should be the perfect exposure. Our goal is to teach food photography, so it's better to learn how to do things correctly in the camera instead of fixing images in post-production. Although it takes more time to learn, you will benefit greatly by using the proper techniques.

Shown on the facing page are four examples of lighting the same shot. The first image is taken with a flash. As with the egg example, the kiwi looks very unflattering. The beauty of the fruit is lost under harsh lighting.

The second image is backlit with no diffusion. Notice how radical the gradient shift is between the shadows and highlights. Pay particular attention to the two left pieces. Notice the glare and that the back one is totally blown out. This is because the light bouncing onto the front is much weaker than the light coming from the back. The gap between exposures is too great, so we have to expose for the shadows. As a result, the back is blown out, and the photograph fails.

The third image is backlit with diffusion. The exposure problem is eliminated; the back and front of the kiwi are within the same lighting ratio. We are getting there, but there is one last element: some fill light.

The final image is back lit with diffusion and fill. Also, see if you can spot in the kiwi photo any of the compositional elements that we discussed earlier.

EXERCISE #3

Get a kiwi and try to replicate the photo session that was just illustrated. Experiment with different elements of fill lighting. Move the cards closer, eliminate one card, and see how that changes the light and what it does to the image. Capture each frame and make notes. The point is to measure how light reacts when we manipulate it. Observe how changes you make influence the final outcome.

Side Light

Another attractive way to light food is from the side. Lighting from the side adds texture to the image. Depending on the angle of the light, texture is either accented or diminished. We have the same elements in this lighting setup as we did with our back lit example. The exception is that the light is coming from the side of the set with the camera facing the background instead of from behind.

The other difference is that the bounce card is reflecting light from the opposite side of the light source. You can also use a mirror to pop some light into a selected area or even brighten the front of the subject.

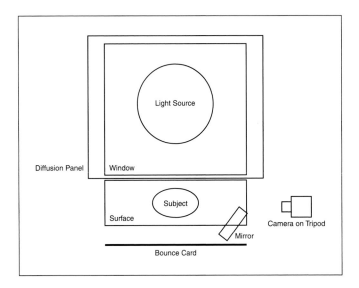

The next example, fudge on parchment paper, was photographed with side lighting. I did a whole series for my stock photography agency using the same set and changing the subjects. Stock agencies are companies that purchase images from photographers. I will explain stock photography relationships in greater detail later on. I like to shoot many subjects on the same background during a single photo session. One morning I had amazing winter light coming into my house. The sun is lower in winter, and the light just hangs in that part of the house for a few hours. It moves slowly, so there is time to get some great shots.

The background is a butter-colored tin wall that soft-focuses easily and allows for great images. I set my diffusion, bounce, camera, and tripod. I adjusted the bounce card until the ratio was to my liking and began to take a series of both food and kitchen props.

Using natural light is fun if you learn to control it. The important thing to remember is that the light moves, so you have a limited amount of time to work before you lose it. If you take too long, especially as the light is fading, you can miss a shot. It's best to plan your photo session around the movements of the sun. If you have the right conditions and plan properly, you can have a long session and get some great work done.

This image of the fudge and the images on the next two pages are some examples of the session I was just describing. My wife, Sasha, and I spent four hours shooting anything we could find around the kitchen. These images sell around the world through stock houses and pay monthly dividends.

Natural light conditions vary. The sun could be shining with no clouds. The light remains even; you just need to diffuse it. On an overcast day, you can shoot under soft light all day. Overcast skies create amazing conditions to shoot food. The most challenging weather condition is when the sun moves in and out of clouds. The diffusion panel is still necessary, but the exposure fluctuates wildly, so you need to be aware of it and make adjustments as you go along.

Budgeting the time you have to shoot is also a factor. The images I've shown until now have been simple still life photographs. I deliberately styled them using food elements or kitchen accessories. I wanted to avoid showing overly styled images so you could concentrate on learning the techniques that go into creating the images.

Adding the styling of complex dishes into the mix might be overwhelming. Food is hard to shoot because you are racing against the clock. Limit your subjects at first to simple foods that will not die on you in the middle of the shoot while you are figuring out the photography. This will yield results that are more positive. When you get the basics, you will be able to move on to complicated dishes because you know how to make choices in lighting, composition, and prop selection.

EXERCISE #4

Demonstrate the side lighting technique. Duplicate the lighting scenario you just learned. Experiment with the bounce card to get the light that is pleasing to you. As an added element, use the mirror to reflect light into an area of the photo that you want to emphasize. One side of the mirror reflects harder, more pinpointed light, and the other broader, less specular light. See how many still life food images you can create with what is in your house. See what props work and which do not. Use the same surface to create a series. Work towards some cohesive point of view for the series. Thread your series together to demonstrate proficiency not only in lighting but also in composition and prop choice.

Overhead Lighting

Another lighting scenario exists primarily when you are shooting outside. When the sun moves higher in the sky, mostly after 10 a.m., it starts to create very unflattering shadows. You can use a simple lighting technique to diffuse the light and get some great results. You will need your stands, clamps, bounce, two heavy 12-inch glass bottles or glass blocks, and a diffuser.

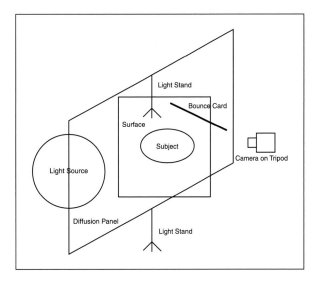

The idea here is not very complex. The sun causes harsh shadows when it is overhead. To create a properly lit image, we have to soften the light through diffusion. Select your subject, props, surface, and background. You will need room to work, so a large deck or driveway works well. You want a level surface. When shooting outside, you need to consider the background carefully. Depending on the camera angle, you might be showing elements of the background. If shooting down into the set from above, the surface usually becomes the background.

If you are incorporating a background that is not covered by the diffusion panel, you have to pay attention to the light that is falling on it as well. The same rules apply with lighting ratios. When the light falling on the background is much brighter than the subject, you will get uneven exposure. Conversely, if the light is much less intense, the background goes dark. These are not always bad things, just other elements to consider.

Set up your composition. Usually you should determine the composition before you apply lighting. There has to be adequate light to shoot, so make sure you have enough time to complete the shot from start to finish. It is frustrating when you set up everything and the light dies on you, so plan accordingly.

Set up light stands next to the surface. Clamp the diffusion panels to the light stands. You may have to weigh down the light stands with sand bags, gym weights, or other heavy objects. When working outdoors, wind is a factor. The wind will pick up the diffusion panel like a sail, so be prepared. Make sure the diffusion panel is between the subject and the sun. Place bounce cards on the surface and put the glass objects behind them so they stand up. You can use this method to hold up bounce cards in the other lighting scenarios as well. As long as the cards stand up where you want them, you can use any heavy object you have at your disposal. Glass block works well and are inexpensive. You can purchase them at any large home supply store.

In the next photograph of strawberries, a bounce card was used on the right side, and a mirror was used to pop just the strawberries and not the bowl. Learning to use bounce light is instrumental in lighting food. In many cases, you might have to hold the card or mirror because you can't get the correct angle of bounce any other way. It's all up to you and your choices for how you want the result to look. Forget post-production for the moment and concentrate on doing everything in-camera. When we shot on film we had to get it right in the camera, and you should strive for the same. Learn how to light, and you will never regret it. Your photography will improve dramatically.

The same technique was applied to the Indian corn images shown below. The only difference was that no bounce was used. The sun was sufficiently overhead so the light was shining in the front as well as from behind.

EXERCISE #5

Demonstrate the overhead lighting technique. Duplicate the lighting scenario you just learned. Experiment with the bounce cards and mirrors. See what holding the mirror in your hand does. Use the reflection to highlight selected elements in the photograph. Make sure your background is not distracting and that it is lit correctly. If you can't light the background, change the camera angle and use the surface as the background.

Overcast Lighting

When the sun refuses to shine, just remember the light is great for food photography. The sky becomes one giant diffusion panel. Apply the same techniques as before. Even though the sun is not shining, it is still moving, so you have to be aware of where the sun is in the sky and light accordingly. Use your bounce cards.

A Final Word about Natural Light

As you can see, the ability to manipulate light is the key to achieving good results in your photography. Hopefully you have practiced these scenarios and are becoming familiar with the use of diffusion, bounce, and fill techniques. Lighting does not have to be hard when the correct method is applied. You should have enough information to start creating spectacular results. Once you feel comfortable, start experimenting with your own style. Try to keep it simple, but perhaps get a beautiful bakery item that will hold up over time. Cookies are great because they don't really change much.

A Note about Lighting Equipment

The light diffuser is an essential piece of equipment when using natural light. The light diffuser is made of light-weight translucent material with a wire collapsible rim. They fold up by twisting them on opposite ends. They come in different shapes, but the most versatile is circular and about 42 inches in diameter. You also can purchase kits for around $100 that come with a stand, an arm extension, and the diffusion disc. The advantage of the arm is that you use only one of your stands. You also may want to purchase two sand bags when shooting outside. Extra A clamps and mirrors are always handy. If you are like me, you don't have unlimited funding. I had to build my kit over years and years. Good photo equipment is rugged and will last for years if you treat it right.

You can also purchase used lighting equipment. I don't think I have ever purchased a new light stand. A great source is eBay and large camera outlets such as B&H photo in New York. Google "used light stands," and many options pop up.

Another piece of equipment you should consider is an external flash. These can range in price from $50 to $1,000. You determine what size flash you need based on the type of photography you do. If you are a macro shooter, a small unit will do. If you shoot larger sets, you will need a larger light source. Flashes have diffusion options as well. You can always use your diffusion panel in conjunction with the flash.

The advantage to having an external flash is that you are not at the mercy of the sun. You can create a set anywhere and can shoot at three in the morning if you want.

Use of a Single Flash

The next example highlights the one-flash technique. The photo of the French onion soup on the left employs similar lighting to the first natural light set. The only difference is that the soup is lit with a single flash unit instead of natural light. In this case, the flash was mounted on a light stand. A pair of bounce cards was placed in front of the soup to the right and left. In the first shot, the bounce cards did not give enough kick. The result is that the front is a bit too dark.

A mirror was substituted on one side of the image on the right. I wanted to keep some of the mood, so I did not eliminate the shadow altogether. Now the cheese is visible in front. It's a much stronger image.

We can apply the same lighting techniques to flash/strobe photography as we did in the natural light scenes. The exception is that you can manipulate the flash. This gives you complete control of the lighting. Both daylight and flash units have the same color temperature, so the two lighting sources can be mixed nicely.

The photo of the cocoa mix combines balancing the light from the electronic flash with natural light. It's a technique called *syncro-sun*. All the elements we have discussed previously were working. No diffusion was used because the sun was overcast, and the set was backlit from the window. Bounce cards were in front. The obstacle was that I could not reflect light into the pot. After trying to use only natural light, I decided that I could mix the light with an external flash.

I was using a tripod and a long exposure, and I decided to hand-hold the flash unit and move it around until I got the light just right. I could fire the flash manually during the long exposure, introducing the secondary fill light into the scene.

The beauty of the shot on the facing page was inside the pot. The chocolate looks luxurious. The spoon creates the action, and my eye goes to the chocolate on the spoon. The rule of thirds was also used in the composition. I wanted to show the wood and hold the detail of the grain on the chair. Those were the choices I made when creating this image.

To light this image, I needed to determine the exposure for the flash when mixed evenly with the natural light. With a flash, you need not concern yourself with the shutter speed. First, I had to determine the f-stop and shutter speed for the overall set. I decided that I wanted to use f-8 at 1 second. I wanted to set a slow shutter speed to give time to fire the flash manually during the long exposure.

Once my f-stop and shutter speed were calculated, I wanted to mix the light from the flash unit. Each flash has a user's guide that gives specs as to its use and how it functions. Some units have radio triggers, so when you fire the camera it fires the strobe. Others have a sync-chord that attaches to the camera. You can also fire the unit by hand.

I wanted the light from the flash to be the same f-stop that I was using for the overall scene—f-8. From the right rear of the set, I angled the flash approximately the same direction the natural light was coming from. The pot provided bounce light from the fill flash because it reflected from the inside of the pot. I bounced very nice highlights in the cocoa mix. The highlights added texture and made what could be a very bland photo pretty.

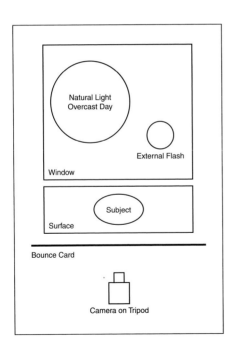

After some experimentation with the flash, I achieved the placement I wanted. The finishing touches were applied. I had a bounce card directly in front of my tripod, and the flash was to the right about three feet away on a high angle. I locked up the mirror in the camera, fired the shutter, and triggered the flash. Timing was critical. I employed another pro technique by using a timer, which I set for 5 seconds. When I heard the shutter fire, I hit the flash. The diagram illustrates the setup.

If you understand how lighting works and how to manipulate it, you will discover that your images will improve significantly. The difference between being at the mercy of light versus being able to bend it and shape it is obvious. Regardless of what light source you are using, you can call the shots and create images that are exactly the way you want them. You can decide how far you want to go with it. We will cover more advanced studio lighting techniques later; for now relax and play with what you have learned.

Experiment with hand-holding the flash, or mount it on a stand away from the camera. As with previous assignments, use all you have learned regarding composition, depth of field, and exposure. Feel free to move the external flash around to see what the light does to texture. Use it on the side or back. I suggest you also fire the flash from the front to see what it does to the image. Bounce the light with your mirrors and cards. Experiment with mixing the flash with daylight as well as using the flash by itself. You also can bounce the flash off a white ceiling or bounce card. The flash becomes a giant diffused source, great for many situations. Lastly, change the power of the flash and observe what that does to your overall exposure.

Telling a Story

You have developed the tools necessary to start creating a point of view. Once the technical aspects of photography are mastered, you can concentrate on creativity. That is the most important goal of my photography. As with every great photographer, there is a point when technique becomes automatic and artistic expression is free to develop. When you achieve technical proficiency, you won't have to wonder if the shot will come out; you just have to concern yourself with expression. When you can visualize a photograph exactly in your mind and then execute it, you will have achieved technical proficiency.

The Web may be the greatest tool for self-expression ever invented. Everyone who is connected has instant access and can make an impact. There is an audience for your work, and literally millions of people can tap into your vision. It's the ultimate Darwinian experiment. If your work resonates with the right people, you could go viral and open up the floodgates. Whether you are a serious photographer, a writer interested in blogging, or a self-publisher of cookbooks, it makes no difference. Telling a story visually or combined with text is a skill. Not boring your audience is hard, and people have limited time to be pulled in.

My blog, "Cook, Shoot, Eat—A Food Photographer's Journey," is a collaboration between myself, food writer Victor Ribaudo, and a recipe developer named Phyllis Kirigin. I shoot commercially for a living, so I need a creative outlet to share my point of view. I do it for fun, and it's a great place to showcase an idea or series. I am not a food writer, and I don't develop recipes. I collaborate with people who need great food photos, and we all benefit.

Blogging is a great way to get your work out there. Publishing a WordPress blog, a Flickr page, or a Facebook fan page is a great way to showcase your work.

Trying to tell an effective story photographically is fun. In this case, I wanted to tell the story of the anatomy of a chocolate muffin. I started out with the ingredients and shot progressively throughout the process until I had a nice photo essay. I think the series stands on it own, but you could write a narrative to go along with it, culminating in a recipe.

EXERCISE #7

Create a photo essay from a meal you prepare. Each photo should be able to stand alone or in the group. When composing your story, try to make each photo strong enough to be an individual piece. Thread the story together. Use as many lighting techniques and compositional elements as you can to move the narrative forward. Move the camera around and experiment with different angles and lighting. The series should reflect everything you have learned to this point. Have a good time with this one. Remember that you are not limited to this process alone. If necessary, combine efforts with a partner who may wish to do the cooking.

Building a Portfolio

A portfolio is an edited body of work that showcases your style, expresses your point of view, and lets people see your photography. Putting together a great portfolio is a long process. The commitment to mastery comes from action. The more time you dedicate to taking food photos, the better you will get. You can take shortcuts by combining other people's interests with yours to benefit each other, and a partnership helps defray the food costs.

One source of collaboration can come from a partnership with a fledgling food stylist. You can make inquiries on places like Facebook, Craigslist, and Quentin's Friends. If you live in a major metropolitan area, it's easy to find people. What is nice about this relationship is that you are both learning, so there is no pressure. You can afford to make mistakes together.

Another source for building your portfolio is restaurants. You can arrange to shoot free photos of items on the menu for a local restaurant. In exchange, you offer them photographs for their use.

Tip

Identify a restaurant with bad photography on its Web site or marketing material and do a better job, knowing that your worst effort will be superior to what they already have. The advantage is that you can photograph expensive dishes, and it won't cost you anything but your time. Of course, you have to do a professional job. Do it a few times, and you will develop a great portfolio quickly.

It can be intimidating to put yourself out there and ask someone for help or offer free services. Just remember that people are generally nice if you approach them the right way. My experience is that if you are offering a free service, people will usually take you up on it. Show them your previous work, and chances are you will be welcome. Putting yourself out there can lead to paying jobs as you develop your style and confidence.

Once you have more than a handful of photographs in your portfolio, you begin to shape it. See if you can spot the emergence of your style. As you begin to create stronger pieces, don't be afraid to edit. Take out the weaker pieces. You should have only your best work in your book. You will notice over time that images you thought were amazing are not as good as you thought. As you develop, those pieces will become more obvious. It's better to have 10 amazing images in your portfolio than 30 mediocre ones. Don't just fill up space.

You should get an 11×14 portfolio book with removable pages. Initially, limit your portfolio to six two-sided pages for a total of 12 images. Printing your work lends legitimacy to it and gives it importance. Going to the trouble and expense of printing a photo before you include it in your book will give you pause. Only your strongest pieces should wind up printed. If you can't fill it up right away, keep shooting. Add images only if they make the cut. Be honest with yourself, and you will create a strong book.

Additional Equipment

There are a few pieces of additional equipment you should purchase if you have the means. They are not too expensive and will come in handy when trying to re-create the lessons in this chapter. The choice for external flash is yours, but make sure the flash can be fired separately off the camera by hand. Some come with a built-in slave (a sensor that reacts when different flash is fired, triggering them simultaneously). Most digital SLR cameras have a flash built in to the camera. You can use that to trigger the external flash.

❖ External flash

❖ More A clamps

❖ Two sand bags

❖ Glass blocks

The Last Word

In this chapter, we learned the fundamentals of photography, composition, and lighting for food photography. You should be able to use what you learned to create a professional portfolio. If you want to style your own food, there is a chapter dedicated to food styling later in this book. You can approach your study any way you like, but my experience is that you need to shoot photographs every week if not every day. Just like learning a musical instrument, the more you practice, the better you become. We all have time constraints, but if you truly want to be a food photographer, you have to put in the time.

Assembling the Right Team

Is the food we shoot fake? Surprisingly, most of the food that appears on the set is real. There are many tricks of the trade to get the food camera ready. This is where food styling becomes an art. The camera sees things differently than the human eye, and a trained stylist knows how to bridge the gap between reality and what appears in the camera.

A food stylist usually starts out as a trained chef, but similar to being a professional photographer, no formal training is required. They usually spend many years working as assistants before they become what the industry refers to as a *first stylist*. By the time a stylist becomes a first, he has an extensive portfolio and experience that goes along with the position. Food stylists are in high demand, and a good stylist can earn a very comfortable living.

Although I am not a food stylist, I have been working with them for the past 15 years. If you are planning to become a professional food photographer, developing a relationship with several food stylists will be paramount to your success.

Finding the right team is not easy, and not every stylist works well with every photographer. I have been fortunate to develop relationships with two amazing stylists who are my go-to people. Occasionally, I am asked to work with a new stylist. In the high-stakes game of commercial food photography, I suggest working with a crew that gels well and can produce the results clients are paying for. This is especially true if you have a new client. You want the shoot to be seamless, and it's important to be in sync with your crew.

Food styling has undergone many incarnations over the years. From the early pioneers like Delores Custer to those on the cutting edge of styling like Brian Preston Campbell, it's interesting to see the evolution. Remaining current on food trends is important and is affected by your photographic choices. A great food stylist is always up on the latest industry trends. Food stylists who work for many different photographers are exposed to current trends even more than a photographer. It shows up in their work and gives me more tools to work with. In addition to my own research, I always look to my food stylists for advice on what's trending. This is a collaborative process, and there are many people involved with the result at the commercial level.

It takes time to develop a relationship with a food stylist. When you have created a relationship where you can anticipate each other's moves, then you have a great team. No matter which side of the camera you are on, it is of the utmost importance to respect the people you work with. A stylist who works well with one photographer may not work well with others, and vice versa. Find people you like to work with and who respect what you can do. It shows in the work when the crew is in sync. The creation of great food photography is a team effort. Remember to keep an open mind during the process and allow creative input from your stylist.

During a shoot, I offer my thoughts on composition, but for the most part, I leave all the decisions in the kitchen to my stylist. This is why it is so important to have a stylist you trust. Once the food comes out of the kitchen, I may ask the stylist to maneuver parts of a dish so that I can get the proper angle. For example, I recently had a shoot in the studio where we were doing winter foods. We shot some chili, and it took a bit of time to get the parsley leaf just right. It kept sliding down into the chili, and if I didn't have a great (and patient) food stylist, we never would have gotten the shot. Aside from the technical aspects of food photography, it is about attention to detail. This is where the photographer /stylist relationship lives.

Most people don't understand that food you shoot and food you eat are very different things. A food stylist must prepare great-looking food that can maintain its appetizing looks for a long time—but isn't necessarily edible. Frequently this means that meat is not cooked all the way through, and artificial products are added to help maintain a natural look.

My job is to determine the proper lens, composition, and lighting. The stylist's job is to make sure that I have something delicious-looking to shoot. We must work together at a reasonable pace. The day we did the chili shoot, we also had to shoot gumbo, pasta fagioli, and vegetable soup. If I spent too much time on any one of them, it would have put us behind schedule, and that's no good for anyone involved. There is big money being put into a day of food photography. You the photographer are responsible not only for hiring the right team to deliver great images but finishing the shot list you presented to the client. If you do not deliver and you fall short, you might have to go into a second day. If the stylist you hired can't keep pace, then your profit disappears and you wind up working for free.

Working with Food Stylists

Here are some tips for working with food stylists. Every person is different. While most of the people I have hired have been above board, I have had some negative experiences working with crews as well. I have been embarrassed in front of clients and had crew members show up hours late, intoxicated, inexperienced, and unable to perform. Before I found my go-to people, I tried out many food stylists. It's a vetting process, but the good ones will earn a place in your rotation. The ones that don't work out you simply don't hire again. Finding a food stylist starts by searching your local market for who is servicing that area. Everyone has a portfolio online, and you can see their style. Some stylists also do propping, which is a bonus. When you first start out and have booked a commercial job, see if you can find a stylist with a lot of experience. If you don't have to hold someone's hand, it makes your job much easier. There are also agents who represent stylists, but you will pay more for the experience. The agent gets 20% on top of the stylist's day rate, so you must be aware of your budget.

Once you have a job booked, which means you're officially hired, your job begins. Someone has to purchase the food for the shoot. You can hire the stylist to do that. It's called a prep day. Sometimes the stylist has to bake bread or cook dishes a day in advance, so be aware of this when you are budgeting the job and providing an estimate for your client.

Once the shoot is underway, there are some things a stylist can do to help facilitate an easier shoot. Have him arrive well before the client. There is nothing worse than a crew member arriving late for a shoot. Remember that the photographer, stylist, and any assistants must pull together to make a shoot go smoothly. If even one member of the team doesn't arrive on time, it will throw the entire day off schedule. It looks very unprofessional to the client if you have an improperly prepared team. This can cast you in a negative light if your client thinks you have poor judgment and can affect future jobs.

Sometimes I have the stylist prepare a stand-in, which serves as a marker for the photographer. While waiting for the hero (the dish that will appear on camera) to be prepared, a stand-in helps the photographer stay one step ahead by helping to figure out issues like propping, composition, and lighting in advance. Some photographers like to work without stand-ins. You decide for yourself what you prefer. Just remember that it's always best to be overly prepared. I appreciate a stylist who goes above and beyond. It makes him more memorable and puts him at the top of my short list when I am deciding on which stylist to use for the next shoot.

There can only be one team leader on the set—the photographer. While I try to make my set as democratic as possible, I have the final word simply because I am hiring the crew, and it is up to me to dictate how the shoot runs. It's the photographer who is responsible for the final set of images.

Things don't always go smoothly no matter how prepared you are. When a client is present, it is important to show a unified front. Stylists should not talk about other photographers they have worked with in front of a client. They are your competition, and it's not good form. It's more than acceptable for them to make creative suggestions in a professional manner and always in a positive light. The photographer bridges the gap between the client's vision and the finished product. It is ultimately the photographer's reputation on the line.

A stylist should always project confidence in front of a client. There will be times when you will be challenged to shoot an image outside your comfort zone. A stylist has the same problem. Stay positive and assure everyone that you just need a little time to make things look perfect. Making sure your client is at ease is a major part of your job. If a stylist is having a problem, keep the confidence in the room high. You are the quarterback and must coordinate the entire shoot, even if elements are beyond your control. Learning new things on the fly is something we all have to do. As a photographer, you have to be able to decide if the shot is working and dissect why if it's not. Many times, I have asked my stylist to redo a dish or come up with a different approach. You can't be afraid to take charge if the style of the dish is not working out or be reluctant to ask the stylist to reexamine his approach.

Always be kind and courteous to your crew, and they will exceed expectations. We all like to be told we are doing a good job, and creative people need that even more. If you are complimentary to your crew, it will go a long way.

Just because you are the boss does not entitle you to be mean or abusive to your crew. Many photographers feel that cracking a whip is a good management style, but I do not agree with that.

Advice from an Expert

(I thought it best to have a food stylist create the next segment from firsthand knowledge. Laurie Knoop and I have worked together for 10 years. She not only styles but also teaches a food styling course at ICE, the Institute of Culinary Education in New York. Even if you never plan to style food, it is good to know how things work. Food styling is the art of selling an illusion of food to the audience. As much as composition and lighting, good styling is the last piece of the puzzle required to create amazing food images.)

The food stylist's job, obviously, is to make the food look good. To do that, the stylist must understand how the camera works; know about lighting, composition, propping, and food science; and possess a strong culinary background. Without this knowledge, presenting food for the camera becomes much more of a challenge. With it, the stylist is able to anticipate and be ready for problems.

Basic camera and lighting knowledge is essential. What the camera sees is not what the human eye sees. The stylist must be able to plate the dish properly to the corresponding camera angle and the lighting. She must be able to anticipate what the camera will sees, which comes only with experience.

Knowledge of some basic techniques can save time and make the stylist's job easier. There are some simple grocery items that every stylist will use at some point or another in spite of recent trends to use real food as much as possible.

Don't get me wrong—we generally use real food. What I am referring to is how real we make it look. For years, the trend was to make everything perfect. Today the trend is to style food more in a natural and organic fashion. There are more crumbs on the plate and a lot less parsley. Food up close and personal is what it has been all about in the past few years, and that is lucky for us because it can be so beautiful.

The Kit

Food stylists work with tools. When a stylist arrives on the set, she will have anything from a few simple tools to a full arsenal, depending on the job. Since every job is different, your kit will vary from job to job. What you need for a drink job is different from what you may need for a cake job, although common elements will cross over. What we use certain tools for may seem very odd to the untrained person, but we use whatever is necessary to get the job done. You must be able to think outside the box to solve whatever problems may arise, and it is always a good idea to have a full kit with you. The key to being a good food stylist is to be able to anticipate the photographer's needs and the requirements for the job. Knives are the most important element in any stylist's kit. If you plan to style food, you must invest in a good quality knife.

A good food photo studio will have a fully equipped kitchen. It is important that you make sure whatever small kitchen appliances you may need are there. Upon arriving, you will pull out the tools you need, organize your food, and get to work preparing the food in the order of the shot list. Many times the food determines the order of the shot list. You don't want to have food sitting out too long before it is photographed.

There are two aspects to styling. Offset styling means preparing and styling the food in the kitchen, away from the camera. It is much easier to do things off the set because the photographer is setting up lights and other obstacles, resulting in a very confined space. You also want to do all the messy work away from the set to keep it clean. The set is reserved for the finished product or as close to finished as can be done before it's placed in front of the lens. When styling a drink, for example, you prepare the glass, arrange the ice cubes, and prepare your garnish in the kitchen. Then you place the glass on the set.

Set Styling

Set styling is where the finishing process takes place. Keeping with our drink example, you would pour the liquid into the glass and garnish appropriately. The photographer then takes a capture, and further adjustments are made until the shot is finished.

The tray of finishing tools should be placed within easy access of the set to be able to make adjustments on the set. A set tray will change from shot to shot, depending on what is needed; however, a basic set tray will have the following. I will also briefly explain how some items are used.

- ❖ Aluminum foil.
- ❖ Assorted spoons in different sizes, including long-handle, baby, sharp-pointed, and wooden, for placing food on plates. Long-handle ones extend your reach. Smaller ones are used for placing food in a tight area. Use the back to make swirls.
- ❖ Assorted tweezers for controlled placement of food. Bent ones, long ones, and silicone-tipped ones are helpful for ice cube placement.
- ❖ Bamboo skewers for moving food around.
- ❖ Brushes for brushing oil and water to freshen up food.
- ❖ Chopsticks.
- ❖ Glass cleaner for cleaning plates. Use glass cleaner with a low-lint paper towel or coffee filter, which has no lint. Polishing the glass with car wax removes all fingerprints and smudges and really makes the glass sparkle. Using gloves will eliminate fingerprints.
- ❖ A set of sharp knives, including chef, paring, and slicer.
- ❖ Latex gloves.
- ❖ Mounting putty.
- ❖ Needle nose pliers.
- ❖ Non-stick food spray.
- ❖ Offset spatulas in several sizes.
- ❖ Oil, very light in color.
- ❖ One-quarter sheet cake pans.
- ❖ Paper bowls, plates, and cups.
- ❖ Paper towels. White paper towels are preferable. Printed paper towels have dye that might bleed. Cutting them into squares in advance saves time and makes it much easier and less wasteful. Be careful with your choice of paper towels, though. Some may leave lint behind after cleaning.
- ❖ Paring knife for quick cuts.
- ❖ Permanent markers.
- ❖ Pins, including safety, straight, and T.
- ❖ Plastic cutting board.
- ❖ Plastic wrap.
- ❖ Q-tips for cleaning smudges and absorbing unwanted liquids.

- ❖ Rubber bands.
- ❖ Ruler.
- ❖ Scissors—several sizes, from very small and sharp to butcher shears.
- ❖ Small offset spatulas for moving food.
- ❖ Small scissors for snipping.
- ❖ Spatulas in several sizes.
- ❖ Sponges.
- ❖ Spray bottles.
- ❖ Stainless bowls in several sizes.
- ❖ Tape.
- ❖ Tongs.
- ❖ Toothpicks for propping up or holding rogue elements in place.
- ❖ Water and oil for brushing on food to freshen.
- ❖ Whisks.

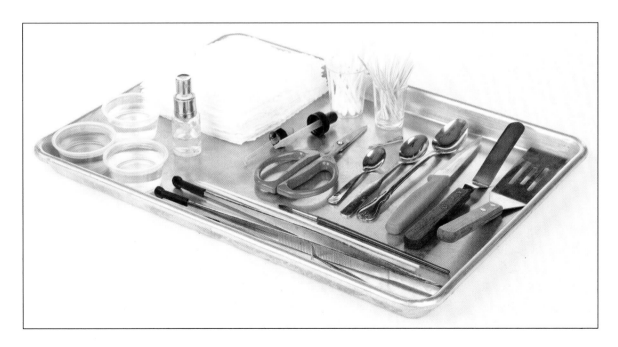

Some Basic Techniques

The whole point of the shoot is to tell a story about food. Unless your story is about how food can make you sick, the food should appear to be fresh. Especially under the lights on the set, food has a limited time when it looks fresh. There are a few things that can be done to extend that life span.

Use a stand-in when possible.

Clean Plates: Unless you are doing an ad for paper towels, chances are you will need clean plates. Smudges, drips of fat or grease, and fingerprints can all take your eye away from the food. Keep glass cleaner, paper towels, and Q-tips handy on the set. Also, don't forget the bottom of the plate. You need to make sure that the bottom is clean so that if you need to move it on the set you don't leave a mark. To clean glass, you can use car wax to get that crystal clear look that is needed for drink shots. Make sure you clean the props before you plate. Things get messy on the set, so it's important to keep an eye out for unflattering spots, crumbs, stains, and so on.

Fresh Herbs and Greens: Herbs wilt quickly. To extend their life, trim the stems and place them in an ice bath. You also can just dunk the leaves in ice water and shake dry right before placing them on-camera, or cut the stems, place them in a container of water, cover with plastic, and refrigerate. Some chopped herbs, such as cilantro and basil, oxidize faster than others, so substitute chopped parsley. When storing chopped parsley, cover it with a damp paper towel and plastic wrap.

Salad: To keep salad fresh on the set, place it over wet paper towels that have been frozen.

Cooked Ingredients: With a small brush, brush clear vegetable oil on foods that have been cooked in oil. Brush water on food that is water based, like produce. Light corn syrup mixed with water may also be used.

Cut Fruit and Vegetables: Use lemon juice to slow the oxidation of cut fruit and veggies. Placing avocados cut side down on a board will keep the oxygen from reaching the exposed surface.

Pasta and Rice: Adding vegetable oil to rice or pasta will prevent it from sticking. Light corn syrup will glisten up rice and other grains.

Poultry: When poultry is cooked, it can become dried out and wrinkled. To give it a finished look, apply stains that are made with a combination of seasoning liquids. This technique will be detailed shortly.

Lobster, Shrimp: Use skewers through the tail to prevent it from curling.

Grill Marks: To create grill marks, use metal skewers that have been heated over an open flame such as a stovetop or an electric charcoal starter applied to desired width and distance. Remember to match what grill marks would actually do. They generally don't go up the side. The electric charcoal starter can also be used to brown edges and sear off fat. Simply brand the meat until grill marks are created. This takes practice. Be careful, because metal holds heat after being unplugged. Make sure you alert others who will come into contact with it.

Drinks and Liquids: Kitchen Bouquet is a browning agent and can be found in every supermarket. Along with light corn syrup, cooking spray, glass cleaner, paper towels, and clear food wrap, Kitchen Bouquet is a staple in styling food. It can simulate coffee or tea, and a little goes a long way. Use a bamboo skewer to control the amount of Kitchen Bouquet to water. By dipping the skewer into the jar, you can control a small amount of the browning agent instead of pouring it out directly from the bottle. An eyedropper works well, too.

To make coffee look freshly poured, place some soap bubbles strategically on the surface. Glycerin or light corn syrup sprayed on the outside of a glass provides instant condensation that will not evaporate. I will demonstrate how and where to place condensation on a glass in greater detail in a little while.

Melts: We want to be able to give a hot-out-of-the-oven look to certain dishes such as French onion soup or pizza. To achieve a melted appearance, use a torch, a steamer, or a household cleaner such as Pine Sol. Pine Sol works to dissolve oil. Cheese contains oil, so the Pine Sol reacts with the oils and creates a melted look, similar to if it were heated. Melt a scab of cheese in an oven to get a nice brown crust and then place it where desired. Melted butter provides the look of piping hot food. Margarine is usually used since it is a better color. Heat a small metal spatula with a torch or on a gas burner and apply it to the butter/margarine. You can use a straw and blow heat from your breath to give chocolate chips a soft look.

Garnishes: Garnishes can be sprigs of herbs, a fancy cut of fruit, or chocolate squiggles. Good knife skills are helpful here. Placement of garnish will depend on camera angle and what is important to the shot. Less is more. Your garnish selection is dictated by the dish. For example, you would not use a lime with a lobster dish, but it would be perfect on certain drinks. A gin and tonic usually gets a lime but would not get a lemon. The wrong garnish creates a disconnect with the viewer and can ruin a great image.

Particulates: When preparing for photography, foods are cooked separately and then composed for the shot. If you are using a store-bought product, make sure you have enough so you can tear one apart to see what is in it so you don't miss anything.

If the story is about hot dogs, the hot dog should be front and center in the shot. If you are selling the bun, the styling must reflect the importance of the bun. Being able to separate the different visual elements of a dish and move a viewer to the intended focal point without being too obvious is a true skill.

Instant Potatoes: Instant mashed potatoes are used as false filling for just about anything—tacos, pies, cakes, chicken. If you need to false fill a bowl for a stew or soup, use polenta because it creates a crust that prevents seepage.

Cornstarch: Cornstarch has a multitude of uses, such as in place of confectioner's sugar on cakes because it won't melt like sugar. It is also a great thickening agent.

Draining: To get better consistency from sour cream, salsa, or ricotta cheese, remove the liquid by placing it in a strainer lined with paper towel. It is easier to add liquid than to remove it.

Plating: The style of plating is where the art of food styling comes through. Pay attention to composition, colors, and texture. Food can't blend into itself, and the objects on the plate must be chosen carefully to contrast with each other and not compete for attention. Different colors and textures will help define the food and make it pop.

Condensation: When styling drinks, condensation gives a glass the appearance of being cold and wet. Because drinks can sit a while on the set, and condensation may evaporate, a few techniques have been developed to hold the condensation look:

❖ Light corn syrup and water in a 60/40 ratio of syrup to water.

❖ Glycerin and water in a 60/40 ratio of glycerin to water.

❖ Commercially prepared dew effect.

❖ Hair spray.

❖ Assorted spray bottles.

❖ Hard bristled toothbrush for splattering the application on glass.

Fake ice cubes are used for different purposes and come in several varieties. There are advantages to using fake over real ice. Real cubes are cloudy, and when they melt, they change the color and shape of the drink. Depending on the look and feel of the drink and client and photographer preference, you will need to use both real and fake ice. One of the best food stylists in the business and the man that I externed with, Brian Preston Campbell, has a cottage business manufacturing fake ice cubes, which you can find at www.fakeplasticicecubes.com. The site features many fake ice products and styling aids you can purchase, including acrylic, rubber, ice crystals, and ice shavings. They are fun to play with, and you can get some very interesting effects with fake ice.

Acrylic
Ice

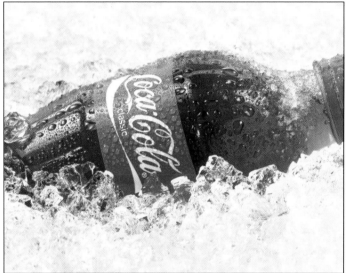

If It Doesn't Work

Even with your best effort, sometimes the styling doesn't work. When that happens, change the garnish, change the plate, or change the color. Replate, make the food higher or lower, or change the camera angle.

You can discuss with the photographer if it's easier to fix in post-production or on set. It all comes down to time. It might speed the process if it's a ten-minute fix in post but an hour fix on set. If a simple problem persists and it's easier to take care of it in post, then make a note and move on. If it's easier to fix it on the set, then do so.

Frequent Styling Situations

Here are a few tutorials on commonly encountered situations when styling food.

Beverage with Ice

First we'll style a drink shot, placing ice, inserting the liquid, and adding moisture. We will set up a glass of whiskey. In our glass we have placed three acrylic ice cubes in a highball glass.

 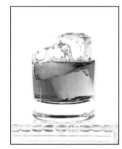

1. To move the ice cubes, use long silicone-tipped tweezers to prevent any finger contact with the glass.

2. To prepare the glass for condensation, create a collar with paper and tape. Place the paper snugly around the glass and tape it so it does not slip down the glass. Place the edge of the paper at the fill line of the liquid. Pour your liquid using a measuring cup to prevent splashing to the fill line of the paper.

3. As we just discussed, the glass did not work. It is apparent that the ice does not fit the glass properly because the cubes are too big. We change to a rocks glass. First clean the new glass and place the ice cubes; they fit much better. Fill the glass with colored water to the fill line. If we were shooting an actual brand of scotch, we would have to use the real product. Since this is not the case, we can use fake liquid.

4. Place the collar on the glass. Cover where we don't want condensation to go with paper towels and spray with the water bottle. Each bottle has a different flow of spray, so you want to experiment with the different types to get the look you desire. In this instance, the Evian spray bottle gives the best result.

Voilà! The photo jumps off the page, as you see here.

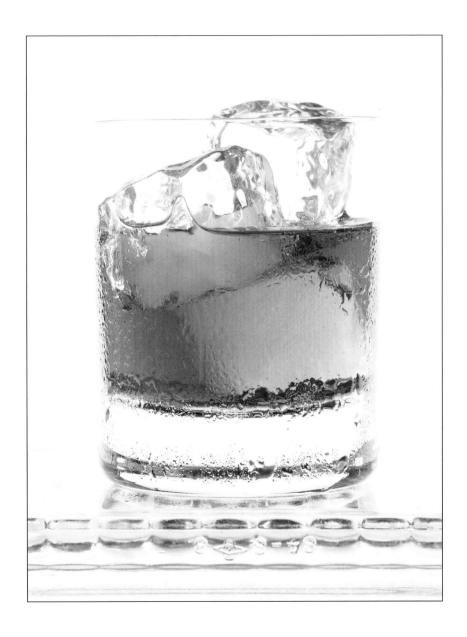

 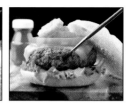

Hamburger

Meat can be challenging. Now we'll demonstrate how to cook and style a hamburger. Form patties and let them rest in the refrigerator before frying them. Remember that hamburger will shrink when cooked, so make your patties a size that will match the bun after cooking.

1. Frying the hamburger in a small pan in oil helps control the amount of browning. You can tip the pan to get the sides nice and brown. Don't overcook. It does not have to be fully cooked on the inside; it just needs to *look* done.

2. Keep all your elements that make up the burger separate until you are ready to build the styled finished hamburger that will appear on camera. The leaf lettuce has nice curly edges. The extra bread in the top half of the bun has been removed for better placement of the bun on the burger; the bun will sit too high otherwise. The tomato slices are cut from the center of the tomato so that the edge is straight. Pickles are chosen for their shape, size, and color. Cheese should be kept covered until right before melting. Rather than using a knife to spread mayonnaise, apply it with an eyedropper for greater control.

3. Sometimes the meat shrinks too much and your burger is too small. Just slice to the center and gently widen the front.

4. There are several methods to melt cheese on the set. In this case we used a hand steamer. Cover everything that isn't going to be melted with paper towels. Here we cut a hole in the paper towel and draped it over the burger, exposing the cheese. Use a paper plate to form a tent over the cheese and the steamer. You can direct the steam with a paper plate until the cheese melts the way you desire it to look. Before placing the burger on top of the lettuce, create a "diaper" out of paper towels to absorb extra fat and prevent it from running onto the bun. Place it between the bun and the meat.

5. To freshen the meat, we brushed it with oil.

For the finished image, place the bun off to the side. It fills the space in the frame to the right of the burger. To balance the shot, we put a small bottle of ketchup to the left in the back and made sure it was out of focus.

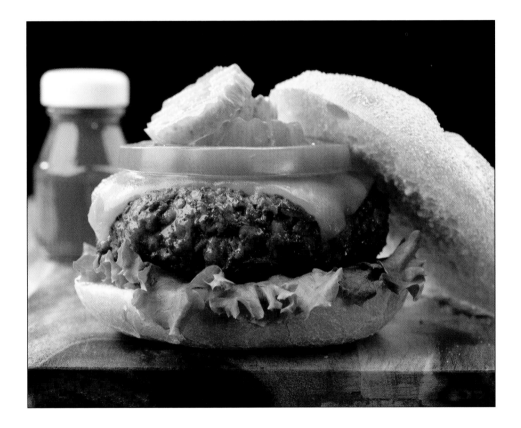

Why three pickles on top? In food photography, odd numbers just seem to balance a shot more comfortably than even numbers. Other finishing touches included trimming the distracting piece of lettuce and brushing away any unwanted crumbs. Finally, there's one more application of juice, which is a combination of cooking oil and Kitchen Bouquet applied to the meat only. If we wanted to moisten the lettuce or tomato, we would have used water.

Vegetable Stir-Fry

1. We start by choosing the props. This bowl is in an Asian style, and the colors contrast nicely with the bright colors of the vegetables. It also has some interesting texture lines that draw your eye toward the middle of the bowl. The tan tile mat introduced another shape to the photograph.

2. Food prepared for food photography is generally undercooked to maintain its color. The items are kept separate so that we can add each piece to arrive at the finished product. To maintain the bright colors, the vegetables were blanched (boiled briefly in hot water) and shocked (placed quickly in a bowl of ice water) and finally given a quick toss in oil over high heat to give them the appearance of being stir fried.

3. When placing the vegetables in the bowl, balance the colors. Vary each vegetable's position by placing some vertically and some horizontally to break the back line of the bowl. This also gives the photo height.

4. The vegetables are sitting on a bed of rice. Using small tweezers, add grains of rice along the edge of the bowl. It is a subtle difference, but now the shot looks complete. Place chopsticks in the photograph to finish the story. When the photographer has taken the shot he wants, sometimes we experiment by adding elements or changing things for alternate shots. In this case, we added sesame seeds but decided the previous shot was the final.

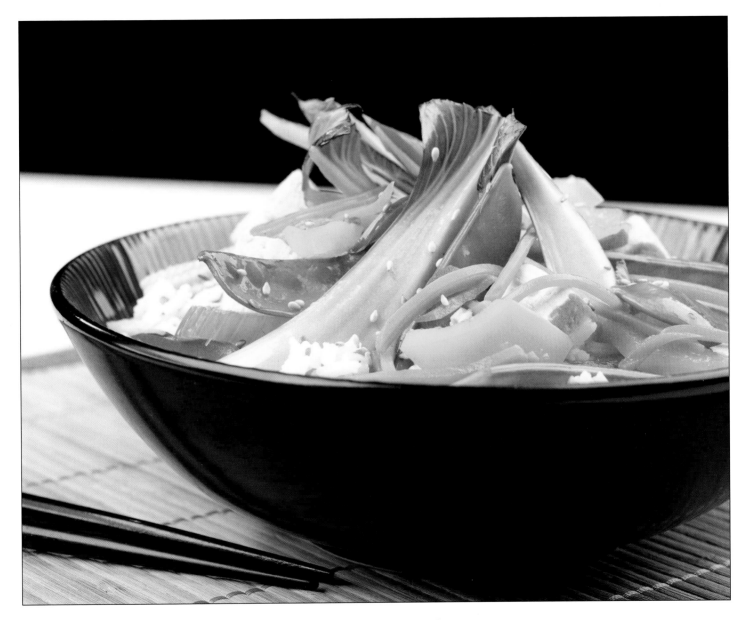

False Filling

False filling is a technique used to save time and ingredients. We use instant mashed potatoes to make a false filling for just about anything that requires raising the level of a dish or increasing the mass of a dish without sacrificing key ingredients. Ingredients cost money, and part of being a good food stylist is purchasing items on a budget. False-fill bottoms are used for pies, tacos, burritos, to plump a chicken cavity, and in bowls and plates to raise the level of the food. There are many other uses. Prepare the potatoes according to the instructions on the box and let cool. This creates a Play-Doh-like material that is malleable.

In this example we use mashed potatoes as the filling between the layers of a cake because real icing moves when pressure is applied by the weight of the top layer. More importantly, we use this technique to prevent icing drag, which can occur when the knife cuts into the cake, resulting in an unattractive streak.

1. To create a layer of instant mashed potatoes, line a pan the same size as your layers with some plastic wrap and fill it with an even layer of mashed potato mix. The mashed potatoes should be prepared a little dry, but not so dry that they fall apart.

2. If necessary, level the top of the layers by placing toothpicks at an even level around the edge of the cake. Use a large serrated knife to slice the dome off the layers.

3. Carefully remove the instant mashed potato layer by inverting the vessel and letting the shape fall onto the surface. Pick it up with two spatulas, and place it on top of the bottom layer. Then place the top layer over the instant mashed potato layer.

4. Apply a crumb coat of icing over the whole cake. A crumb coat is a thin layer of icing that prevents crumbs from getting in the icing. After that layer sets, apply the final layer.

5. Slice the cake. Use toothpicks as guides when you take a slice out of the cake. This helps you cut the slice perfectly rather than simply relying on your eye. It's good to make more than one cake in case something goes wrong when you slice the first cake. That way you still have a backup and don't have to wait for an entire cake to be baked again.

6. Cut out the slice and carefully remove it. Keep it in case you need to "spackle" any holes. Put some petroleum jelly on the end of a skewer and apply it to the hole to act as an adhesive, and then use crumbs to fill the hole. With a small knife or other appropriate tool, scoop out the mashed potatoes between layers where the slice was removed. Fill a pastry bag or a small plastic storage bag with icing and pipe in the icing layer where you scooped out the potatoes.

Unless you are going to see both angles in the photograph, you need to do just the one that is facing the camera.

Apply some swirls of icing and place crumbs on the cake plate. A cake server and plates finish the shot.

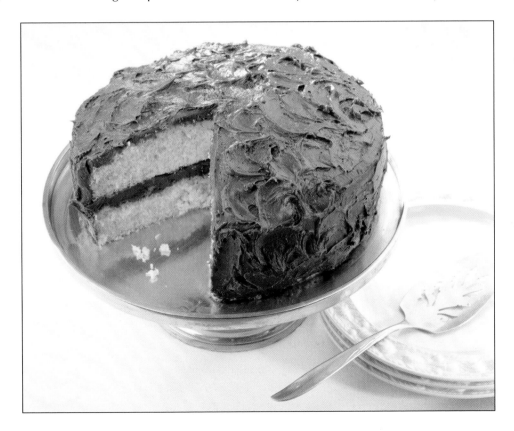

Poultry

Anyone who has ever cooked a Thanksgiving dinner with thoughts of that plump juicy bird they saw in a cookbook or magazine must have been disappointed to find that a cooked, fully done turkey is rather wrinkly. For this reason, we use several techniques to make the bird look amazing. We undercook it, and we use a staining method. This is still the norm, even with the more natural approach to food photography. A dried-out bird is just not that appetizing. When shopping for poultry, make sure that it has an even skin tone with no rips in the surface. Chickens vary in color because of the way they are raised. Some chicken brands are brighter yellow than others. Poultry raised organically tend to be smaller and have more even skin tone.

1. It might be necessary to pin back the skin to get a smooth surface. Use the pins to tighten up the skin in order for it to cook smoothly.

2. We stain the bird to give it the appearance of being cooked. If we were to really cook it fully, the skin would wrinkle up and look overdone. Instead, we cheat by partially cooking the poultry and paint in a stain to give it the appearance of being fully cooked. To prepare your poultry for staining, first soak it in a tub of soapy water. This removes the outside grease, enabling the stain to adhere better, and it plumps up the bird.

The stain recipe is as follows:
- ❖ Three-fourths of a cup of water
- ❖ One tablespoon of Kitchen Bouquet
- ❖ Four shakes of angostura bitters
- ❖ Two squirts of yellow food coloring
- ❖ One squirt of clear or white dish detergent

You can apply this with a spray bottle, brush, or make up wedge.

3. Truss the bird. We use raffia (a type of straw rope) because it looks nice. False-fill the neck cavity with mashed potatoes or wet paper towels. Heat the oven to 350 degrees. Place the bird on a foil-lined pan and bake for 15 minutes. Remove from the oven and spray.

4. Repeat at least two more times until the chicken looks done to you.

5. The chicken needs to look more cooked in some areas, but it is sufficiently browned in other areas. Apply the browning stain selectively with a brush. Use a torch to brown the parts that look uncooked, mostly underneath. Use the torch with care; don't burn the bird.

Garnish the platter with appropriate herbs and fruit. Always make sure that your garnish is applicable to the dish. If you are planning to stuff the poultry, fill the cavity with separately cooked stuffing at this point.

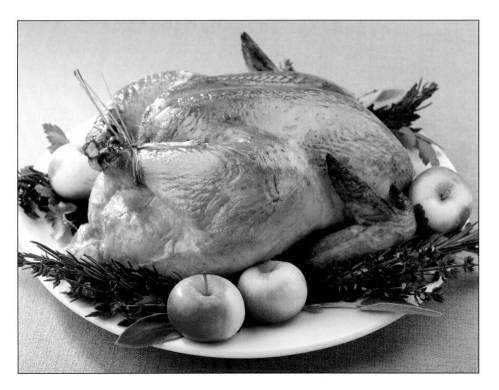

Props

Props are key to telling the story. A simple setting can tell you many things about what the dish is. Certain colors invoke certain moods. A blue and white napkin with a yellow mat or a bright white dish with a juice glass says *breakfast*. An elegant silver-rimmed plate means a high-end dinner party.

Props denote a certain period, but they also can date a photograph. Vintage pieces can say *grandma's house*, while modern, different-shaped plates say *young upscale urbanites*. The surface (what the set is built on) adds to the story. Wooden picnic tables, sleek marble, farmhouse wood, butcher blocks, different-color linens that complement the food—all add to the overall feel and mood of the shot.

Color is very important. One of the key tools to use when choosing props is the simple color wheel. Choose colors across the wheel from each other or in similar hues. Make sure the colors don't clash with the food and that the color will complement the food.

To the left is an example of how spaghetti looks on four different color plates.

It is also a good idea to have a selection of props. You can never go wrong with white plates, but be aware that there are different shades of white. Like the lighting temperature we talked about in a previous chapter, some whites are a bit blue, which is considered colder, and some are more ivory, which is considered warmer.

On the right is the spaghetti image on pure white.

You can acquire props at flea markets, yard sales, and discount stores. Having the correct props can enhance or destroy a photograph. Some budgets support a prop stylist. As a food stylist, I also do propping duties. Having a good eye for aesthetics is essential to good propping.

The Last Word

I hope these examples have given you insight to the technical skill that goes along with food styling. Those who choose food styling as a career get most of their experience on the job, but if you plan to style and photograph your own food, there is plenty of source material in books and on the Web. You can also look for classes on styling in your area. The more practice you put into it, the easier it will become.

The advantage of styling within a digital workflow is that you can see results and make adjustments in real time. Like learning digital food photography, if you master the basics of styling, you can take your work to the next level.

Have fun. There is no right or wrong; there is only what looks good and what does not. With practice, you can create some great results. The previous techniques were presented by Laurie Knoop, a professional food stylist. I thought it best to have someone who teaches food styling walk you through the styling section and give insight as only one who practices this as a profession can do.

If you want to style and photograph your own food, your learning curve is that much steeper. If you are already a chef and familiar with presentation, you should do fine. I have styled my own dishes when the budget does not support a food stylist. It's hard to do both, but it can be done. I remember I had to style a sandwich once, and it took all of my experience watching my stylists to pull that off. Some food is easy to style. Just like photography, if you know how to apply the correct technique, you will be successful. I recently styled ice cream on my own, and that was really a challenge. I prefer using a stylist so I can concentrate on photography. When I shoot for my blog, I style my own food, but it does slow me down.

How you choose to approach styling is your own personal choice. I recommend that you work with a stylist at least once to really get the flavor of the experience, no pun intended.

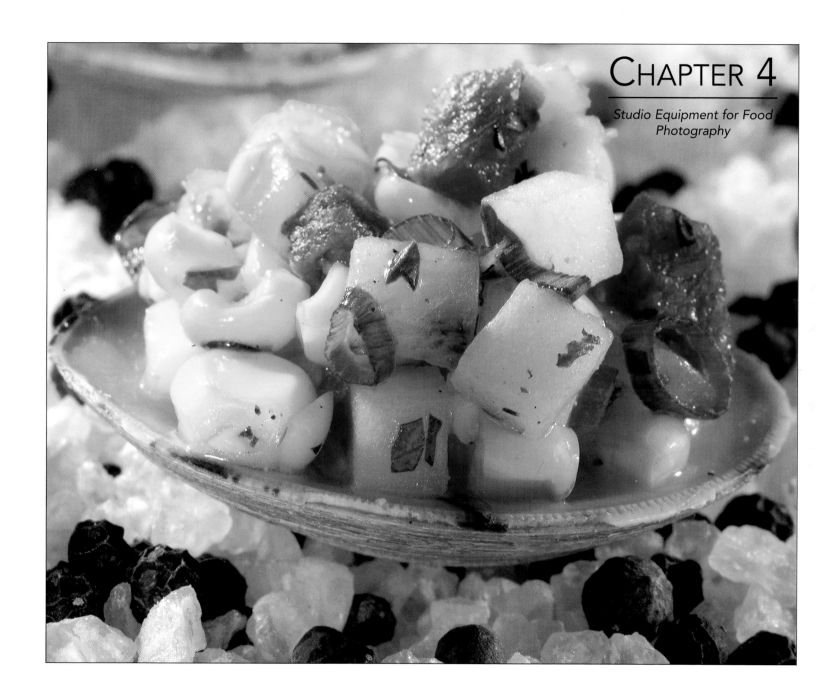

Once you have learned the basics of food photography, what comes next? There are photographers who never want to learn artificial lighting, but to be a commercial photographer, you have to. When you are being paid to work as a professional photographer, you can't bank on the fact that Mother Nature will provide you with the perfect light. Most of the time, you have to create the light yourself. Budgets on commercial jobs are large, so you're expected to produce results. If you aren't ready to execute the job the day of the shoot, you will have a problem. Your reputation as a photographer is on the line with every job you undertake. If you become proficient in studio lighting, you will be able to produce any job, any time, in any situation.

Recently I did a shoot with a PR agency for a restaurant opening at a high-end New York venue. It was a poolside restaurant, and the client wanted to use the pool in the shots as a background element. We had a small window of time to shoot because the press release and photos had to coincide with the restaurant opening, so we were on a tight deadline.

On the day of the shoot, it was pouring rain, and the skies were very, very dark. Because of the time constraint, I could not postpone the shoot and wait for a nicer day. Being a professional means you leave nothing to chance.

I decided to mix artificial lighting with daylight. I wound up using the pool as a background through the window and did a mixed exposure. Using selective focus, I was able to throw the background out of focus. I doubt you would be able to tell that it was pouring rain when the shot on the facing page was taken.

I use this example to illustrate my point. Had I not been proficient in artificial lighting techniques, I would not have been able to complete the assignment. My client would have missed his deadline, and my reputation would have been damaged. It is essential that a professional food photographer deliver the finished product no matter what.

The first example below illustrates the use of artificial light without the long exposure. It has the feel of a studio shot, and it's a nice shot, but it wasn't exactly what the client wanted. The second example below shows a mixture of the two elements. I started by determining the f-stop for the flash only. By knowing the f-stop—in this case f-14—I had to simply determine the exposure for the rest of the image using the built-in meter of the camera. Using f-14 as my starting point, I adjusted the shutter speed until I was able to get a properly exposed image. In this case, it was 2.5 seconds. By balancing the natural light with the artificial light, I was able to arrive at an exposure that showed both the drink and its surroundings. Given the conditions, had I simply used natural light, I would not have been able to correctly expose both the drink and its surroundings. One element of the image would have been improperly exposed, and the client would not have approved the result.

In this chapter you will read about some more tools of the trade. In addition to the camera system, there is an entire segment of lighting and grip equipment that you must learn. Learning how to use studio equipment is integral to your advancement as a professional photographer.

Flash Units/Strobes

The studio flash is also known as a strobe. A studio flash, unlike an on-camera flash, can be manipulated to create stunning lighting scenarios. When used properly, strobes produce accurate and repeatable results, power, and accuracy.

If you own a portable flash unit that detaches from the camera, a studio strobe is similar but on steroids. The studio flash has a modeling light, which unlike its smaller, more portable cousins, provides a basic guideline of what the light will do when the flash is fired. There are two lighting elements attached to a flash unit: the modeling bulb and the flash tube. The modeling light is usually in the center of the flashtube, positioned to give a pretty accurate semblance of the angle of the flash when fired. This is an extremely helpful gauge, showing how your light will behave. The modeling light is only a guide, and there are differences. For instance, the shadows are a bit stronger with the actual flash. It takes a bit of training to get used to the subtleties between the modeling lamp and the flashtube, but with practice it's not difficult.

A studio flash provides repeatable results. The flash will produce light with the same consistency all day long. In commercial food photography, it is essential to be able to create consistency in your lighting.

One of the biggest advantages of using a studio flash is the power it produces. Strobe units provide a large burst of light in a very brief amount of time, measured in watts per second (or watt-seconds) or joules. The units usually start at 300 watts per second (w/s) and go up to several thousand. There are two types of studio strobe units: monolights and power pack units with multiple head attachments. A monolight has the entire unit built into the head and can operate only as a single unit. Monolights are usually less powerful than power pack versions. They range from 300w/s to 1,000w/s.

Power pack units are usually more powerful—1,200w/s and up. There are two parts to the system. The power pack is independent of the flash unit and consists of a box slightly larger than a car battery. The strobe lights—or heads—are plugged into the pack using a thick electrical cord with a special plug to match the power pack. Some packs can accommodate three or four separate strobe heads. The advantage to a strobe pack/head combo system (versus a monolight system) is that the distribution of power between the heads can be controlled. For example, a unit that is 1,200w/s can distribute power between three heads and can be configured in several ways. With a single head attached, the unit throws 1,200w/s to a single strobe light, which makes a very bright flash. Adding a second head splits the power between the two strobe lights so that each light outputs 600w/s. Adding a third head can create an even lighting ratio with all three heads producing 400w/s each, or you can split the power to the heads in an uneven ratio. For instance, half the pack's power can go to one head, producing 600w/s, while the remaining 600w/s can be channeled to the other two heads for a split of 300w/s each.

Why is this important? Good lighting is subtle. Being able to place just the correct amount of light in any given area of a photograph enables you to create a photograph that dances off the page instead of landing flat. You have seen photographs that make you go "wow." The proper use of lighting is what made it pop. Examine photographs carefully, and you'll notice that the really inspiring ones are lit, controlled, and manipulated precisely. Nothing is random, and everything in the image is coordinated. Having lighting tools that you can dial up or down makes a huge difference.

What you need to set up a studio depends on what you can afford. From my experience, you will need a minimum of three flash heads to cover most lighting scenarios for tabletop photography. Studio equipment can be very expensive, but your return on investment is usually very good. It's taken me years to build up my studio equipment. It's important not to go overboard. Buying the latest and greatest new gadget can be fun, but it can't take the place of learning good photography. Even so, there are limits to what you can accomplish if you don't have the right gear for the job.

I use Broncolor lighting, which is a premium lighting system. It's expensive for one simple reason: The lights are built to last. What is amazing about the Broncolor system is that you can mix and match equipment from the 1980s to the present. A strobe head from 1980 will work on a modern power pack.

A good rule of thumb is always to buy the best equipment you can afford.

Tip

Buy used lighting. You can often buy whole systems in good condition on the cheap if you shop around and know what you're looking for.

I have never bought a new piece of lighting equipment. I buy cameras new, but never lighting.

I have gotten great deals on used equipment. This stuff is made to take a punishment. A lighting kit can last for 40 years if treated with care. You have to change the bulbs, but the hardware is meant to withstand use in the field.

My first monolight kit that I purchased over 20 years ago is still in use. I have a pack made in the 1980s. I have purchased used lighting from dealers, on eBay, and from retiring photographers. Always make sure a unit is in good condition when buying used, but the price for entry is much lower than buying new. You can also rent lights to supplement your kit and bill it to the client.

If you find yourself on a budget, there is an American company called Buff located in Nashville, Tennessee (www.paulcbuff.com, 800-443-5542). It manufactures good quality lighting at a decent price. It has several product lines and is accessible for the most budget-conscious photographer. Buff sells both mono heads and power pack models. You can purchase three heads and accessories for under $1,500—not bad for a full lighting kit. When I first started out, I could afford only two lights. This severely restricted me photographically. I recommend purchasing at least three. That will satisfy most beginning lighting situations, and you can always rent or add more equipment as needed.

Strobe Modifiers

After you purchase lights, you are not quite done. There are other accessories that go along with professional lighting. The idea of working with studio lighting is to be able to manipulate light in the same fashion as we did with natural light. The major difference is that you can modify artificial light to produce your photo-graphic vision. Often, the source of natural light shifts and tends to be inconsistent. Because it is repeatable and consistent, artificial light lets you learn how light behaves and how to use it to your advantage. By taking advantage of the types of accessories out there, you can perfect the art of light manipulation. Then your work becomes very interesting.

There are so many attachments that can be added to a flash head to manipulate light. One of the most basic accessories is the reflector. The reflector funnels the light in a forward direction. It is lined with a silver reflective surface to concentrate and increase the light as it is fired.

Attachments for reflectors are available. *Umbrellas* soften light and come in different styles. Umbrellas can be lined with silver or gold reflector material or be translucent. Each type of umbrella acts as a diffuser to soften the light. It looks just like a regular umbrella and attaches to the unit through a hole in the reflector.

Attachments that are invaluable especially to food photographers are *grid spots*. They are circular in shape and come with varying degrees featuring a honeycomb pattern inside. They fit over the reflector and modify the light. Grid spots are great for adding a hard light source to a photo. The honeycomb pattern softens the light around the edges but lets enough harder, undiffused light through. This, when combined with a mirror to reflect the light, makes for a great light source.

A *soft box* is another light modifier that is essential to food photography. A soft box is exactly what it sounds like. Consisting of a reflective nylon box, the soft box has two layers of diffusion—one on the inside of the box and one that attaches to the outside. It is erected using bendable rods that fit into a circular metal ring called a *speed ring*. It opens like a tent and when fully expanded attaches to the strobe head via the speed ring and acts in much the same way as the diffusion panel we talked about previously. An umbrella gives a similar effect, but the soft box has more adjustment capabilities.

Soft boxes also have accessories that further shape the light. Louvers and grid-shaped attachments usually come with a soft box when you buy them. I encourage you to experiment with these tools after you learn the basics of artificial lighting.

A *snoot* is another interesting tool. It has a conical shape that is narrower in the front. It works in almost the opposite way to a soft box: Instead of spreading out the light, it focuses the light into a narrow beam, allowing you to direct the light. This is useful for highlighting a narrow area. Often when we are lighting food, there is a spot on the dish that you just can't illuminate correctly. The snoot allows you to direct the light in the perfect way to overcome this obstacle.

Light Modifiers

Other light-modifying tools we use are not attached directly to the strobe head but instead are placed on a stand between the light and the subject to control specific aspects of your lighting.

Cookie Cutters

A *cookie cutter* is placed between the light and the subject to project patterns onto a scene and simulate dappling light. It can be either store bought or made by hand.

Flags

Flags are square or rectangular frames that keep light from hitting the lens. A lens flare, which occurs when the light bounces directly into the lens, can ruin a photograph. A flag can be as simple as a black card clamped to a stand, although you can also purchase one from a camera store.

Cutters

A *cutter* is a framed mesh screen that helps reduce the intensity of light hitting a subject. It can come in various densities and is used to tone down light in certain areas while allowing more light into other areas. It can be made of mesh in varying degrees of mesh opacity or can be translucent white like a light diffuser. For example, these tools are useful if you are lighting a set and want partial diffusion in a particular area.

Fingers and Dots

Fingers and *dots* are similar to cutters but on a much smaller scale. As their names suggest, fingers are long rectangular shapes, and dots are round. You can purchase them or make your own using wire hangers and black pantyhose. They are used when the light overexposes a particular part of the photograph. For instance, if we are shooting a pie with whipped cream on top, a finger would be used to flag light from hitting the top of the white cream while allowing the full intensity of the light to reach the pie, which requires more light for proper exposure. The exposure disparity between the two elements prevents getting both areas to receive the proper exposure. Using a finger or dot reduces the amount of light hitting a particular area of the image, bringing the balance to the exposure.

Grip Equipment

Grip equipment is any hardware that aids in the creation of the production. Things like stands, apple boxes, clamps, sand bags, and gaffer's tape are all considered grip equipment. Flags and other items such as light modifiers and things not attached to the lights themselves are usually considered grip equipment as well.

There are a few other useful pieces of equipment worth mentioning. A *boom stand* is an essential piece of studio equipment. A boom is a large stand with two main parts: a base and an arm or extension. The base supports a boom arm, which extends horizontally from the base. This can be useful if you want to place a strobe head directly over the subject. The base remains off to the side and out of frame, but the light can be manipulated horizontally over the subject.

Something you will need to round out your lighting kit is extra stands. You will need light stands not just for your lights but also to hold cards, flags, backdrops, and mirrors. It takes time to build up your gear, but these are essential elements that you should have to progress with your lighting skills.

Don't get too wrapped up in buying too much equipment at first. You don't have to have everything I just described all at once. If you need something to complete a job and you can afford it, by all means, purchase it. If you can't, improvise and make do with what you have. Make it work. I used to borrow equipment. The more tools you have at your disposal, the more you can manipulate light, which is the goal.

Learning studio photography is a process that requires a great deal of experimentation. You are limited by the tools you have, but that is not necessarily a bad thing. If you have only one light, do the best job you can with that one light. As you add equipment you will inevitably find new ways to light. It took me many years to build up the kit that I have. The process was fun. As I developed my skills, I figured out what equipment I needed and acquired it. I am still buying lighting gear. I recently found a great Broncolor mono kit for $500, complete with 2 heads, stands, grids, reflectors, and a case.

The purpose of acquiring lighting equipment is to provide the tools to help you become a professional photographer. All the items that I have mentioned are suggestions, so feel free to get creative as your budget dictates. What I use as a professional does not necessarily mandate what you need.

I will warn you not to buy junk, and try to avoid shoddy equipment. You get what you pay for, and it's better to buy top brand used equipment than it is to buy new equipment that is essentially garbage. The failure rate on cheap strobes is pretty high, and you can't afford to have your equipment go down during a job.

Tip

Always try to have backup pieces of key equipment when going out on a job. Equipment can break or break down, If you're not prepared, this can throw you off your game, so make a backup plan so you can be prepared at all times for the unexpected. If your equipment fails during a paid assignment, it may set you back, or worse get you fired.

I remember shooting an assignment for a textbook on phobias many years ago, before I was fully into food photography. I had to shoot in a high school. When I arrived, a photography teacher informed me that they were all set for my lecture and both photography classes were going to attend. They had misunderstood the actual purpose of my visit, which was to get photographs for my book, and instead thought I was volunteering to teach the class. Having no choice, I began a lecture and made an impromptu lesson on the spot.

After the initial shock wore off—that I had to teach 50 high school students—I began to set up. I detailed everything I was doing so the students could learn. The kids were great, and I wound up completing the assignment. During the lesson, one of my lights stopped working. I had a spare moonlight, so I quickly replaced the unit and used the opportunity to explain to the class that things can always go wrong during a photo shoot. The moral of the story is to be prepared for the unexpected and always carry backup. If you don't own a backup, then rent it or borrow it, but have it.

Artificial Light

There are two key differences between using natural light and artificial light. The first is that you can control artificial light and manipulate it any way you see fit. By playing with the light, you can see how it reacts to different subjects. We will begin the experimentation process shortly using one light and seeing how it relates to a still life when moved around the set.

The second key distinction is that with artificial light you can use more than one light. Obviously, the sunlight you have been using creates a single shadow. Using multiple lights creates multiple shadows. This isn't always a bad thing, but it's something to be aware of. In lighting, you have to make the same types of choices you make when composing an image.

Aside from lighting aesthetics, you have to know and control your equipment. Strobes have different power settings, and you can increase or decrease light incrementally on an individual basis.

When sharing a power pack or splitting between heads, you need to learn how each head behaves when you adjust the intensity of light.

Syncing a Flash

Additionally, a flash/strobe has to communicate with the camera. This is called syncing the strobe to the camera. For the flash and the camera to be in unison when you fire the shutter, it has to sync with the flash so that the flash doesn't fire too early or too late in coordination with the camera. When you fire the shutter, the flash reacts and properly exposes the image. To sync a strobe, you need a sync cord, which attaches to the strobe and the camera either via a hot shoe (on top of the camera where the flash goes) or through a port in the camera. Another method of syncing strobes is via the use of a radio control unit. The transmitter attaches to the hot shoe of the camera, and the receiver unit attaches to the strobe via the sync port. When the camera fires, either the radio or the sync chord (depending on which you are using) triggers the strobe to fire in synchronization with the camera shutter.

When using multiple strobe units, you have to trigger all the units simultaneously. Most strobes have a slave button that fires when the flash fires. It reacts to the light burst triggered when another flash unit fires. Since these bursts are in microseconds, all the flashes fire simultaneously. A problem with slaves and some fluorescent lighting is that the flicker of the light can sometimes trigger the slave and rapid-fire the unit, causing a fuse to blow. The unit is useless under those conditions. You may not be able to shoot the assignment if your flash units are firing randomly. Radio-controlled slave units overcome this problem.

When shooting with a flash, you need not concern yourself so much with shutter speed. If you are using light from the flash exclusively, check the sync speed of your camera shutter. The sync speed is the fastest shutter speed a camera can fire at to be in synchronization with the flash.

Most new camera models sync at 1/250 of a second or slower. If you shoot any faster, there will be a lag in the curtain, and part of the image will be black. The choice is yours to shoot exclusively with a flash or combine daylight and flash.

Syncro-Sun

To mix the light, you first need to determine the correct f-stop for the flash. Once the overall f-stop is determined, you need to adjust the shutter speed until the natural light from the set is exposed correctly with the corresponding f-stop of the flash. For instance, the photo of the Bloody Mary is similar to the pool images earlier in this chapter, combining natural light with a flash. The pitcher and glass are exposed with the flash, and the background window is exposed for room light. The result is a successful mixed lighting exposure.

Notice how the spill of hard light coming in from behind nicely backlights the tray. If I had used only natural light, I would not have been able to capture the detail of what is in the front of the glass.

The horseradish and detail in the ice cubes make the shot pop.

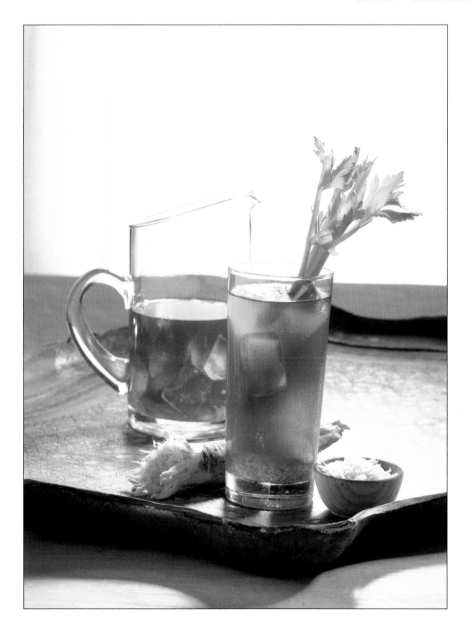

A flash creates a very short burst of intense light. In the next chapter, I will introduce lighting concepts and then provide appropriate instruction. For now, I want to continue to emphasize techniques and concepts because I believe that repetition facilitates quicker learning.

As with natural light, artificial light requires that you apply the same rules regarding composition, point of view, and what you want to achieve with each photograph. Continue to ask the pertinent questions regarding your images.

Once you learn studio lighting techniques, whether you are on location or in the studio, you will be able to produce professional jobs for clients. If you master artificial light, you can control the outcome of your images at will.

Remember the key to being a professional is to visualize the image in your head and then execute it. Sometimes you will be required to produce a photo according to a layout. Sometimes the client will rely exclusively on your vision and interpretation. You have to be able to produce the assignment according to the specifications given.

Miscellaneous Tools

In addition to actual studio equipment, food photographers use many different types of apparatus to manipulate objects on the set. The previous photograph illustrates the various devices we use to hold objects in place, float, or level them. The clear plastic blocks and cylinders, called *rigs*, are used to float or fly objects behind other objects in order to position objects where you want them in the photograph. They come in all manner of shapes and sizes.

If you examine the still life image of packaged goods, it appears that the Kimchi soup bowl on top is floating in thin air. Underneath it is a plastic cylinder. The same is true for the tortilla soup on the right side.

When shooting what we call beauty photos, I often am asked to insert a package or can into the shot. I am also asked to shoot packaged goods without any cooked food in the shot. Being able to read the product labels is essential. We often use objects called rigs to float objects so that the product can be read.

Sometimes we empty the product out of the packaging to make it lighter. We use pins, wax, and other devices to hold things in place. A few years ago I discovered how useful poker chips can be. I like them because you can stack the chips in very specific heights. I also use loose change to level objects. The can of chunky gumbo has a dime under the left back of the can so it looks like it's straight to the camera.

When dealing with packages, there can also be challenges regarding reflections. Most of the time you can avoid a reflection by turning the object slightly. If that does not work, use dulling spray. Dulling spray is an aerosol wax substance that comes in a can. You have to be careful with it, and it does not work on all surfaces. It comes in handy when everything in a photograph is perfect except for one reflection that you can't get rid of.

Wax, also called tacky wax, is very useful and serves many functions. We use it to hold objects in place. It's usually white and often blends into surfaces. I use it for one purpose or another on every shoot.

Other Types of Artificial Light

Strobe lighting is not the only type of artificial light. There are incandescent lights, also known as *hot lights*, that burn at 500 watts to over 20,000 watts (large movie lights). Hot lights can be used for still and motion. If you are considering shooting video capture and still photography, it is worth looking into this type of lighting.

I have two lighting packages: a set of hot lights and my strobe package. The disadvantage of hot lights is that they are hot. This is especially problematic when shooting food, because the heat can affect the food. It fades quickly under hot lights. It also gets uncomfortable in a room when three or four 1,000-watt lights are elevating the room temperature. Additionally, they limit your ability to create mixed lighting situations because of color temperature and exposure problems. The advantage of using hot lights is that they are inexpensive. Hot light packages can be purchased for about half of what a strobe system costs. I use both types of lighting and prefer strobes.

There is another type of lighting available called the Kino Flo system. It consists of color-corrected fluorescent tubes. They are quite pricey, and I see no advantage over strobes unless you shoot motion. The lights produce a soft light, so you will still have to supplement the lighting setup with a hot light or strobe to create the hard light source that food photography likes so much.

The Last Word

In summation, studio photography requires the mastery of many concepts. Becoming familiar with the tools of photography and learning how to use and control them are aspects of this mastery. Making the best photograph with the equipment you have is the challenge. If you think that one piece of equipment will make or break a shot, go rent it. If you plan to be a professional food photographer, you must immerse yourself in the tools and techniques necessary.

You must also expand your knowledge as you progress. I recently purchased some new light modifying tools. I was bored with my lighting and wanted to explore new possibilities. I love coming up with new ways to light and shoot. I always want to reinvent my work and style and keep current. With enough hours invested, you will eventually have a library of lighting techniques to draw on.

As a professional, your job is to solve photographic problems. Believe me, if the clients could do it themselves they would. Clients rely on your experience to make sure they get what they need. Mastering studio equipment is a necessary step in your professional growth.

In the next chapter we will discuss one of the most critical elements of being a professional food photographer: artificial lighting techniques.

In this chapter, we will begin with simple lighting techniques using artificial light and then move into multiple lighting scenarios. As you become more proficient, you can create your own techniques. Always remember that these are guidelines. When you have the actual dish on set, you will always have to adjust the lighting to solve problems—such as an unwanted reflection or lens flare—that may come up.

We know that lighting food from the front is unflattering. One of the major differences between artificial light and natural light is that you have greater control over artificial light; its strength, direction, and effect on the image are elements that can be controlled or modified. I prefer artificial light for this reason.

If you can't afford the more expensive lighting gear yet, it's important not to let the lack of equipment interfere with your food photography education.

We discussed using strobe lights in earlier chapters, but if you haven't been able to purchase strobes, there are ways to create an inexpensive lighting kit. (You can even make your own soft box!)

You can also take studio lighting courses if they are available in your area. Gaining access to the proper equipment is helpful. If you can't get your hands on professional equipment, practice with inexpensive clip lights, found at your local hardware store. No matter what equipment you use, you still need to learn how to use light. You will never advance professionally until you learn proper lighting technique. This can be achieved only through practice and trial and error. You have to take a lot of bad pictures to be able to take great photographs.

It is important to begin each new photography session making sure your files are not only properly white balanced, but also that all the different types of lighting you are using have matching color temperatures. Your camera manual will have specific instructions on how to do a custom white balance on the camera. What you are essentially doing is telling the camera that under a given set of lights, a neutral or gray card has an accepted color balance—kind of like making sure a scale reads zero before you weigh yourself. If you recall from previous chapters, every type of light source has a specific color temperature. Strobe light has a different color temperature than tungsten light. Having a color-correct image is always important. In food photography, having accurate color is critical. Achieving the correct white balance is an important step in the photographic process and should not be overlooked. Setting the white point saves a lot of headaches later, when images come out looking too yellow or blue (warm or cold). Images can be manipulated in post-production to correct the color balance, but it's better to do it on the front end and save yourself a lot of time and money.

A quick review: Color temperature in an image is related to the Kelvin scale. Each temperature gives off a specific color. If you heat a piece of metal, the color of the metal changes as the metal gets hotter. The metal turns red, then orange, yellow, white, and then blue-white to darker shades of blue. The temperature is measured in degrees Kelvin or absolute temperature. Color temperature is abbreviated K for Kelvin. The yellow-red colors are considered warm, and blue-green colors are considered cool. The higher Kelvin temperatures (3,600–5,500 K) are what we consider cool, and lower color temperatures (2700–3000 K) are considered warm.

The following scale shows the color temperature corresponding to the types of lighting available.

If you are shooting with just one light source, you can skip this next step. However, if you want to mix light from different light sources, you must balance each light source to one another using color correction gels because a camera can shoot at only one color temperature rating during each frame.

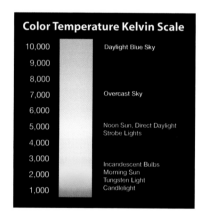

Gels come in multiple colors, in both sheets and rolls. Specific colors change the color temperature of a light source light. For example, if you are combining natural light from a window with artificial tungsten light, you warm up the natural light with an orange gel (Color Temperature Orange, or CTO) or cool down the tungsten light with a blue gel (Color Temperature Blue, or CTB). It makes no difference as long as the color temperature is balanced to each source and the white balance in the camera is set correctly. Strobe lights were designed to be the same color temperature as bright daylight, so if you are shooting with natural light and strobes, the light is already balanced.

Artificial Lighting

Artificial lighting involves using man-made lighting to light the set and subject. Depending on your budget, those lights can be strobes or some variation of hot lights. Regardless of what type of lighting package you use, you can accomplish most of what you need photographically with any type of artificial lighting. Strobes are my preference because they offer the greatest degree of flexibility. For example, you can't take splash or pour shots without a strobe to freeze the action. It's also more difficult to create syncro-sun techniques and fire effects without strobes.

Lighting Food

The first example illustrates the use of a single light. This lighting scenario looks familiar; it's a replication of the back light technique we discussed previously using natural light. The soft box was positioned on a stand at about a 45-degree angle toward the back and right of the set. I usually place the light about one foot above the set, positioned downward to start. The bounce cards are then positioned to kick light into the front of the set.

 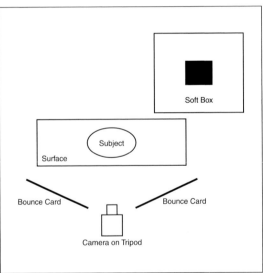

The shot of the calamari on the facing page was taken under those lighting conditions. It's a simple lighting setup that works well every time. I generally light with one light when I want to simulate natural light. The light is soft with subtle highlights.

Using artificial light, create images that demonstrate both back and side lighting techniques. Experiment with the position of the light to see how moving it affects the image. Unlike with natural light, you can set the lights and fine-tune them to suit your needs. Play with the light and move it around. See what it does when you move it higher or lower. Notice how the distance of the light source in relation to the subject affects the hardness or softness of the light. For instance, a light source closer to the subject creates hard edges, and a light source farther away creates softer edges and shadows. How does it react when moved more from behind or to the side? Use the bounce cards to illuminate the front of the subject. You can work with a stylist or style it yourself. The goal is to see how light reacts when you control it.

This exercise will give you a very good tutorial on how light moves and behaves. Until now you have been at the mercy of natural light. Manipulating light is the key to being a master food photographer.

You also can place the soft box perpendicular to the subject instead of behind it. Just as we did when we illustrated how to light from the side in Chapter 2, the same rules apply to sidelighting using artificial light.

One light may not be enough. Light gets weaker over distance, so the intensity of the light decreases the farther the subject is from the light. This is called *light fall-off*. With the main light diffused from behind and to the right, the light hitting the subject from the right side of the set is stronger than the light on the left because of fall-off. The right side of the subject will be brighter than the left. When we expose for the highlights, what is not in the light will be in shadow. The darkness of the shadow dictates how much light we need.

Let's build on your knowledge by adding a light. Using the same lighting set we just discussed, position another light on the opposite side of the set, away from the first light.

The objective is to introduce another light source to the equation to bring more detail into the left side of the subject and see how it affects the shadows. This light can come from any angle, but its power is half that of the first light. This is called a *fill light*.

The brightness of the fill light compared to the main light is called the *lighting ratio*. For example, a 1:1 ratio means that the fill light is equal in strength to the main light. Generally, we want the fill light to be weaker than the main light to create drama.

Compare the two spaghetti images on the facing page. In the left spaghetti image, the lighting is nice and even but somewhat flat. With the addition of a sidelight, we get some catch light in the sauce, as shown in the image on the right.

Lighting ratios have a direct relationship to our camera exposure settings. If you remember from the f-stop and shutter speed lesson in the previous chapter, changing by one f-stop either doubles the amount of light or cuts the amount of light in half. Lighting ratios follow the same principle. A 2:1 lighting ratio means that the main light is one f-stop brighter than the fill light.

If you are using strobe lights, assuming both lights are diffused, simply set the main light to full strength and the fill light to half power. Make sure the lights are the same distance from the subject. If you are using hot lights or clip lights, you can control the ratio by adjusting the distance of the light in relation to the subject. For example, if the main and fill lights are of equal value (they both have the same wattage), measure the distance from the set to the main light. When you want to add the fill, measure twice the distance and place the light there. If the main light is one foot away, place the fill two feet away. It helps to use a light meter, but with strobe lights you need a meter that can calculate for a flash, called a *flash meter*.

The key light and the fill lights are the only lights involved with the lighting ratio; all additional lights are used for accent. The lighting ratio sets the mood and gives depth and texture to a subject. When dealing with lighting ratios, you either multiply or divide by 2. A 3:1 ratio is one and one-half stop difference, 4:1 is two stops, and so forth. Generally, you would not want to make the gap between lights more than 5:1 or 2½ stops; otherwise, the fill light will be ineffective.

EXERCISE #2

Using two lights, create a series of images that demonstrates proficiency in lighting ratios. Start with a main light. Once you establish its correct position and distance, add the fill light. Create images at ratios of 1:1, 2:1, 3:1, 4:1, and 5:1. If you are using hot lights, use the light meter in the camera. Determine the strength of the main light by metering the scene. Turn that light off and determine the strength of the fill light. When both lights are in balance (both are of equal strength and require the same f-stop), you will have a 1:1 ratio. Take a capture and then move the fill light until it is one stop less than the original reading. You have to turn off the main light or it will override the meter. For example, use f-16 as the base exposure. To achieve a 2:1 ratio, the main light remains at f-16, and the fill needs to be set at f-11. Continue adjusting the lights in this way until the assignment is finished.

If using a strobe, you can leave the lights where they are and adjust the strobes using the controls. I prefer to place the fill light on the side opposite the main light. I like to put the fill at a perpendicular angle and wrap some of it around the front of the set. You can always use bounce cards as well to give a little more kick—especially on the right side. You can also create specific lighting ratios with one light and bounce cards acting as fill, but I want you to step outside of your comfort zone and use two lights.

Now let's take it to the next level. What I consider the most important lights in food are accent lights. Until now we have been using soft light, which is nice, but those yummy food images you want to create need a bit of spice. A hint of mint, as my colleague Rich Buyer calls it, comes from the accent lights. These lights are either undiffused or diffused partially using a grid spot inside the reflector, which is my personal preference. This creates soft edge light with a hard but controllable light in the center. The light comes from behind on the side opposite the main light and enables the introduction of opposite-angle complementary accent light. What happens then is magic.

In the pasta example, we added a third light. By introducing a hard light source from behind, you highlight the back rim of the dish, which creates separation and adds nice highlights to the food, which adds a different dimension to the sauce. The key is that we use mirrors to redirect the rim light from the front and pop glowing light coming from the back into the front of the subject. The light dances on the subject and creates great food lighting. If you have only two lights, use bounce cards for fill and place the hard light coming from the back opposite the main light.

If you don't have grids you can use raw light. You might have to back off the light a bit or shade it using a scrim. A *scrim* is a small flag, such as our fingers or dots, that partially blocks the light. You can make a diffuser for the rim light with black pantyhose stretched around a wire hanger. Just be aware that hot lights burn things easily, so if you are using hot lights do not put anything flammable near the light.

Another useful item is called *black wrap*, which is a roll of black foil. Black wrap can be used for many things and can be found at most professional photography shops like The Set Shop, Calumet, and Fotocare. All can be found easily online.

Be aware of lens flare, a problem that can occur with backlighting. Lens flare occurs when the light hits the lens directly. If you have ever taken a photograph facing directly into the sun, you know what I mean. To keep this from happening, always use a lens shade. You could also use a flag, a black card, or a piece of black wrap to block the light. Hold the card or place it in a stand and adjust it until the light no longer hits the lens directly. Don't use a white card as a flag. A black card will absorb stray light and reduce unwanted flare, but a white card does the opposite and will bounce light into places you may not want it.

As we experiment with artificial lighting, we run into new challenges. A single light source such as the sun creates a single shadow, but multiple lights create multiple shadows. Shadows can be softened with bounce cards and mirrors, and you can eliminate unwanted shadows by moving the lights around. When we start adding more lights, multiple shadows can look strange or unnatural. Don't get too caught up with this but simply be aware of it as a potential problem. Be aware of shadows as you work through the lighting exercises. Look at the spaghetti images again and notice the direction of the shadows.

To shoot food properly, you need a minimum of three lights to achieve the best results. You can get away with two lights if your compositions are tight. The size of the set determines how many lights you need. If you have to show the background in the shot, you also have to light it. In this shot we have four lights: the main light, the fill light, the accent light, and a background light on a low stand.

EXERCISE #3

The goal of this exercise is to experiment with the rim (or accent) light. Using three artificial lights, create a series of images that build on the previous exercises. Establish a main light and fill light, making sure you have the correct lighting ratio. Place the accent on the side, the back, or even the front if you like. When lighting from the front, use a mirror in back of the set to bounce light onto the back edge. Play with the edge light here, and you will see how useful it can be. Use mirrors and bounce cards to create highlights in selected areas. Remember there are two sides to the mirrors. Use both sides and see what that does to the image. If the magnified side is too hot, it will blow out the detail, so be aware of this and adjust accordingly.

Here are some more examples of multiple lights using key, fill, and accent lights with mirrors to pop the lights.

Lighting Drinks

Lighting drinks and bottles presents its own challenges. Because of this, styling drinks can at times be even more difficult than styling food. In addition to styling challenges, you have to deal with elements such as ice (either real or artificial) and the different shapes of glasses. Let's say you are shooting a drink in a highball glass. You set up the shot and achieve great results. But then you have to shoot a martini. The glass has a different shape and reacts to light differently. What do you do? You need to understand that a subtle move of the light or rotation of the ice cubes in the glass can make or break an image. Some clients like highlights in their glasses, and others do not. You have to experiment with subtleties in still life photography. Also, the shade of a drink varies. A Manhattan is very different from a martini. How you adapt to changes comes with experience, so don't be afraid to make mistakes.

I prefer fake ice, but real ice is also nice. Your garnish must be fresh and beautiful. Often it's the only splash of color in the shot.

I will demonstrate a few of the standard lighting techniques for drinks. I prefer shooting on Plexiglas. When shooting on seamless paper, the paper gets moist and buckles, but you can wipe down Plexiglas for a neater set.

Shooting Drinks on White

Let's deconstruct a drink shot on white first. Contrary to what you might think, the light is not shot through the Plexiglas. While this technique can work, I find it inferior to bouncing the light. I have used many methods to shoot drinks. I like to shoot with two lights evenly placed in a 1:1 ratio. When photographing drinks on white, I prefer raw light. The trick is to light the drink from both behind and in front at the same time. Place two lights on stands evenly with no diffusion, at about 45 degree angles in front of the set. You can position the lights so that they intersect at the drink. Make sure you are using regular reflectors. You can also cut out thin white or black cards and experiment with placing reflections in the glass or drink. In some instances, you may have to flag some of the light coming from behind if you are getting any lens flare. It's a simple setup, but there is some degree of manipulation involved with cards and reflectors to make it look the way you want.

I generally do not use mirrors on drink shots except to bounce light from behind or to accent a garnish.

One of the first steps in drink photography is setting up a sweep. A sweep is when we take either a roll of seamless paper or Plexiglas and create a background with no seam that goes off into infinity. It's a bit easier with seamless paper because you roll it out so the paper sweeps across the set and is clamped to the front. With the paper higher than the table, you roll it out until it creates a rounded back corner that gently goes up the back of the set.

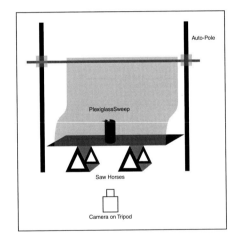

Plexiglas needs to be bent in a similar fashion. I use poles with a metal bar running between called auto-poles. Auto-poles are a cool addition to your equipment kit. They are essentially stands that extend from floor to ceiling, have suction cups on each end, and use spring tension to hold them in place. Since they do not have tripod legs, they leave a small footprint, which is good in tight spaces. I put zip-lock bags on the tops because for some reason the suction cups leave ugly black marks on the ceiling. I then use Mafer clamps, made by Matthews, to secure the rod in place. A Mafer clamp tightens to the auto-pole or other surface and has a metal knuckle extending out to form a tight grip. You can also attach a light to the clamp, which is very useful.

Any good studio photographer needs a flat shooting surface. I use a 6×4 piece of one-half–inch plywood on two sawhorses. This makes a sturdy surface to work on, and it is easy to break down and store flat. The front edge of the 4×8 foot Plexiglas is then clamped to the plywood at the front of the set. The back end of the Plexiglas is then bent and attached to the rod to create the sweep. A piece of Plexiglas the size needed costs about $150.

If that is impractical, you can use a regular half-inch clear pane of glass about 2×2 feet. Set up the seamless paper sweep and then put the glass on top. This might cause an unwanted reflection, but it will do the job. You can also put the piece of glass on four clear pint containers to elevate it above the set. Be careful not to get the paper wet when you spray moisture onto the glass.

Dealing with reflections in the glass is the main problem. If the drink is placed directly on top of the sweep, you will get the white of the Plexiglas edging up the glass. You can use pieces of black card and place them directly around the glass to stop the white from creating unwanted reflections, or you can elevate the glass above the set by placing it on a glass or glass block. I like using glass blocks because they are very sturdy. Sometimes you need a smaller base. A wine glass turned upside down often works well. I eliminate the original background, which consists of creating a path around the drink in post-production. Then I add an artificial shadow.

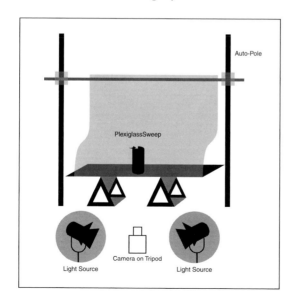

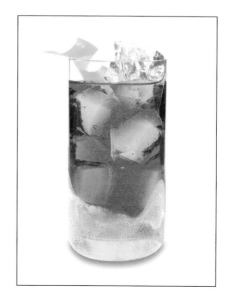

Shooting Drinks on Black

Shooting drinks on black is very trendy these days. It took me a bit of experimentation to get the technique down. Start with a sweep the same way we approached our last setup. Black is tricky because not all black surfaces absorb light. When using black seamless paper, the light source will brighten the paper, making it more gray than black. If you are using paper, use super-black seamless. I prefer to use either black velvet or black Plexiglas. I use one light positioned directly above the subject with a reflector and a grid spot on it. A snoot works great here as well. To isolate the light around the drink, I use a boom stand to get the light directly above the drink. The boom stand allows maximum control over the light. When shooting on black, isolate the light as much as possible.

I prefer Plexiglas because I can bounce light above and behind to create a good lighting effect. If you are shooting a mixed drink, it's not imperative, but a clear drink does not look like much if you don't have light coming in from behind. I sometimes use a second light as an accent coming from behind to give the shot some pop. Depending on the density of the drink, you might have to experiment to get the look you want. Unwanted reflections and shadows on glasses are often a result of the camera angle. Sometimes a problem can be solved quickly by simply moving the camera up or down. When shooting drinks, remember to level the camera so the lines of the glass are parallel to each other. You can also defeat stubborn reflections in drinks by moving the camera position slightly up or down.

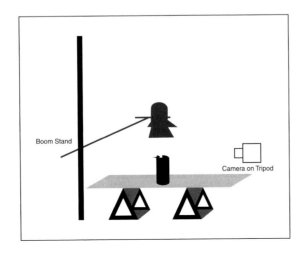

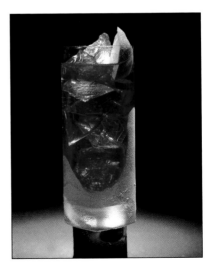

Other Considerations

This next section discusses how to transform your drink shots from ordinary to extraordinary. The tips here are designed to help you get to the next level as a drink photographer. If you follow the instructions laid out here, you will be able to replicate images you see in magazines and high-end advertisements.

Ice and Garnish

You have to style drinks in such a way as to create something interesting within the glass, because that's where the action exists. If the drink contains ice, the combination of ice and garnish create the beauty. Try moving around the ice cubes to create interesting shapes in the glass. If the ice cubes are not dynamic, the drink looks flat, like an ordinary glass of liquid. When the liquid is not clear, you may have difficulty showing any real detail. The goal is to catch angles and reflections in the cubes and create interesting shapes. It is a good idea to examine photos of drink shots you like in advertisements. A shot of ice cubes reaching out of the glass is always interesting.

Moisture or condensation and garnish are important elements in drink photography. Notice what makes a drink shot sparkle, and then figure out how not only to replicate it, but to improve it. In the 1970s, a popular myth existed in advertising circles about the presence of subliminal messages like the word sex spelled out in ice cubes. Although that was unfounded, I will attest to the fact that creating interesting drink photographs using ice cubes is a reality of drink photography. The correct placement of ice can make or break a shot. When adding the garnish, make sure you are using extremely fresh ingredients. When cutting produce such as limes, always make sure your knife is razor sharp. Jagged edges on garnishes do not look good. Also, do not cut garnishes too thick. You want them to have some translucency.

Pours

When you master the lighting techniques detailed in this chapter, you may want to have some fun by attempting a pour or splash shot. With an action shot, you introduce new variables into the image. Photographing the action of liquids pouring requires a partner. One person fires the camera and another does the pouring. It is difficult to shoot these shots alone because you have to work out the timing of the pour, splash, and shutter release simultaneously. Strobe lights are required to freeze the action. With pour shots, timing is key. If you shoot too early or too late, you miss it. Also, no two pours are the same. You may get a great stream and a weak splash or a great splash with no stream. Sometimes you get it quickly, and other times it can take all day. It usually takes me and my stylist about an hour of straight pouring. You also have to reset and clean the glass frequently.

The shape of the glass affects the angle of the pour. You need to experiment with different containers to create the correct stream. You also have to determine whether the liquid is coming out of a specific vessel like a bottle, or if the pour is being generated out of a frame. It takes a lot of captures to come up with a good pour shot. In this example, the drink is on white. We are not including the vessel the pour is being generated from in the shot. For our first attempt, we placed the glass flat on the surface and tried to pour the liquid. It was not very interesting. We then angled the glass on the surface by anchoring it to a small Plexiglas rig with tacky wax. From there, it was just a matter of timing the pour and the splash to coincide with the shutter release. It is better not to look through the viewfinder but instead to observe the pour directly. It took some time to figure out the correct angle of the stream to create the proper action in the glass. Notice that both the splash and the pour are dynamic in the shot at the bottom left.

The right shot is similar, but it's done on black. Instead of a curved glass as with our previous example, we are using a rocks glass. We introduced ice cubes to give the liquid something to bounce off of, creating the action.

This next example on page 129 incorporates a bottle in the shot. Notice there is ice and condensation on the bottle. How was this done? First, we cut off the bottom of the glass with a tool called a dremel. To find out the capabilities of the dremel, go to www.dremel.com/. Using grip equipment, we rigged the bottle with a stand and clamps. To eliminate any shake in the bottle, a glass block was positioned under the bottle so it had a solid surface to rest on and would not shake when the beer was funneled through it. The stylist added the condensation and fake ice. We filled the glass halfway with beer. Then we created the pour by funneling the liquid through the hole in the bottom of the beer bottle. With some experimentation, we arrived at the correct angle the bottle had to be to get the correct pour. This shot is a composite of two images. Everything is live except for the head of the beer, which I added in post. I had captured a few shots that were good, but the head was not perfect. I shot the head of the beer as a standalone without the pour and merged the two images in the interest of time. It's a complicated shot. Had we not been able to use post-production, a photograph such as this would have taken several hours if not a whole day. As I stated previously, you need to measure whether you can accomplish a task quicker in post-production or when on set.

Tip

I recommend that you disable the autofocus feature. It's hard for the camera to lock focus when things are moving. Disable the autofocus and focus the camera manually.

Different Perspectives

Experimenting with close-up angles, macros, and other unconventional perspectives can create some amazing results. You don't always have to approach drink shots so literally; you can photograph them within their environment. Your prop choices can lend interesting results as well. There are so many ways to shoot drinks beyond just showing them straight on. Here are a few examples to illustrate my point.

EXERCISE #4

Using the techniques illustrated previously, create three drink shots. Photograph one drink on white, one on black, and one in an environment. By an environment, I mean create a still life that includes a surface, a background, and props. Each requires a different lighting setup. Play around with the styling, and make sure the garnish is fresh. Move the ice around until you achieve the desired result. Apply the moisture technique we learned from the chapter on styling. If you feel daring, try demonstrating a pour shot.

The Last Word

Learning to use artificial light is an integral step toward becoming a professional food photographer. The lighting examples in this chapter are a starting point, but you will need to experiment to find what works for you. The more lights you add to the setup, the more complex the shot will be. A two-light setup is a good starting place, but adding a third and fourth light might add new dimensions to the image. Also keep in mind that it's possible to overlight a shot. Sometimes the best lighting setup is also the simplest and the one that best showcases the food or drink.

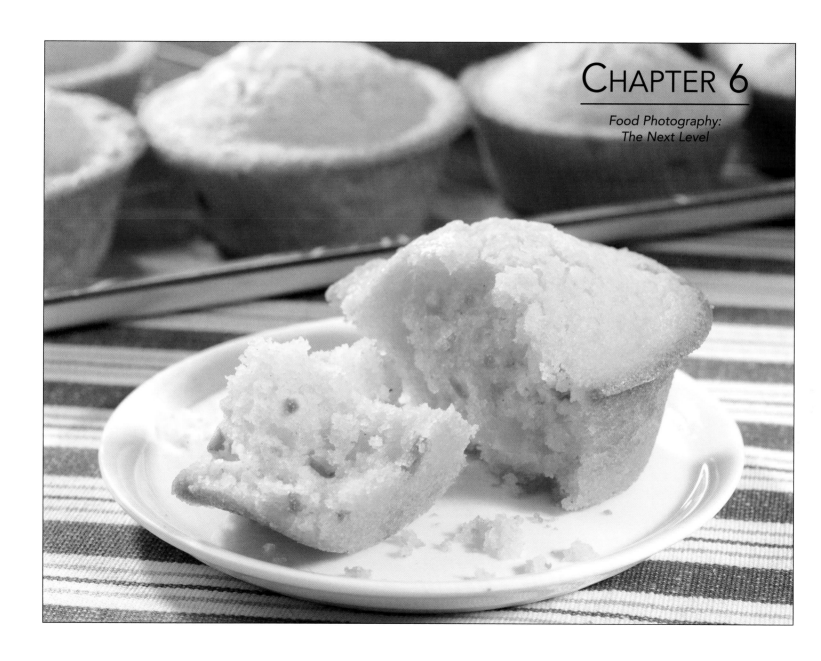

Mastering Food Photography

Until now, you have been working toward the goal of being able to photograph food. We have concentrated on the foundations of photography in general with food as the emphasis.

Using digital equipment doesn't excuse you from learning the principles of photography that have existed since the inception of the medium. The advantages of digital have been outlined, and hopefully you have been shooting the assignments I suggested.

The goal now is to take your work to the next level, to gain greater insight as to what a professional food photographer does. How do you distinguish yourself from all the other food shooters out there? According to Malcolm Gladwell, in his book *Outliers: The Story of Success*, it takes 10,000 hours to master a subject. That means if you practiced food photography for three hours a day, it would take approximately 10 years to achieve mastery. So get to work. I use this to illustrate that it takes a great deal of study and practice to become a true master at food photography.

I have found this journey to be a joy. Being paid to do what you love is the greatest gift you can give yourself. As Joseph Campbell, the great American mythologist, writer, and lecturer said, "Follow your bliss."

What's the secret? Details, details, and—did I mention?—details. Your approach makes all the difference between a boring photo and a masterpiece. Not everything you shoot will be exciting, so the key lies in your approach. It's up to you to make it interesting.

To illustrate my point, let's look at an example. I think the Dannon folks would differ in their opinion, but from a photographer's perspective, the subject of yogurt is not very exciting or sexy. By making conscious photographic choices, I've turned what could be a very mundane subject into something that I am happy to show.

Making a subject interesting involves making the right decisions. Usually the stylist and I will confer. The first decision is whether to take off the lid or leave it on. After looking at an example, we decided that the lid added to the appeal of the shot. The camera angle had to convey the contents and highlight the product. Flatware and napkins were omitted so that the product received all the attention. This image was photographed as part of a campaign. The background and table were used in hundreds of images similar to this one. Also, I determined the camera angle after my food stylist prepared the yogurt and figured out how to make the lid stay in place. This is extremely precise work. Normally when you shoot a product shot, the client provides either a color-correct package or a case of the product so you can sift through and pick out the one that has the fewest imperfections. Color-correct packages are used for still and motion photography, so they are nearly perfect—but they are also very expensive to make because they are handcrafted. In this case, we had only three samples of each product to work with. The best package was chosen out of the three, and my stylist, Brian Preston Campbell, set the lid properly by rolling it carefully back and affixing it to the rear of the container. He then created texture in the yogurt and cleaned up any excess yogurt on the rim and the lid.

When Brian placed the yogurt on the set, my job was to make sure that all the details of both the package and yogurt filling were brought out. Had it not been lit correctly, it would have been very easy to miss the subtlety of the ripples in the yogurt.

As mundane as this package of yogurt is, the image is a combination of great styling and great lighting. There are five lights used in this photograph, with two soft boxes on the lights pointed from the right rear and left front sides. Each light was on a separate power pack. The lighting was in a 1:1 ratio. The soft boxes provided an overall set ambience. There is a monolight on a low stand below the table to illuminate the gray seamless paper. The angle of the light created the even tone of the background. The other two lights are coming from the left back. The first light is on a stand with a reflector and a medium grid, and the second is right next to it with a snoot attached. These lights serve two purposes. The first is to create a rim light. The second and most critical is that they bounce light back into the front of the yogurt, using the magnified side of the mirrors. There are three mirrors used in this photograph.

The first two mirrors are on the table out of the camera's frame. The third is being held by hand at the time of the exposure. The mirrors help pinpoint the light. Two mirrors are reflecting light on the package itself. The handheld mirror is popping light into the yogurt. The combination of light and shadow highlights creates detail in the yogurt so the delicate ripples of the strawberry are visible. Had there been particulates in the product such as fruit, we might have styled the yogurt with fruit rising up and breaking the surface. The reason the image is successful is that it dances with light. Without the subtle details, this shot would be nothing.

With the exception of the lid, this photo is not retouched. I use Photoshop as a precision instrument to fix any imperfections that can't be addressed in-camera. The lid had many imperfections that were smoothed out in post. Neither my stylist nor I could overcome this obstacle on set, so we opted to fix it after the fact. Taking notes on what needs post-production attention while you are shooting helps a great deal. I generally determine what problems need to be addressed in-camera versus retouching simply based on the amount of time it would take to fix the problem.

Tip

Keep a pad and paper handy while shooting to take notes about specific shots and to note what might need post-production retouching.

The devil is in the details when it comes to food photography.

Like any other job, you will be challenged to take on difficult projects. If you truly want to progress as a food photographer, you have to put in the extra effort to turn an ordinary approach into an extraordinary one. I can't think of another approach that would have yielded the same result, and I am confident in the choices I have made here.

EXERCISE #1

Using the lessons just discussed, pick a product to photograph. Examine how lighting and composition can make a boring image stand out. Get more than one package—a still life of a bowl of cereal with the box might be a good choice. Do not limit yourself to shooting the package entirely in frame. Our drink photograph of Duggan's Dew Scotch in the previous chapter illustrates that you don't have to show the whole product to get product recognition. The Tabasco image here is another example.

Fixing Images on Set

The difference between a good food image and a great food image involves the scrutiny we place on an image while it is on set. It's easy to fall into the trap of relying too much on the world of post-production magic. I actually had a food stylist complain to me once that I should just fix it in the computer. Needless to say, I fired her. Taking care of simple problems on set is the way to go. Being able to adjust a dish in real time is far more appealing. Noticing obvious mistakes and making adjustments will help you create much stronger photographs.

The decisions you make on set can affect your entire workflow moving forward. Some adjustments will be flagged for post-production, while others should be fixed on the spot. Just take good notes while shooting, and you will be able to create amazing final results.

Filling Holes

Pay close attention to the details of the dish in the next series of images. We used the same lighting as with the yogurt except for minor adjustments to mirrors and the rim lights. Every time you move the camera or change perspectives, the light has to be tweaked accordingly.

I adjusted the lights and took a capture. The salad looks pretty good. Not bad for a first capture, but let's take a closer look.

Upon further examination, we decided a few changes were necessary. We initially noticed there was a reflection on the lettuce causing a hot spot. The first decision was not to take the salad off set to replace the leaf. Instead, we determined it would be more efficient to fix it in post-production due to the simple nature of the retouching required. Both the stylist and I began moving objects around in the dish. While I looked through the viewfinder and pointed out moves, the stylist made it happen. We often discuss how to handle moves and come up with the appropriate solution, but much of this comes from instinct. Any change to the photograph is referred to as a move. Food photography is really about layers: Layers of light, texture, shadow, and styling all make up a good image. Many minor adjustments, or moves, make up a much stronger photo. It's about solving problems on both the macro and micro levels. In the next example, shown at the bottom left, we moved some of the bacon and repositioned the egg that appears in the middle.

Another capture was taken. Further adjustments were needed. We moved the bacon around and added some in places. The most significant tweak, I think, was the addition of a crown leaf to the top. See the bottom-right image.

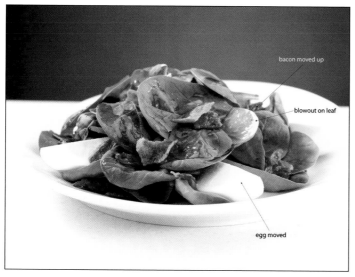 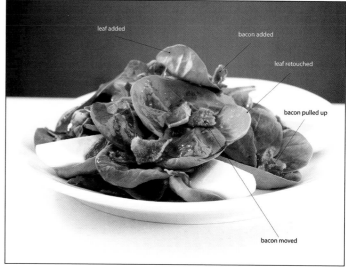

The final retouched image looks pretty good. I was pleased with it, and so was the client.

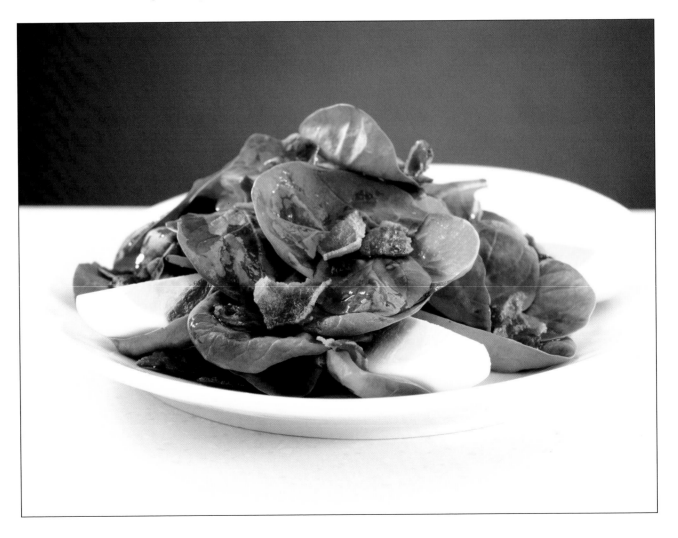

Little Moves Equal Big Changes

Let's examine another series of photos. The shrimp was cooked in an iron skillet and placed on the set the way it came out of the oven. My initial framing was way off, so I made an adjustment immediately. See the bottom-left photo.

After reframing the image, we decided the dish did not look abundant. We added some more shrimp and some garlic bread to better fill the space. The improved image is at the bottom right.

The first adjustment yielded a nice result, but it still needed improvement. I was not happy with the bread; it was too prevalent in the image, and its size was taking my eye away from the shrimp. There was a dust spot on the back edge of the skillet. Also, some holes needed to be filled. A hole is a dead space in a photograph that is distracting. By moving things around or adding food to the plate, we can fill in gaps that are creating problems in the photograph.

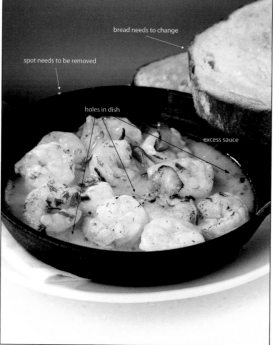

No matter how well a stylist builds a dish, it generally looks different when placed on the set. The stylist is told where the camera position will be and builds the dish to face the camera. Since the stylist cannot see exactly what the camera sees, she makes her best guess. When the dish is then placed on the set, a capture is taken. There are vast differences between how people see and how the camera perceives a subject. Factors such as lens choice, distance from the subject, and camera angle all play a part in how details in the dish are registered. The stylist makes her best guess as to how the lens will perceive these details. Generally, the matchup is good, but there are always adjustments and tweaks to be made. When the dish is viewed through the lens, we determine that there are holes we would like to fill. We accomplish this by adding more shrimp and then moving what is already there around. Lastly, we notice that the sauce level is too high. We don't want the dish to look too oily, so we need to drain some sauce. Below shows the image at this stage.

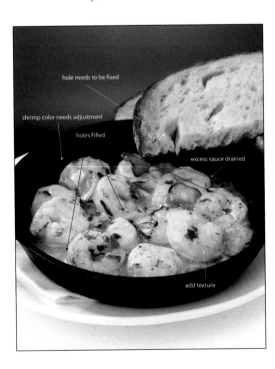

hole needs to be fixed

shrimp color needs adjustment

holes Filled

excess sauce drained

add texture

We took another capture and saw some improvements were still necessary. The holes were filled in nicely, and the bread was much better. Now it is not so big as to distract us from the shrimp. The last three adjustments were accomplished in post. The imperfections in the bread were removed, some texture was added to the shrimp on the bottom right, and we adjusted the color of the shrimp slightly to give it a more pinkish hue and a bit of contrast. The result shown on the facing page speaks for itself. A lot of small adjustments add up to perfection.

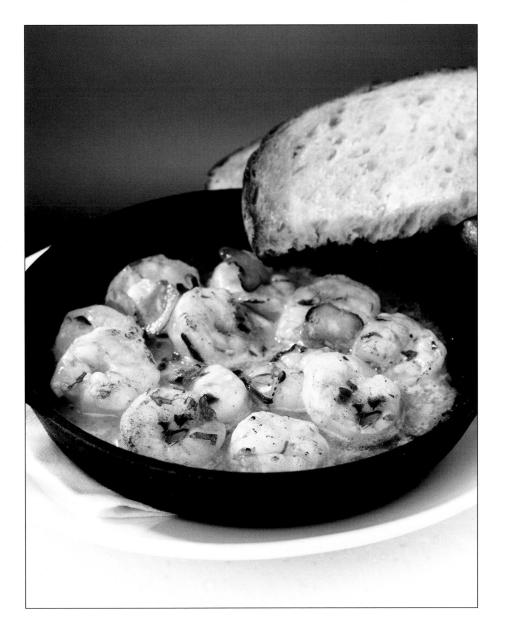

EXERCISE #2

From the previous lesson, begin with a styled dish. First, establish your lighting and composition. When the technical aspects of the photograph are finished, take a capture and start looking for ways to improve the image. Look for holes that should be filled and add elements as needed to complete the dish. You might have to rotate the dish or raise the camera to make it perfect. You may have a dark spot that needs to be brightened with a mirror. Use all of your acquired knowledge to finish the photograph and make it stand out.

Can't You Just Fix It in the Computer?

I have mentioned post-production in the last few examples. While I am adamant about learning photography correctly, post-production is the cherry on top of the cake that is digital photography. It is essential to hone your post-production skills if you want to bring your images to the next level. Retouching can be a problem if you spend more time trying to fixing bad images than you do shooting good ones. It can be a timesaver if you take notes on the set and fix minor imperfections quickly when the shoot is over.

When photographers shot on film, we wished for a magic machine to fix problems. Enter Adobe Photoshop. When Photoshop was introduced, to me it was like the missing piece to the puzzle had been revealed. I immersed myself in photo retouching and photo output. Back when we still scanned film, an image needed to be manipulated to compensate for the scanning process. I learned post-production in Adobe Photoshop, which is a very powerful program. It's also expensive. Adobe Photoshop Lightroom is a great alternative; it's much less expensive, and it can satisfy most of your image editing needs as a photographer. If you want to get into more serious retouching, then go with Adobe Photoshop. For feature and product comparisons, consult the Adobe Web site at www.adobe.com.

Image manipulation existed long before the digital age. Photo purists can argue that digital photography is not real photography because you can easily manipulate the image. Negatives are pure. Perhaps, but some of the most famous images had extensive darkroom work performed on them. Some famous photographers such as Ansel Adams used very elaborate techniques in the darkroom to achieve stunning results. I feel there is no difference between making adjustments in a traditional darkroom and making corrections using a digital one. The advantage with digital is that you have a much larger arsenal of tools.

Before purchasing Adobe Lightroom, you might want to check out Capture One software from Phase One (www.phaseone.com). Not all cameras are created equal. The medium format camera system that I shoot with comes with very sophisticated software. The color corrections are phenomenal. When I shot food with a digital SLR, the differences were noticeable. Color corrections are more challenging with digital SLR cameras, and I spent a lot of time removing unwanted colorcasts, even when a proper gray/white balance was performed.

Capture One packs a punch because it's an image-editing program that also, as the name implies, works with your digital SLR during capture, giving you many of the software capabilities of medium format. Because the software was originally developed for cameras costing five figures, it's pretty fat with capabilities. It's much more sophisticated than the camera software that comes from the major manufacturers and much better than the raw image converter in Photoshop.

This book is not a post-production tutorial. It would take an entire book to delve into the topic. I will discuss a few essential things you should look into. Image editing can be addictive. You can learn as much or as little as you choose, but do not use it as a crutch to cut out essential steps to learning actual photography.

A weak image is just that—weak. Relying on post-production to prop up a weak image will always crush you in the end. I know a photographer who spends days retouching after a shoot. That's his process I suppose, but I enjoy my life. Having to spend 20 hours retouching an inferior photograph is not my idea of fun. The number of photographs I produce makes it impractical to work that way. I will reiterate: Fixing one image is easy, but fixing 100 images on a deadline is something else. Clients expect flawless images delivered with quick turnaround times. If you can't finish the image yourself, you will have to pay someone to do it.

Additionally, part of your photo education is learning to distinguish between good and bad colors. In food photography, the wrong color will sour the audience. You need to develop a level of proficiency in post-production in order to manipulate your images toward perfection. You should acquire the knowledge of how to shift colors subtly in an image. This can take place on a global level or in isolated areas of the photograph. The wrong shade of green in a piece of basil can ruin the image. Today, post-production is what the darkroom was to film photographers. If we were still shooting film, you would have to learn darkroom proficiency. Consider this to be as necessary as learning how to light in photography.

Post-Production Essentials

Post-production is a fact of life with digital photography. This next section is not meant to be a tutorial. Rather, it's meant to open you to the possibilities of what you can accomplish through post-production. The examples use Adobe Photoshop.

Color Correction

Color correction, brightness, contrast, and levels are all musts in my book. These filters can compensate for a lot of technical errors, but the best use I have found is to enhance a photo that is already great.

If you look at the final shrimp image from the previous example, you can see just a subtle shift in the pinkness of the shrimp that takes them from yellow to pink. Add a bit of contrast, and you have a nice improvement.

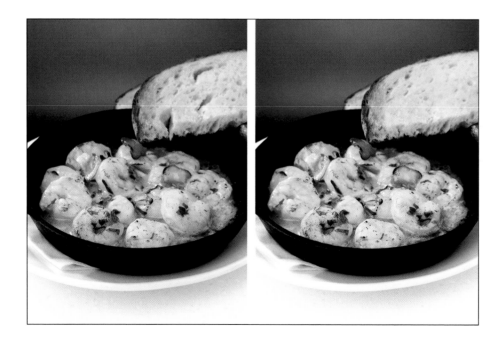

Clone Tools

Learning how to repair or clone a section from one area of the photograph to another is a key skill that can elevate an image. Clone, patch, and repair tools remove unwanted spots and dust and can repair sections of a photograph or cover imperfections. They work by replacing defective areas of an image with different areas of the same photograph. It is also useful for repairing edges of a larger patch. The next example illustrates before and after from a part of an image that needs to be repaired.

Leaves need retouching

Leaves retouched

Cropping

Learning to crop an image is fundamental in photography. Cropping involves selectively cutting out parts of an image to get it to fit into a specific area. The dimensions of a capture are specific to the sensor size. A full-frame 35mm digital SLR has a sensor the same size as a traditional 35mm film frame (35×24mm). Standard print sizes are expressed in inches. Standard print sizes like 4×5, 5×7, 8×10, and 11×14 differ from the 35mm size. There is a disparity between the print size and the film size. Some part of the photograph has to be cropped to convert it to its correct size. The Crop tool is designed for this. You have to keep in mind when shooting that you will lose part of the image to cropping. Landscape images are cropped on the left and right. Vertical images are cropped at the top and bottom.

A trick you can use is to tape a piece of black gaffer's tape over the viewing screen to make a box that will approximate the final crop. It might not seem like a big deal, but if you frame the image in-camera and it doesn't fit the output size, you might have to compromise on your composition. It's never good if you can't fit a photo into a layout—that's just poor planning.

A little trick I use is to frame the image the way I like it and then back the camera out. The distance you move the camera varies according to the lens choice. It's always a good idea to give yourself an extra cushion so you can crop the image exactly the way you envisioned it.

You can use the cropping tool to alter a photograph drastically. Have fun experimenting with cropping. It's an invaluable skill to learn. You have to be careful with cropping, though. You can't crop an image severely and then enlarge it back to the original size. There is a great deal of forgiveness when upsizing images, but there are limits as well. If you try to crop and blow up the image too much, it will become pixilated and degraded.

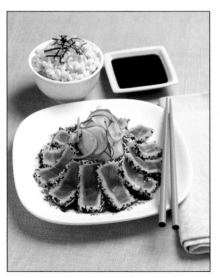

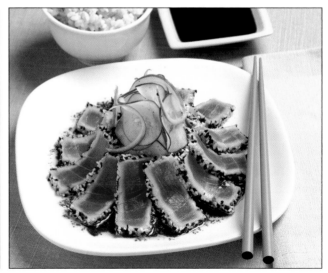

The Photoshop Advantage

I use Photoshop because it allows me a great deal of flexibility when working on images. In the right hands, it is nothing short of magical. Photoshop enables you to dissect an image and essentially peel it apart. You should review the features of the editing software available to you before you decide what to buy. After you evaluate your needs, you can decide which program is right for you.

I prefer to work with layers when I am retouching images. A program that enables you to work in layers opens up an entirely new universe. That is why I work in Photoshop. Think of layers of tracing paper placed over a background photograph. Photoshop allows you to work on the different sheets of paper digitally to create different elements. If an element doesn't work, you can delete the layer, or if you want to see the image without the changes, you can simply hide the layer. You can introduce anything from a simple background element to a flying car. The possibilities are endless.

The ability to maneuver sections of a photograph individually is very useful. For example, if we were working on filet mignon, it might split when it's cooked. The meat is expensive, so we might have purchased only one piece. You don't throw it out—instead you repair it in post-production. Being able to fix imperfections in post-production has advanced food photography by leaps and bounds.

Think about it. Prior to post-production, retouching was done by hand. That meant when an image needed to be retouched, an artist worked on the negative or positive piece of film by physically painting in the correction. Food stylists spent much more time making the dish perfect and fixing imperfections on the set.

Along came Photoshop, enabling us to fix problems after the fact. It has opened up a more relaxed food styling approach because minor imperfections can be fixed easily. Styling is still done professionally, but it no longer needs to be flawless. Minor imperfections that would have cost up to an hour on the set now take 10 minutes to fix in post. This is all made possible with layers.

Layers

In the next example, notice the big split in the meat in front.

I could have used the Clone Stamp tool to fix this, but I wanted to replicate a bigger surface. I find Clone Stamp to be a finishing tool. Instead, I isolated an area of the photograph that I wanted to use to patch the imperfection of the image, and then I copied it and created a separate layer for the patch. I positioned the patch and used the clone to blend in the edges. If I mess up and want to start from scratch, I just trash the new layers and start over again.

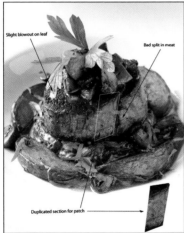
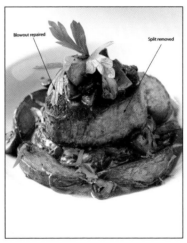
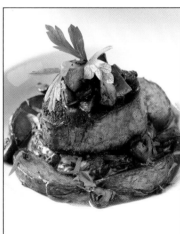

Selection Tools

There are many ways to create selections in Photoshop. In the filet mignon example, we had to create a patch for the split in the meat by first isolating the area and making it its own layer, using selection tools. These include the Magic Wand, which selects based on a range of specific pixels, and the Lasso tool, which selects by drawing a simple shape around the selected area. The big daddy of all selections tools is the Pen tool.

The Pen tool creates what are called *anchor points*. Anchor points come in two types: fixed and adjustable. We use both to create precise patterns around objects we want to isolate. These are called *curves*. We do this so we can manipulate isolated areas of the image while leaving other sections intact. When we complete the selection, we refer to this as a path.

The image on the right shows what anchor points look like. We can manipulate the path to adhere to any shape we like. Pay particular attention to the cherry stem. Notice how the anchor points bend around the object. This is the key distinction between the other selection methods: You can move any point in the path, change it from fixed to adjustable, and manipulate the path in any way necessary. This enables you to create seamless transitions. You can also adjust how hard or soft the edge of the selection is. This is an extremely precise instrument and one of Photoshop's most powerful tools. Learning how to use it will give you amazing control with your images.

For a complete tutorial on how to use the Pen tool, visit http://help.adobe.com/en_US/photoshop/cs/using/WS08E4D386-15E9-4dcd-91E6-DF4219CC6D24.html.

Masks

Masks are one of the most useful tools in your post-production tool bag. There are different types of masks, which I will discuss in greater detail later, but for now let's look at what a mask is and why we use it. Masks in image editing software are designed to protect specific areas of your image, just as you would use a stencil to protect particular parts of a canvas when painting.

Whenever you work in a photograph, the image exists in a specific color space. Red, Green, and Blue (RGB) is the normal color space that cameras and files generally assign to files when they are created. Each color has a specific channel assigned to it. There is a separate channel for Red, Green, and Blue. When you combine all three channels, you get a color image. There are also channels you can add to a photograph in Photoshop. A mask consists of another channel called a grayscale channel or alpha channel, which is added to the photograph. The darkest areas of a mask are the ones most protected, and the white areas are completely unprotected. Shades of gray represent areas of partial protection that correspond to the level of gray. Often, masking is used to apply varying levels of transparency to a layer or image. Masks are useful for hiding or highlighting areas of an image by combining elements of different layers. They also exist to selectively work on exposure, color correction, and contrast in a photograph.

Layer Masks

You must learn to use layer masks in Photoshop to create realistic transitions. It took me a while to grasp the concept, but it was well worth the effort. A mask enables you to cover up a part of a layer, revealing the layer below. Why is this useful? It lets you blend elements from one layer with another.

Layer masks are useful for eliminating the background and replacing it with another. The following examples are not meant as a tutorial but only to introduce you to how a layer mask works and why it is useful.

A layer mask is simple. Masks use colors in the gray scale from black to white and all the shades of gray between. Black masks (hides an area of) the photo, white unmasks (allows an area to show), and shades of gray create varying levels of transparency. The darker the mask, the less the layer below will be affected by whatever action you take on the unmasked area.

To illustrate this, let's look at an example. I shot a drink on a wood background. The client called and wanted to eliminate the background and replace it with a different background.

Using the Pen tool as shown in the previous example, we draw around the glass on the wood background. This selects the glass, which we want to keep. Then we paint over the background with a brush. We simply paint black over the area we want to hide.

The next image shows what a mask looks like. The area in white will remain in the final image. The area in black will be hidden.

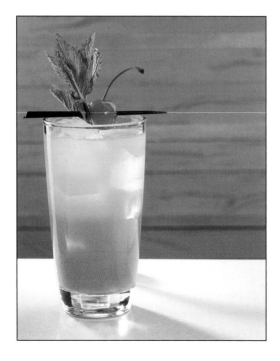

The next image represents what the mask did. The background is now transparent, and anything we place behind it will show through.

We now introduce a new background by adding another layer from a different photograph, the gray gradient background. The background from a different image is merged with the drink. The key here is that the edges are seamless. This is referred to as a *composite*.

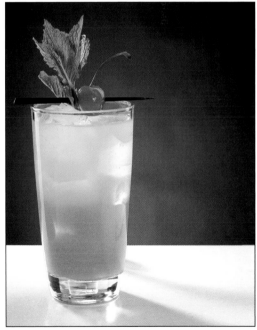

We have one more thing to do to make the transition from wood to gray truly believable. The wood background is visible through the glass. We could simply mask that out as we have just seen, but it would not look real. A glass has reflections, and if we mask them out it will look fake.

By painting a shade of gray onto the transparent area of the glass, we can subtly introduce the new background into the image without losing all the detail. In the next image, the mask has changed. The gray area represents what is now semitransparent in the photo.

The final image results in a more believable transition.

Layer masks are used in many post-production solutions.

If you own a copy of Photoshop, explore this topic further at www.adobe.com/designcenterarchive/photoshop/articles/lrvid4003_ps.html.

Adjustment Layers

Adjustment layers function exactly like layer masks using black, white, and gray to paint over areas of the image. Unlike a layer mask, an adjustment layer is its own layer and allows you to change an area and leave the surrounding area alone. For example, if you have a photograph that looks perfect except that you want to enhance the color of a particular section, an adjustment layer will do the job.

Let's look at the shrimp photograph. We want to add some contrast and change the color of the shrimp. If we adjust the shrimp, it will change the entire image. We don't want to change anything in the photograph except the shrimp. There are many types of adjustment layers. They enable you to brighten or darken sections of a photograph, adjust exposure to selective areas, and change the contrast levels and colors. The beauty of an adjustment layer is that is comes with a mask built in. Once the layer is created, you can paint in the corrections to one area and paint out the areas you do not want to change.

In this case, we want to bump the shrimp from yellow to a more pinkish hue. We use a color adjustment layer to change the shrimp color. But the rest of the photograph changes, too. Now the neutral tones have a red colorcast. Even the bread is influenced by the red.

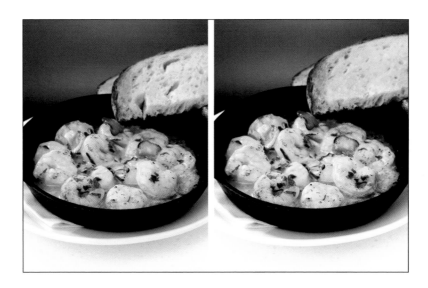

We get the other colors back by painting on the mask the same way we painted on the layer mask in our previous example. We use black to conceal the color correction we just applied. The bottom-left image shows what the mask looks like. The white area allows the color adjustment to show through, and the black area remains hidden.

Our final image shown at the bottom right illustrates that we have successfully returned all the elements except the shrimp to their original color.

With adjustment layers, you can change any area of the photograph you want while leaving other sections alone.

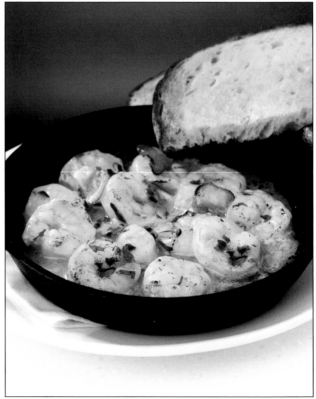

The advantage of using masks of any kind is that you can redraw the lines of the mask. If you decide later that you like the background with the color adjustment, you can simply paint it back in. The same is true for layer masks. Nothing is discarded; it is only masked or made invisible and can be brought back at any time.

For a complete tutorial, visit http://help.adobe.com/en_US/photoshop/cs/using/ WS5A7BAC5F-EF4C-4fd1-94BB-6ACA59C8E73Fa.html.

All the other bells and whistles in Photoshop are great, but if you can learn the things I have just outlined, your product will improve tremendously. When I first approached Photoshop, there was very little information aside from the manual that came from Adobe. It was very technical and dry. I had to teach myself these concepts and learn through trial and error. Today there are so many ways to discover Photoshop, and the learning curve is not as steep. With the amount of information available, you can get up to speed quickly.

Here are a few places where you can start:

- ❖ www.adobe.com/
- ❖ http://psd.tutsplus.com/
- ❖ www.devppl.com/tutorials/photoshop-tutorials/

Shooting with Layouts

A layout is a guide for the photographer to follow. As a professional photographer, you will often be asked to shoot to a specific layout that was created by a third party, such as an advertising agency. Generally, you will be hired at a stage when concepts have been formulated, and you need to execute a photograph to fit into a specific space. An example would be a book cover. On the cover is not only a graphic, but the book title and author name. The combination of all the elements of type, photography, illustration, and supporting graphics comprise the layout.

Until now, you have most likely been shooting a photograph as a standalone. Shooting to a layout is more challenging because you have to weave the photography into and around objects, leaving room for copy and additional elements. You also have to make sure that the copy does not conflict with the background and can be read easily. Your job is to allow spaces in the photograph so the other elements will stand out clearly on the page.

Composing a Layout

When you compose an image, normally you arrange objects as you think appropriate. With a layout, your composition has to fit into a predetermined space. Layouts can be horizontal, vertical, or square. For example, if you shoot an image vertically but the space in the layout is a horizontal, it won't fit. Key elements of the photograph will be cropped out. This must be factored in when shooting. Image-capture software that allows you to shoot to your desktop gives you an advantage. My camera software comes with a feature that allows me to import a layout and overlay it with a capture. I can determine exactly where my elements go. If your software does not support this feature, then you have to import the image into the computer and overlay the layout manually.

When you use capture software, the computer is connected to the camera. When you fire the shutter, the image appears on your desktop. Software differs, but there are ways to show specific crops within the software, which is extremely helpful.

If you are going to shoot professionally, learn to capture through the computer. The screen on a digital SLR makes everything look good. How many times have you taken a seemingly amazing photograph only to find that it was flawed when you imported it into the computer? I don't know why photos look great on the little screen, but I do know that what you see is not always what you get. Viewing the same image on the monitor lets you examine it in detail and make adjustments accordingly. If you can't tether, then shoot a few frames and import them into the computer. Always look at your photos. Don't assume they are in focus. In fact, don't assume anything. As a digital photographer you have no excuse for not getting the picture right. Nothing should go wrong unless you are lazy and cut corners. Clients don't accept excuses. They expect results. The bottom line is that shooting tethered to a computer helps you fit your image into a layout and eliminates guesswork. Trying to retrofit a photograph into existing ad space is a painful process. Shooting a photograph to accommodate for other elements on the page is the challenge, but doing this successfully is the mark of a true professional.

Let's work with a few examples.

In the example on the left, I chose an advertisement on a white background for simplicity.

The way objects in an ad relate to one another can be different than in a normal photograph. I was given the ad spec and read the creative brief, a document the client gives you detailing the assignment. Often it will detail style and objectives. There were three photographic elements to the assignment: a bowl of olives, a can, and a martini.

At first I tried to fit all the objects into one photo. I wasn't happy with the result because I wanted to control the depth of field individually. I decided to shoot the ad as a composite, combining separate elements into one file to achieve a single graphic. The martini was the difficult part. I needed to show the liquid splash on a white background. I used a lighting setup similar to the white drink setup from the previous chapter. I shot the can and bowl of olives separately. Once committed to a camera angle, I could not move the camera or the elements wouldn't match. It took about 20 tries to get the splash just right.

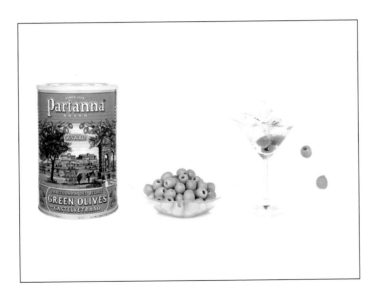
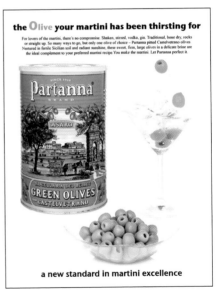

The image on the right is actually a combination of four shots. The olives that are falling in midair were the fourth element that we decided added extra impact to the splash. The problem was that when the olives were in midair they had not hit the liquid so there was not splash. Adding the copy was the final element that needed to be introduced.

Let's look at a print ad going into a magazine. The lobster ravioli ad is an example of how we fit other objects into space. Now we need to incorporate additional elements into the same space. Generally we leave space around the hero for the additional elements—in this case the headline, body copy, and logo Web site info. We also had to include the other types of pasta the client sells. And we had to cram a lobster somewhere in there as well, large enough for it to not be mistaken for a bug. The client wanted the ad to say "lobster."

Some layouts can be very stringent, and you must strictly adhere to them. Other layouts require more of a loose interpretation. You the photographer are often charged with coming up with the creative on set. The requirements for the following example were pretty loose. As you might suspect, the ravioli is the hero, and the other elements are supporting cast members. The additional pasta and lobster were photographed separately. This assignment is not a true composite. The additional elements are graphics and not part of the original photograph.

I wanted the ravioli (and specifically the filling) to speak to the audience. We began by picking our props. The first plate and sauce combination were okay, but the image lacked soul. The sauce was too antiseptic, and it did not look delicious. We also experimented with a wood background; the results were not satisfactory.

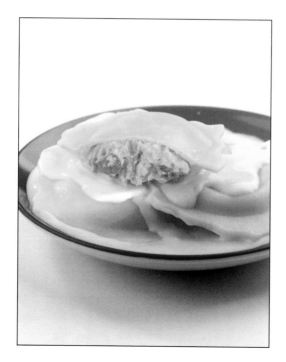 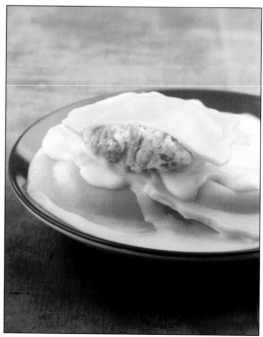

We eventually settled on the yellow plate with the red sauce. A lot of what happens to arrive at a finished product happens on the set. There is a fair degree of spontaneity when shooting food. No matter how you might plan, things will change on the set. You can try to micromanage the details if you like, and in a perfect world everything runs smoothly. There are so many variables at play that it's difficult to anticipate everything in advance. Translating a concept to an actual image requires problem-solving skills. In a way, shooting food in akin to improvisational jazz. You just start to flow. An idea sparks, and you're off to the races. The right look and feel comes together eventually. Sometimes you nail it out of the gate. Sometimes you have to work a little harder at it.

The new plate and sauce combination proved to be the right tack. The particulates in the lobster were selected for texture. The stylist added some sauce to the back of the plate and weighed the filling to make sure the serving weight remained the same when we restyled it. The garnish was added to introduce another color into the shot. It also completed the colors of the Italian flag, a nice subtle touch. I had to be sure to allow enough room for the lobster, pasta, and copy.

In this case I did not receive a formal layout—just a concept. I had the dimensions and a general idea of what the ad was going to look like in my head from reading the creative brief. Originally, the photograph was centered in the frame with white space on the top. The designer moved the plate up in the layout and decided to lay the type directly on the ravioli. The ravioli is really in your face. I like how bold it is in the image.

As a photographer you always have to provide space in the photograph to move the photo to the left, right, top, or bottom. Because paper moves around on a printing press, it can slide as much as one-quarter of an inch. Anything you don't want cut off needs to be within what is called the *safety area*. Copy, logos, and other elements need to be inside that area. The safety area is usually one-quarter of an inch in from the trim line.

The *trim area* is where the paper gets cut or trimmed. *Bleed* is a part of the photo that gets cut away, usually one-eighth of an inch all around. If you don't want any border around the ad, you have to allow for bleed. When shooting to an ad spec it's always a good idea to ask the printer for a template or at least a sheet detailing where the safety, trim, and bleed should be.

For example, if the final ad size was trimmed to 8×10 inches and you wanted the ad to be trimmed without any white space around the edges, you would have to turn in a slightly larger file. By adding one-eighth of an inch around the entire ad for bleed, the final file size would be 8.25×10.25 inches.

As a photographer, you would be responsible for filling the space correctly.

The example on the right illustrates with color keys what the bleed, trim, and safety areas might look like. Anything shaded in gray falls within the safety area, and blue represents where the ad will trim. Red represents the bleed.

Grey equals live area Blue equals trim Red equals bleed

Problem Solving

As I keep saying, much of professional food photography is problem solving. In this next example, I was assigned to shoot a picture of a sandwich for a large panel on the back of a truck. The creative brief said that the sandwich had to be a certain size relative to other objects in the ad. The problem was that when we went to shoot the ad, the scale of objects relative to each other did not match. The sandwich was much smaller than the whole pieces of turkey in the background.

We built a huge sandwich, but it was not the correct scale relative to the background elements. When we placed it on the set, it was just too small. We needed to separate the sandwich from the background while keeping the background element and the sandwich in line with each other. The only way to achieve this was to shoot the background first with the sandwich removed. Then we had to remove the background elements and put the sandwich back on the set. Normally we could have just scaled the background and fit the sandwich in. The problem was that the resolution of the sandwich had to be extremely high. To solve the problem, we moved the camera. When you move the camera forward, the perspective of the sandwich changes. The sandwich and the background needed to be on the same focal plane. I had to figure out how to move the camera both forward and down at the same time to keep the same perspective.

I ran a long string from where the sandwich was to a column in the back of the room at an angle a few feet above the opposite end. This created a guide by which to move the camera. The string intersected where the camera was positioned, and when it was taped a few feet higher than the camera it created a guide. If we would have positioned the string straight back when we moved the camera forward, we would not know how far we had to lower the camera on the tripod while maintaining the same camera perspective. As we moved closer to the set, we simply lowered the tripod to match the angle of the string. Problem solved. This is the kind of thing that comes up on a commercial food set.

The following illustrates the steps we went through to get to the finished product.

Sketch from client

Photo in layout

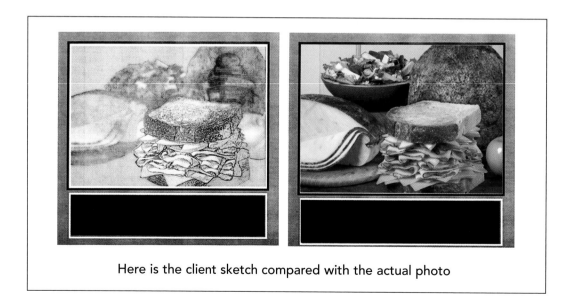

Here is the client sketch compared with the actual photo

In this final illustration we again use the retouched artichoke ravioli from the cloning example. Photography was needed for a package design assignment. The objectives were to convey the idea "fresh" and call attention to the main ingredient, artichoke. The challenge was to break away from a direction the client was comfortable with and come up with an untested, new approach. Instead of the traditional approach, splitting the ravioli on a plate with sauce, we decided to make the ravioli dramatic. We wanted to convey "fresh," so we decided not to cook the pasta, instead treating it like a painting. The package design shape was fairly easy to fit the photo into. The props and lighting had to be right on. We used the black slate for the surface to create contrast. Imagine what the shot would have looked like if we had chosen white marble instead. It would have altered the vibe completely. To make the pasta pop (and since the color of the pasta is dark green), room was left at the bottom for copy and weight information.

Another problem involved the artichokes. We had to retouch the artichokes instead of using fresh ones. The reason was simple—we couldn't find any. A problem we often encounter as food photographers is finding fresh produce out of season. Since our shoot calendars are usually a few months ahead of the season, sometimes it's hard to get the produce. For example, Halloween photo shoots usually book in late summer, and it's hard to get pumpkins in August. For this particular shoot, we also needed small baby artichokes for scale. We were lucky to find the ones we did. Without the baby artichokes, it would have been impossible to show both the small ravioli and the artichoke in proper relation to each other.

When you are shooting an assignment of this nature, the client usually likes more than one choice. You can't show just one idea. If the shot does not resonate with the client, you need to show alternatives. I find three choices to be the magic number. More than that and people start combining elements from each one, and it becomes a much longer day.

Tip

Give the client three choices, but have your own opinion of what you think is best. Be flexible, though. The client may always be right, but having your own point of view allows you to defend your choices and find an acceptable solution.

Once we agreed on the right composition, ravioli placement, number of ravioli, artichoke placement, and lighting, we arrived at our first finished image. After getting approval, we started changing background elements. First we cut the background artichoke in two to show the inside. When we were happy with that we swapped in an uncut artichoke, and a wedge of cheese replaced the larger artichoke.

After the front element of the package was photographed, we then photographed elements for the back of the bag, including individual ravioli, the slate background, and individual artichokes.

Additional shots are usually needed as supporting graphic elements. It's always less expensive for the client to shoot for multiple uses in a day than to hire me and my crew again later. We always try to maximize the number of shots in a single day. A full day is expensive, but my crew and I can usually get a lot done. If you can shoot more shots per day for a client, the price per shot goes down, and they will remember this the next time they need to hire a photographer on a budget. Your fee might have been slightly higher, but if you outproduce your competitor significantly, you can gain the advantage. If a potential prospect can only shoot four finished shots per day but is less expensive, and you can produce eight in a day, which is really less expensive?

To give the client more bang for his buck, the image on the next page was photographed on the same day for other uses.

Create a series of three photographs as if they were going into an 8×10 print ad with quarter-inch bleed, 8×10 trim, and a 7.75×9.75 live area. Leave room for copy as well as other visual elements. Experiment with variations on the same shot to create three separate concepts. Be sure to isolate individual elements and backgrounds as separate shots for use as design elements. Be creative, but work within a constraint. Scan an existing ad into the computer. Use the type as a guide.

Another alternative is to see if you can team up with a design student who needs professional photos for his portfolio. Local design schools are a good place to look, and so is Craigslist. If you can't find anyone, practice shooting to different shapes. Try squares, panoramas, and long verticals.

The Last Word

We have covered a lot of ground in this chapter. You should have a feel for the types of problems you might encounter. There is a huge distinction between shooting great food images and doing so commercially.

Food photography is demanding both mentally and physically. It's a job that requires problem-solving skills and ingenuity to perform with success.

As you learn, you will understand that making mistakes is part of the process. You may want to pull your hair out, but don't give up. When you get paid to do what you love, you are truly lucky. Learning to work with others is a big part of what we do as well. You have to learn to be respectful of the creative people around you while still remaining true to your point of view. Unless you are designing your own ads, you will have to work with a designer, an art director, or some other creative person. Unless you are styling your own food, you will have to manage a crew.

You will be dealing with clients. Learning how to take direction but still assert your own opinion is a delicate balance. My advice is to always follow your instinct. The buck stops with you, and clients will let you know if the job is not to their satisfaction, regardless of who told you to do it that way. They only see that they paid you a lot of money and did not get what they wanted. A client once told me he loved my style, showed me the work of the previous photographer, and said he was unhappy with it. Then he told me to do it the same way. I told him he could save himself a lot of money just by rehiring the other photographer to reshoot the same work he disliked, or he could trust me to deliver the job in my own style.

The client realized what I was saying, and I did the shoot the way I thought it should be done. He hated my photos, too. (Just kidding. He liked them very much.) In professional food photography, details matter. This chapter was designed to give you a bit of insight as to the situations we food photographers encounter, the necessity of post-production, and how we must factor in working around the constraints of a layout. It is also important to reiterate that no matter how much others influence your decisions, the end product of a photo shoot rests on your shoulders. If a client steers you down the wrong path and you know it and don't speak up, you are still to blame.

I keep speaking of being a professional food photographer. My definition of a professional is simple. If you get paid to shoot, then you are a professional. I am not saying that you can't be talented or creative as an amateur, but as a professional you are working for money.

Being a professional takes more than just the ability to take great photos. You also have work within specific parameters. What you are challenged to photograph is not always extraordinary, but the job is to make it extraordinary. You confront these challenges through the use of good lighting to create texture and shadow and great composition to create interesting and engaging photography. If you accept the challenge, the payoff is rewarding. You can earn a substantial living as a food photographer. There is never a dull moment, and the job changes each day. If you like solving problems, being creative, and having lots of fun, food photography as a career choice might be for you.

Turning Pro

For those of you considering becoming a professional food photographer, it's important to highlight a few things you should consider when weighing your decision. The photography business is just that: a business. I went into this profession with no formal plan, no contacts, and no idea what type of photography I wanted to concentrate on. The only thing I knew is that I wanted to become a professional photographer. I would not recommend quitting your day job until you build your pipeline of business or you can supplement your income to support yourself.

When I started out, I had no overhead, I was single, and my living expenses were very low. I had created alternate revenue streams working in the film business, assisting, and photo retouching. Because I was freelancing, I could build my business in my own time.

You might say to yourself, "I am a photographer. Why do I need to learn how to run a business?" Being a professional photographer requires so much more than taking professional photographs. It requires that you learn all the aspects of running a small business. To paraphrase Winston Churchill, those who fail to plan, plan to fail. Without proper business knowledge skills, you will be hard-pressed to earn a living, let alone keep your doors open.

Before you rush headlong into a career change, you should do a careful analysis of the competition in your area. Measure your portfolio and style against photographers who you are going to compete with. There are levels to every business. Some photographers are competing for $500 jobs, while others are competing for five-figure assignments. Your level of skill dictates what you can charge; however, those $500 jobs can lead you toward the higher paying ones. Think about it like leveling up in a video game. When you start the game, you aren't expected to defeat the champion on the first level. Instead, you are introduced to weaker challenges until you figure out the game and earn skills to get you to the next level.

Business is the same way. You will bid on jobs that you are qualified to shoot. How you get those jobs is a combination of how good your portfolio is and how good of a business person you are. Being a good business person requires you to be personable, responsive to clients' needs, ethical, and smart.

You will work longer hours being in business for yourself, because you will be responsible for running a company as well as all the tax implications.

This chapter is not a blueprint but rather a guide. It covers basic business concepts.

Business Strategy

Once you learn how to take food photographs and are proficient enough to be paid for your work, consider turning professional. There are many facets of running a successful commercial photography business.

Unless you work for a company on-staff, you will need to open up your own shop. One of my photography professors, Mr. Blake, told me that if you want to open up a photography studio you should have saved enough money to operate for one year without making a penny. That means from the day you open your door you should have all the money you need to operate a business and live on for an entire year in the bank. Many people underestimate the cost of doing business and see their dream destroyed by poor planning.

Things have changed dramatically since I graduated from photography school in 1984. In the 80s there was a lot of money for photography budgets. There was also not nearly as much competition. Everything was less expensive, and you could rent lots of space for practically nothing. My two business partners and I opened up a full-service studio in 1999 only when there was enough work to support the overhead. It took me seven years as a professional photographer to get to that point.

Prior to that I would shoot on location or rent space when needed. I borrowed studio space from my friend and mentor, Bill Helms. I also had a loft space in NYC where I lived. I worked from my home for a few years. Working from home is challenging, so it was great to open a studio. There was a certain prestige that came with it. What also came with it was a big expense to cover each month.

It worked well until our largest client terminated their contract with the ad agency that hired us. We decided to close down the space and adopt a new business strategy when the recession hit in 2009. Today I rent space and charge the rental to the client. There are some photographers who don't even own their equipment. You have to adopt the business strategy that makes sense for you. If you come to New York, you might want to follow my example. If you live in Detroit, space is less expensive, so it might make more sense to open up a studio.

A major factor to consider when opening a food photography studio is that you need a professional kitchen. Generally this can run you a minimum of $5,000, so plan accordingly. You will need an industrial stove, two refrigerators, a dishwasher, sink, counter space, and pantry. Many stylists I have worked with prefer natural gas stoves over electric stoves. It's easier to control gas burners. You have to consider your space and what it will accommodate.

When is the right time to open a studio? Only you can decide, but a good rule of thumb is to assess your client base and the frequency of work. Repeat business and a diverse clientele are the keys to being financially successful. Landing that one big account is amazing, but budgets get cut, your contacts move on and are replaced, and your style may fall out of favor with the client. If you predicate your business model on that one big account, you are going to pay for it dearly.

There is a lot to be said for running lean. If you have a big studio expense and have borrowed money to purchase a kitchen to accommodate the work, if the work dries up, you are stuck. I have seen it and experienced it first-hand. Now I prefer renting studio space. Let someone else worry about filling the space. Bill it back to the client or incorporate it into your rate, but your profit margin is much better if you do not have to worry about a studio.

Instead of that one big account, try to spread your services over a few big clients and a lot of little ones. Then if one client leaves, you still have the others. It's a lot easier to replace 25 percent of your income than 100 percent all at once.

This is a difficult business to be in. Many photographers consider themselves artists first and businessmen second. Unfortunately, a lot of our time is spent looking for business, running a business, and trying to keep the business we have. I stress this because it is a huge aspect of being a professional. You are thinking that you are so talented that the world will accommodate your lack of business acumen just to have the privilege of seeing your work. Not really. I have seen extremely talented photographers and artists eclipsed by lesser talent who were better at the business side. You *must* learn how to be a businessperson to become successful commercially.

There are exceptions to the rule, of course, but don't be fooled into thinking that the rules don't apply to you. If you succeed quickly and can afford to hire a staff to take care of all of your day-to-day business dealings, good for you. Most of us have to handle the business aspect ourselves in the beginning. As your operation grows you can add staff. Keep in mind that adding full-time employees is expensive. It's not just their salary; there are additional expenses to running a payroll, including health insurance and other taxes.

Business Entities

According to Craig Fine, CPA for WeiserMazars LLP, there are certain advantages to creating an entity. You can deduct your expenses without forming an entity, but you cannot open a business bank account. Opening a bank account has become more challenging since 9/11. By creating a structured business entity, you legitimize yourself in the eyes of the business community, the government, and your clients.

How do you choose what type of business to be in? There are different types of companies you can start up. The type you choose should be carefully researched and discussed with an attorney or Certified Public Accountant (CPA).

Sole Proprietorship

You might want to consider being a sole proprietor. This is the easiest and least expensive form of business structure. You have to do some research, and the process is different from state to state. A sole proprietorship is an unincorporated business owned by one person. In a sole proprietorship, there is no legal distinction between the owner of the business—you—and the business itself. As with any business entity, you are responsible for all the tax consequences. You are linked to your business through your Social Security number. You can conduct business under your own name or choose a trade name to work under. I ran my business for many years under this model. There are certain tax advantages to being a sole proprietor, which you can research. The major disadvantage is you are personally liable for the debts of the business. If the business is sued, the claimant can go after your house and personal finances, since there is no legal distinction between you and your business.

A second disadvantage of conducting business as a sole proprietor is that you might pay higher income taxes. By incorporating your business, you should be able to reduce your tax rate.

Limited Liability Company (LLC)

Another business model is called a limited liability company (LLC). It is similar in structure to a sole proprietorship except it offers some of the protections of a corporation. It exists as a separate entity, so owners cannot be held personally liable for company debts unless they have signed into a personal guarantee. For example, many landlords will accept you as a tenant only if you personally guarantee the lease. With an LLC, there are also more flexible ways to distribute profits. Additionally, there is less paperwork involved than with a traditional corporation. You also avoid paying both corporate tax and individual tax.

The disadvantages are that if a partner dies or you dissolve your involvement, the business ceases to be an entity. You cannot go public and offer shares. Running an LLC is more complicated than running a sole proprietorship.

Small Business Corporation (S-Corp)

Another option is a small business corporation, or S-corp. It has a tax structure similar to an LLC or a sole proprietorship. The advantage is that the profit and loss of the business pass through your own personal income tax to avoid double taxation. If you sell the business, capital gains are reduced, and you can write off start-up costs of the business. The biggest advantage, though, is that your personal liability is limited.

The disadvantages of these types of companies are the type of stock you can issue, the inability to solicit investors, and the requirement to conduct corporate meetings and maintain minutes. I currently operate my business as an S-corp. I switched from a sole proprietorship when I purchased my home to limit my personal exposure.

I am not advocating one business structure over another—but I do recommend you choose one. It will limit your tax and personal liability and open numerous doors that are available to small businesses. What is right for me may not be right for you.

An IRS Web site explains the various types of entities in greater detail. It can be found at www.irs.gov/businesses/small/article/0,,id=98359,00.html.business.

Hiring Professionals

You should hire a lawyer if you plan to form anything other than a sole proprietorship. There is no substitute for good legal counsel. What you save upfront could cost you dearly if you incorporate or form an LLC on the cheap. At the very least, hire an attorney for an hour to advise you on how to proceed.

I also strongly urge you to hire a good accountant. Make sure the accountant is a Certified Public Accountant (CPA) and has experience with photographers. Many CPAs are very conservative when it comes to deductions. Photographers have many deductions available, and it's best to deal with someone who is familiar with the industry. A CPA will also be able to advise you as to what type of company to structure. When I switched from sole proprietor to an S-corp, I consulted both my CPA and my lawyer. They each had strong opinions, but I went with my accountant's advice and formed an S-corp instead of an LLC as my lawyer advised.

Sales Tax

Depending on the types of business transactions you perform and services you provide, you may have to collect sales tax. Many people in business have paid dearly for forgetting to collect and file sales tax. You are responsible for collecting and handling the sales tax on certain transactions. Consult your state tax code for specifics regarding sales tax collection for your business, and talk to your CPA. I recommend that you understand the implications for collecting sales tax prior to doing business with clients. Depending on how you deliver your final product, you might be required to collect sales tax. In New York State, you need to obtain a Certificate of Authority to collect sales tax. To obtain it, you must have some form of business entity in existence.

I also recommend you create a separate bank account to hold sales tax money so you do not accidentally spend it. It is not your money. It belongs to the state, and you are responsible for collecting and paying it to the government.

Once you have formed your entity, you are entitled to all the benefits of being in business. You will open a separate bank account for your business and follow the recommendations of your accountant on how to distribute money to yourself. How you get paid depends on the type of entity you structure.

Keeping the Books

When you run a business, you are responsible for maintaining your books, keeping track of expenditures, and recording income. If you develop good habits from the beginning, you will be in good shape. Today, maintaining the books is easier than ever. I use QuickBooks Pro, available at http://quickbooks.intuit.com. You can download your information from most banks electronically and keep track pretty easily. I recommend hiring a good bookkeeper to set up your system and show you how it works. Once you get up and running, you can either maintain your books yourself or have the bookkeeper do it for you.

Prospecting for Clients

I cannot emphasize enough the importance of generating leads, creating a pipeline, and maintaining the flow of sales to your business. Neglecting this aspect will put you back in your nine-to-five fast.

You need to learn how to bid on jobs. The more jobs you bid on, the more you will be awarded. It's a numbers game. Prospecting for clients requires a 360-degree strategy. You need to approach prospecting from all angles. You must be consistent and relentless in your pursuit of clients. If you wait for the phone to ring, you will go out of business.

What to Charge

After you have formed your business, set up the books, and created a bank account, you are ready for business. How do you get hired? What types of jobs do you want to shoot? What are you even qualified to shoot? Where you go depends on the types of assignments you like or want to shoot. I will emphasize that the course you chart is entirely up to you. Take the types of photographs you like and then monetize them. You decide.

When you are ready to take your photography to the professional level (meaning you are getting paid), the big question is how much to charge. What is a fair price? What will the market bear?

What you charge depends on who is hiring you. What you charge also depends on the specific job and how the photographs will be used—known as *usage*. For example, a job photographed for an ad campaign being distributed worldwide with all usage rights is much different from shooting for a local restaurant. You can charge the major ad client more than the local restaurant. The more your images are seen, the more you should be paid. Generally, we are asked to negotiate a price based on a four-part equation:

1. The photographer's day rate, which is how much you charge.

2. How much work is involved based on the complexity of the images and the number of shots.

3. Usage—where the photographs will be distributed.

4. Expenses or costs associated with producing a job.

Suppose you are just starting out, and a local restaurant calls you for an assignment. They want you to take photographs at their location. The photographs are to be used exclusively for their Web site and local advertisements. How much do you charge?

Being new to the field and eager to get a paying job in the first place, you might err on the side of caution when bidding, which could cause you to underbid the job. You need to have a base of reference to operate from, but unfortunately there is no guidebook on the subject. You throw out a price of $800. Sounds like a nice figure, and $800 seems like a lot of money. But you need to factor in how much work is involved. If the job requires only one day of work involving eight shots and minimal post-production, then $800 is fair for the type of time and usage involved, depending on where you are located. On the other hand, if the job requires 100 shots photographed over four days plus post-production time, that price is too low. You need to calculate all the time it will take to photograph and finish the images in post-production.

What you charge also depends on your market. Major metropolitan areas command higher prices. It costs more to shoot in New York, so prices reflect that cost. Essentially, you need to calculate the cost of doing business in your area and what profit you want to make. Consider your time and what it is worth. As you advance up the food chain, you can charge more.

Another consideration is the type of photograph you are taking in relation to the market. Not all food photography jobs are created equal. The budget for one market varies considerably when compared to a different market. Each industry has a specific pricing structure associated with it. For example, a job shot for a public relations (PR) firm at $8,000 would cost $16,000 if it were commissioned by an ad agency. The amount of work is the same, but the difference lies in the usage. The reach of the campaign dictates price. If ten million people will view your photograph, you should be able to charge more than if ten thousand people will see it.

There are also varying price structures that depend on what part of the industry you are catering to. Package design, advertising, PR, trade, point of purchase, Web, and editorial are some of the specific categories you will shoot for. Each has an associated pricing structure. For example, photography for editorial work pays much less than advertising photography. What you lose in revenue you gain in recognition by receiving a photo credit. Credit for your work translates into recognition and can result in additional assignments. Advertising photography pays more but does not credit you for the work.

Whatever you negotiate for your day rate, consider the amount of time you have to devote to the job and base your price on how much you value your time, what the market will bear, and your cost of doing business. To calculate your cost of doing business you have to subtract your overhead from your fee. If it costs you $200 per day to be in business and you charge $200 per day, you are merely covering your overhead.

Often I get calls from potential prospects asking for a discounted price on photography because the images are to be used exclusively on the Web. For some reason people think that photography for the Web should cost much less than for other media. This is nonsense. Often it's more difficult to shoot to a smaller format and make the images read with impact.

I try to explain this rationale by considering what Web images used to look like in the beginning. Before the Web evolved into the commerce engine it is today, any image was better than no image. The level of sophistication was not quite there. Subsequently, we associated the Web with poor image quality. As the Web has become more sophisticated, the quality of images has increased. The perception has not changed to keep up with the level of advancement, so people diminish the value of Web photography.

The reality is that good photography costs money, and bad photography is everywhere. When pressed on this point, explain to a prospective client that you charge for your time. They would not be calling you, the expert in food photography, if they could shoot the photos themselves. You are a specialist. Food photography is not easy, and your prices reflect this specialty. I have seen many photographers unsuccessfully try to take on food as a subject. If you have taken the time to learn your craft, you deserve to charge for your expertise. A heart doctor charges more than a general practitioner, and so should you. I like to ask this question to potential clients when they give resistance on price, "How much money will you lose if your images are bad?"

How do you arrive at pricing when so many factors affect each job? The first thing you should do is find out what your individual market will bear. This means somehow determining what other photographers in your area are charging. When I first started out in 1992, I charged $500 per day plus expenses. As my skill increased and I was offered better-paying jobs, I increased my day rate to $1,000 per day. Eventually I reached my present rate of $3,000 per day plus expenses. The day rate is your fee and what you personally make on the job before usage is calculated. If you miscalculate your fee by forgetting to factor in all the expenses, you will lose money. My rate is based on years of experience, overhead, and time involved. I also charge for post-production, which brings my rate up to about $4,000 per day when all the time is factored in.

What you charge is up to you and entirely depends on if you really want the job. Anyone can work for free; I can get hired every day of the year to work for nothing. The important thing to remember is that you have a specialized skill that is not easy to perform, so charge accordingly.

Most likely you will be asked to bid on a job, and your quote will be compared with at least two other photographers. Usually prospective clients will call photographers with similar skill sets. My market is different from yours because of my experience, portfolio, and reputation. It's important not to overbid a job, but it is equally important not to underbid it, either.

Underbidding a job has two negative effects. First, you can't turn a profit. Second, the prospective client will not take you seriously if your competition is charging much more that you are. It's psychological. Human nature is to question things out of the ordinary, and if your price is much lower than your competitors, there must be something wrong with your service. Even though that may not be the case, your work will be perceived as inferior.

I learned this lesson in 1992. I advertised a $100 headshot package and got $100 headshot clients. These were the worst clients because they were looking for a bargain basement price but asking for the moon in return. The clients were demanding and wanted free prints and extras. One day I decided I had had enough and raised my price to $600. Guess what happened. I started attracting better clients. They respected me more because I charged a higher price. $600 clients never questioned the results and were far more pleased. The lesson here is not to undervalue your service. You will attract the lowest common denominator if you undercharge. You will spend your day arguing, doing free retouching, and losing money. It's also very aggravating.

Handling Inquiries

When a prospective client calls, there is a good possibility you are in strong contention for the job. Chances are the client has prequalified you by looking at your Web site and is calling to gauge your personality. How you respond will either get you hired or lose you the job.

A great starting point is to inquire how the client came across your name. Was it a recommendation, a cold solicitation, a Web inquiry? You can determine how serious a prospect is quicker if you know how he found you. Record how your leads come in. This provides you with valuable data. It also gets people talking about your work, which is why they called you. Ask what particular images they were drawn to from your portfolio. Most jobs are awarded because you have taken a photograph similar to the one the client has in mind.

Always ask if clients have a budget. This is a valuable question that most people won't answer. They feel that if they disclose the budget that's what you will charge. They fail to see it from your perspective. If it costs $5,000 to shoot and they have only $1,000, there is a problem. My food stylist charges $1,000 per day. There is no way you can turn a profit if the client can't pay at least the fixed costs plus your fee. Financially, you have to start at the point where you can make a profit; otherwise, you are working for free. The initial phone call is the most important one you will take. Saying the wrong thing, acting nervous, or coming across nonprofessionally will stop the process in its tracks. It's exciting when the phone rings, but realistically, you will not get every job. There are so many variables in the hiring process that your goal should be to generate a good number of inquiries so that you build up momentum.

In order to be able to intelligently speak about a prospective job, you have to ask good questions. The more information you can gather, the better equipped you will be to bid on the job correctly. Ask how many shots there are. What type of environment, and what types of sets are involved in the shots? Are you shooting on a white seamless background instead of a full propped set? For example, with a white background, once you set up your lighting you can bang out as many shots as your stylist can make. If, on the other hand, each shot requires new sets and props that require considerable preparation, multiple backgrounds, and multiple props, you have to set up each environment and light it accordingly, which takes more time. You might be able to get only half the number of shots in an environment as on seamless, in which case you have to bid the job as a two-day assignment instead of a one-day assignment. If the client doesn't have the budget to pull it off, the conversation is over. A good tactic for determining budget is to give your price list and see if this is in line with what the client has to spend. Ask if you are the first choice or if the client is just collecting bids. Tell the client you can make the numbers work if you are in serious contention. The budget has to make sense. Depending on the response, you might want to ask the client point blank: What do I have to do to get the job?

Often times a client will tell you. Where you go from there is up to you. Only you can decide if what the client is offering works for you and your overhead requirements.

Many times my phone will ring and I will be asked to price a job. Some people have no idea what good food photography costs and are stunned to find out. Jobs, budgets, and photographers are unique. If someone is way off on the price, chances are you will not be able to meet that client's needs. If a client is asking you for the impossible with a given budget, walk away.

You will never convince a prospect who has $100 to spend that your images are worth $1,000. Some clients just don't get it, and they never will. Let them find a different photographer.

Generating Quotes

You will be asked to provide a formal quote for most serious bids. This entails writing a proposal. One software package I recommend is made specifically for photographers. It's called Blink Bid and is available at http://blinkbid.com. At a cost of $229, it is helpful in generating professional-looking bids. It also generates invoices, but I recommend generating them in QuickBooks because you can translate all your costs into the proper categories. When you quote a job, be sure to include everything. I use Microsoft Office to generate bids from a customized template.

Collecting a Deposit

Once a bid has been accepted and you are hired, I recommend getting 30–50 percent up front and the balance upon completion of the assignment. I generally require a deposit to cover the cost of expenses, which is usually between 30 percent and 50 percent of the total. The more moving parts to the job, the more money you are on the hook for if things go wrong. Once you hire a crew, it is your responsibility to pay them. If you do not cover the costs and the client doesn't pay, you are still obligated to pay your crew. Not only did the job not turn a profit, in this case it cost you thousands of dollars, which is never a good thing. Not every client is on the level, and it's much harder to collect money after you turn in a job. You really have very little leverage to collect if a client refuses to pay. Many times it has nothing to do with the job you did; that's just how the person does business. Some people have learned it's more expensive for a person to sue them and refuse to pay you because odds are most people don't bother going the legal route. It's too expensive. Getting upfront deposits insures that at least your operating expenses are covered.

A client hired me for a job and was happy with the result but got upset because she felt the food stylist did not do "enough work" on the shoot day. She demanded that we not pay the stylist. I explained that my stylist and I had been working together for years, and her refusal to pay the stylist was unacceptable. I had neglected to obtain a deposit from the client. At that point I was on the hook to pay the crew since we had completed the job. I used the only leverage at my disposal, which was to refuse to turn in the job. The client was upset, but I managed to persuade her to pay me in full. I demanded the full payment when I delivered the files. I refused to show up at the client's office until she had a certified check waiting for me. Had the client not paid me, I would have been obligated to pay the crew out of my own pocket. Moral of the story: Cover your expenses up front.

Coordinating the Shoot

Once the assignment is scheduled or books, you have to coordinate the shoot. Unless there is a producer attached to a job, it is usually on your shoulders to make sure all of the elements for a successful production are put into place. The production cycle has three phases: pre-production, production, and post-production.

Pre-Production

Pre-production is planning the job. Generally you receive a creative brief, as mentioned earlier. The client goes over the objectives of the shoot, the number of shots, prop requirements, and layouts. These can be anything from rudimentary sketches to fully executed layouts. You formulate your plan and give input to the client. He is relying on your expertise, so if a client wants something that cannot be done, this is the time to speak up, not when you are on the set.

Pre-production also involves booking the crew, sourcing the props, shopping for food, booking the stage (studio), and renting vehicles and any equipment that may be needed. Meals must be coordinated for the crew and clients when shooting. Kraft service, which consists of on-set snacks, coffee, beverages, and other comforts, is customary during shoots. Production days are long, and it's standard to offer food on the set.

It is also customary to charge for a prep day. Some photographers charge their full day rate. I generally charge half my day rate. It depends on the amount of prep. Also, if the job is in a different city and I have to travel, I usually charge a full day for traveling, which translates into half my day rate for each travel day.

Production

The production phase is the actual photo shoot. It can range from one day to many weeks and beyond. I have been on jobs that have lasted 12 weeks. A production requires a minimum of three people: the photographer, the stylist, and at least one assistant. If there is room in the budget for an assistant, I like to hire a second food stylist instead of a dedicated photo assistant. The stylist usually needs more help than I do unless we are on location and I need to move gear around. During a shoot, inevitably you will have to get something from the outside world. No matter how well you plan, something always arises. If it's just you and the stylist, the production grinds to a halt. For example, if you need mint, you and the stylist can work on another shot while the third person gets the mint.

A typical day of food photography in New York City is 10 hours. We generally shoot for nine hours and include a break for lunch. After 10 hours the day goes into overtime. The crew and studio rental space get paid for overtime. I generally don't charge for extra time for myself, but that is an individual business choice. For example, if a client is severely holding up the shoot because of indecision, after a certain point I will advise him of overtime penalties. You want to reserve the option or you will be taken advantage of. Discuss this in your proposal before the shoot.

Usually you can shoot 10 prepared dishes in a single day and around the same number of drinks. That averages to about one shot every 45 minutes.

The shoot day has to run flawlessly. The more preparation you put in, the more productive you will be. Clients must be schmoozed, the photography must be perfect, all the equipment must function, and the work must be completed.

There are also different types of productions. Shooting in a studio has a different flow than shooting on location. Unless you operate your own studio, every job is a location job. You have to load the equipment, props, set pieces, and food supplies. If you are shooting at a venue where the food is being provided, then it's one less thing to coordinate. Here is a cautionary tale. Even if you are shooting in a restaurant, insist that the produce is fresh. I have been on shoots where the chef prepares the food and uses bad produce. You can't fix bad produce. Make sure the chef gets good stuff, or put a disclaimer when shooting that this shot is not what you consider acceptable food props. Always cover yourself. You're paid to shoot food, but you can't make rotten food look good. Some people don't get it and will try to give you week-old lettuce from the walk-in box. This is not conducive to the beauty of what you do. Remind the client that because he is going to all this expense, the food should be perfect.

I will also mention quickly that the items you shoot should be the best. When you or your stylist shops, the best selections of meats, produce, and garnishes should be chosen. Often you will receive the product from a client. If he is new to photography, you must tell him that whatever he ships to you should be the best he can send, and it should be packed to secure against spoilage, breakage, and defect. Many times I have received inferior product, the wrong product, or damaged product from a client. I stress to you again that it's much harder to fix damaged product than it is to make sure that your product is of the highest quality. It can be done, but it costs time.

Coordinate your product deliveries and match them to your shot list in the pre-production phase. The shoot day should be just a shoot day. If you lose time because the product is not right and you are just finding that out the morning of the shoot, you have a problem. If that does happen, don't panic; just solve the problem. No matter how big the problem is, you must always maintain and project confidence in front of a client during a job. If the client senses you don't know how to fix a problem, he starts to panic, and that's never good.

It is important to get approval when you are shooting. You have to gauge the client's reaction to the shots. Make sure he signs off on each shot. Often the ultimate decision-maker is not actually at the shoot. In this case, make sure he approves the images. I have been in situations where the person at the shoot does not have final approval. All day long he is approving shots. He asks you to send the images to a third party. Suddenly the phone rings, and the third party does not like the direction or the props or whatever else. You have been getting approvals, but now it turns out that you have to reshoot a lot of the images. Of course, this sets you back. In some cases you have to add another day or commit to massive post-production hours to get the job done right. You may have trashed the food you already shot and don't have another $80 T-bone lying around. All these factors set you way behind. You may have to wait for an assistant to shop for more food, costing you valuable time.

Who pays for this is up to you, but my experience is that if the images are done to technical perfection but you were simply given the wrong direction, the client pays. If you mess up, then you should pay. Always get approval from the ultimate decision maker, or it will come back to bite you.

During the production phase, you will have to manage different personalities on the set. You are not just the photographer but also the architect of the photo shoot. The buck stops with you, because all decisions regarding crew, props, sets, and menu are yours.

Being a commercial photographer requires a lot of patience. You have to be able to work with differing creative forces. Until now you have probably been operating within a bubble. You have been shooting your images with limited input from others. When you work professionally, you have to be able to satisfy the objectives of an assignment.

When you are asked to execute a photo assignment from a creative team, branding most likely has been completed before you even know about the job. By the time the job lands on your desk, many details have already been worked out well in advance. You might have an opinion on how things should be, but your client and his client most likely have good reasons for the direction you are given. Listen to your client, absorb the creative brief, and then offer opinions or solutions.

Some clients are so buttoned down there is no leeway for your artistic interpretation. You are being hired to execute a layout to exact specifications. In those instances, know where to interject your opinions. If the direction is not working, speak up. You will be judged on the result, but you will also be judged on how you conduct yourself on the set. If you feel you are being given bad art direction after you have satisfied the client, shoot the photograph you think is better. You can always sell it to a stock agency if the client does not want to use it.

On the flip side, you may be required to come up with the entire creative direction. When you first start out, the people you will be dealing with are most likely going to be your team and the owner of the company or restaurant. The assignments you will be asked to produce at first will be much less involved. You may very well become the art director, making all the creative decisions. Again, project confidence in your choices and make good decisions, and your clients will be happy.

Some clients are indecisive and do not know what they like. They can tell you what they do not like, but they can't move you in the right direction. At that point you have to start using broad strokes by changing props, consulting with the stylist. You have to think on the fly but gently urge your client and keep reminding him of the time. Nothing moves a client into a decision faster than running out of time. If you go into overtime, it will cost him. If he can't decide what he likes, he will pay for it. Always maintain your poise, even if you get frustrated. As long as your execution is good and the shot is technically sound, the burden falls on the client.

Post-Production

When the shoot ends, post-production begins. When all the time is factored in, a two-day shoot may require four days to complete the post-production work. Charging clients for post-production is part of the budget. You can throw in post-production for free or at a discounted rate to entice the client to hire you over someone else. Just be aware of the amount of time post will take you. Clipping paths is very time consuming. You can outsource the mundane task of creating clipping paths to service bureaus for as little as a dollar per file. If you have 100 files to clip out and it takes you two days to do the job, how much did that cost versus sending it out for a dollar an image? I use www.misterclipping.com/. I build the cost into the budget and concentrate on the real details of post-production, such as color correcting and fixing imperfections.

Delivering the Final Job

When retouching is completed, I deliver my files electronically. The job is uploaded to a File Transfer Protocol server, also known as an FTP. FTP servers allow you to transfer large files to a third party. The client can then access the files by going to that location (via the Internet) and downloading the files. Using an FTP server to transfer files is more advantageous than emailing the files because you don't have to deal with file size restrictions or bounced-back emails. I use a service called YouSendIt.com (www.yousendit.com). I can upload up to two gigabytes of information in a single upload. If there's more than that, I break up the data into batches. There are many FTP services out there. You can also turn your computer into an FTP server. With a little research, you can discover what works for you. Another reason for transferring files electronically is that you are not producing a tangible product, so you do not have to collect sales tax.

The job is officially complete when the files are accepted by the client. There may be some back and forth regarding minor tweaks to files. You bill the job and are paid your remaining balance. If the client likes you, you'll be hired again. Try to get paid when handing in the job. Larger clients pay on a 30-, 60-, or 90-day cycle. Ask what their policy is up front. My experience it that the bigger the company, the slower they pay.

Building Your Business

Repeat business is the goal. It's much easier to service an existing client than to prospect for new ones. Every satisfied client has the potential to become a regular account. Some jobs by their nature are one-offs, a job that will never repeat itself. A restaurant is a good example. Unless they change the menu, chances are they will hire you only once. Some clients go out of business; some clients may even hate you or clash with your personality.

Promises, Promises

Beware of the promise. When a potential client asks you for a reduced rate with the promise of tons of work, don't fall for it. If all the work that I was ever promised by clients actually materialized, I would be retired by now. This is a cheap ploy to get you to reduce your price. One of two things usually happens. The first is you do the job and never hear from the client again. The second is that the client gives you repeat business but asks for the originally reduced rate. Once you establish a price, you can't really say you have to charge twice as much now.

People have short-term memories and will press you for the reduced price. You might have done the first job at a loss to secure the business. You can't shoot the job at that price again. Either way you lose. There are fixed costs associated with every job, and there are adjustable costs. Fixed costs are studio rental fees and crew expenses. What is variable is your fee. You can decide to shoot a job for less money as long as the fee you receive covers your expenses and you make a reasonable profit. An assignment might shoot in a cool location. You are willing to take less money for the experience. It's entirely up to you.

Revenue Streams

There are many ways to earn a living as a food photographer.

Some photographers concentrate on cookbooks, some are strictly looking for editorial assignments, and some mix food with traditional still life. Each type of photography has its own structure, but the basics remain the same.

You can shoot food strictly for stock agencies, brokers who take you on as a photographer and sell your photographs to their clients. You get a commission for each sale. The plus side is that you benefit from their marketing. The down side is that there are millions of stock images out there. Someone has to search specifically for your category and pick your image from the other choices. Still, I know a few photographers who make a killing as stock photographers.

Catalogue photography is another good source of revenue. These are not the most glamorous jobs, but they pay well. The job lasts for an extended period, and it provides a guaranteed income. Catalogs can be both for print and online, but that should not affect the price. I generally come up with a lower rate for catalogues because of volume and the number of days. Catalogue rates are typically lower than advertising rates.

Advertising assignments generally pay the best but are the most difficult to land. In the beginning of my career, I hardly did any of these assignments. Now it's practically all I shoot. Advertising jobs that involve spirits are very lucrative.

Package design photography, similar to advertising work, is assigned to top shooters. It pays very well but is technically difficult. It requires a great deal of patience—even more so than regular food photography.

Choosing a Direction

Is there a guideline you can follow for success? No. Each photographer's journey is individual. What worked for one photographer will not work for another. The only quasi-guarantee I can make is that if you want to do this, you will be successful, provided you put in the time. If you give up too soon, you will fail. When I first started, I took any job that came along, tried to make a profit, and absorbed as much knowledge as I could. The learning process never stops. There is always a better approach or a new way to find a desired result.

In order to become a professional photographer, I needed to develop my skills first, so I began developing my eye. At first I photographed landscapes and urban scenes. I took a few still life images of liquor and seemed to be good at that. I practically slept with my camera for three years. After I took thousands upon thousands of photographs, I felt I was ready to do it professionally. I quit my job and began to shoot for money. At first I photographed actors, bands, and models.

I was introduced to food photography through my involvement in film production working on Wendy's commercials. The owner and director, Alex Fernbach, was a great guy and let me experiment with stills on his film sets. I learned a great deal about lighting from those sessions. Film production involves a huge crew. Gaffers and DPs (directors of photography) have unparalleled expertise in lighting. They let me play around. Between assisting on motion and still shoots, I began to see how things worked and what was possible. You can only gain this through firsthand knowledge.

Where to Begin?

Where do you start? How do you get clients? Where do they come from? You can find clients easily; it's just a matter of how much time or how much money you want to dedicate to the issue. In the old days, you had to prepare a portfolio, which acts as your resume. Once you created your resume, you had to shop it around. Finding people to show your work to was a problem because you could only show your work to as many clients as you had copies of your portfolio. If you had two books, then you could show it to only two people at a time. You had to drop your book off and wait a week to pick it up. Magazines and ad agencies reviewed portfolios only on certain days. It was a long process.

If you can secure a photographers rep, that is a great way to get your career started. A rep is a middleman who has special relationships within firms that hire photographers, like ad agencies. A rep usually wants to discover you and will usually call you if he is interested in your talents. Scoring a rep can be good or bad depending on the type of photographer you are and how you want your career to evolve. A rep usually gets the bigger jobs, but I am finding that clients are calling directly and cutting out the middleman to obtain a cheaper price. Most likely, you will not be represented unless you make a big splash, so you will have to represent yourself.

Creating a strong portfolio and taking amazing food photos will get you hired. Speaking intelligently on the phone with clients will get you hired.

The Digital Portfolio

Today your Web site is your portfolio. It is your chance to make a great first impression. Your site must be good enough to keep a prospective client from clicking off and moving on. It can be your most powerful and effective sales vehicle. Conversely, a poorly designed site with inferior images can kill your sales.

Art buyers today have more resources available to help them connect easily to your work than at any other time. I use my Web site as my main sales tool. Potential clients can review my work and pre-qualify me before even picking up the phone. My Web site functions on many levels to generate income for my business.

If you don't have a Web site, there are sources such as Livebooks (www.livebooks.com/) that will build an entire Web site especially for photographers. They offer different packages based on price.

I recommend staying away from Flash-based Web sites because they are not searchable. They look great, but no one can find you. I have a site built on an HTML platform that can easily be found by prospects. You do not need fancy bells and whistles on a Web site. You are selling your photography work. Make sure your photographs are stunning; that is what will drive sales. Type in the search phrase "Web sites for photographers," and you will see many companies that create Web sites. You can have a customized site developed, or for less money you can use a template to do it yourself. Just make sure your site looks professional.

Creating a Pipeline

Being in business requires that you create a pipeline. A pipeline is the number of potential jobs you have based on your contacts and lead generators. Sitting around waiting for the phone to ring is not a good approach. However, you can make your phone ring by marketing your Web site correctly. To make sales through your Web site, potential clients have to be able to find you.

Marketing on the Web

I can't stress the importance of the Web as both a research tool and a marketing tool. Gaining a web presence is not hard if you have a budget. You have to spend money to penetrate the marketplace. There are many vehicles for marketing your food photography business. Marketing on the Web can be cost effective if you learn how to create a presence there. If that's not for you, you will have to pay someone to do it for you. Without a Web strategy for creating traffic to your site, you do not stand a chance. Unless you are manually directing people to your site, no one is seeing it. For your phone to ring, you have to generate visitors to your site.

Here are some strategies you can familiarize yourself with. I have used all of them, but I prefer to generate traffic organically as opposed to paying for ads to drive traffic. I have had a Web presence since 1998, so I have a huge advantage. The longer you have been on the Web, the more traction you have. Also, the better the information on your site, the higher up in the Web universe you will rise. Do it well enough, and you can reach the holy grail: page one for your niche under the exact words and phrases or keywords that are relevant to your business. Crack that code, and you will generate regular leads with little effort.

You have to create a good experience for the audience searching for your site. If your work is no good, it's a pointless exercise.

Paid Placement

One way is by paying companies like Google, Bing, or Facebook for advertising based on keywords. A keyword is a word or phrase you use to describe your service. For example, keywords for me would be *food photographer* and *food photography*. You pay to be jumped to the top of a search page to be noticed. When a potential client clicks on your ad, you pay the provider a fee based on the desirability of the word. As long as you pay for clicks, the clicks keep coming. You need a monthly budget to run a campaign, and it can get very expensive quickly. I recommend you hire a person who specializes in online ad campaigns. The percentage you pay can be far less than wasting time and money figuring it out.

SEO

For those who have more time than money, getting ranked for your key words is a less expensive long-term strategy to get business. To be found for your specialty, your key words have to be targeted properly. To increase your audience, you have to create good content. Web sites that generate good content get rewarded, and those that do not have to pay for clicks.

To be ranked for your specific keywords, you have to provide information specific to your topic. For instance, if you shoot photos of food but also shoot photos of dogs, you should have two different sites. If you dilute your message, your rankings will suffer.

Every Web site has a specific ranking. Someone has to be number one, but someone also has to be last in the rankings. When you build your Web site, it is rated based on its content using various metrics and placed in its ranked position. To move up in the rankings you have to optimize your site. Optimizing your Web site is called *search engine optimization* (SEO). SEO is a long-term strategy. It requires updates and tweaks to get it running properly.

If you have a niche, I recommend a company called Site Build It (http://buildit.sitesell.com/). The site teaches you how to create a monster presence in the rankings. It costs about $300 per year, but if you can write about your topic, it really gives you a leg up. It is also very time consuming, so beware. There are about forty hours of tutorial, but the concepts are solid. If you are planning on selling images that are not assignment based, this might be a good way for you to go.

Where you rank on the Web also depends on how old your URL is. An easy way to jumpstart your rankings is by purchasing a dead domain from someone who has let her domain expire. The old domain still generates traffic and is ranked by the search engines. Once you repopulate the site with your images and content, the search engines will recognize that, and it could advance even further. You can also set up a series of dead domains you purchase and redirect them all to your primary Web site. Hosting companies sell these. You can do a search for dead domain names and see what comes up. I use www.godaddy.com/, but there are many others out there.

Web 2.0 and Social Media

You can also write articles about your subject in a blog. It all depends on how much effort you want to put into it.

You can use social media to generate traffic via Facebook, Twitter, Squidoo, and WordPress. If you spend an hour a day using social media to drive traffic to your site, the number of visitors seeing your work grows. Think of traffic the same way as you think of foot traffic in a store. Not everyone buys, but the more people you get in the door, the odds of making a sale increase. It's a numbers game.

Researching Prospects

The Web also serves as a tool for you to research companies and people you want to work for. You can research the companies yourself, but it takes a lot of time. You can purchase access to services and databases from various companies. I recommend Agency Access (www.agencyaccess.com). It is a robust platform that allows both email and direct mail lists. You can create multiple campaigns concurrently for both Web and print. You can narrow your list to advertising agencies, art buyers, or whoever you desire. The lists are qualified, and most emails are provided. You are allowed to solicit the people on the list. It's $925.00 for a year, but if you can swing the price it's a powerful resource.

You need to establish a regular presence in front of art buyers, ad agencies, design firms, book publishers, and magazines. Email campaigns are highly effective and very cost effective. Through the lists you either purchase or research and qualify on your own, you can solicit individual people or send out a mass promotion. Don't get spammy, and your promotions won't be deleted. Spam refers to junk mail. Even though you purchased a list, if you abuse the cycle of how many emails you send out, you will get an unsubscribe. Don't send out a promotion every day. Assuming the art buyers like your work, they won't mind looking at it. How often you send out an email promotion is up to you, but twice a month is a good rule of thumb.

Direct Mail

Do not discount direct mail. In the electronic age, the level of snail mail promotions has decreased significantly. Direct mail is much more costly to produce, stamp, and mail, but it can be highly effective. Companies like Modern Postcard (www.modernpostcard.com/) and Vistaprint (www.vistaprint.com/) can create direct mail campaigns. These companies provide inexpensive pricing on printing promotions.

Networking

There is no substitute for developing personal connections. Building your network in order to supply your pipeline is crucial. Networking groups like Business Networking International (BNI) (www.bni.com/) are great resources. If you are afraid of meeting people or don't know how to present yourself as a businessperson, I suggest joining a group like this. The theory behind networking groups is simple. People want to do business through recommendations or referrals. By meeting in a group setting and really getting to know the people you are networking with, you develop an understanding of your networking partners, and they get to know what you do as well.

The relationships I formed and education I received from being in a BNI chapter were well worth it. I recommend organized networking over open networking events. Open networking can have benefits, but the people you meet have no accountability or loyalty to you. A personal referral from a trusted advisor is always better. People hire you when they have a specific need. They can go about it in many ways, but people in business frequently ask their circle of trusted contacts if they know (in this case) a reputable food photographer. Someone who understands your business and knows you personally can recommend you and will almost assure you get serious consideration. Obviously, the assignment must be a correct fit, and your price must be right, but it really jumps you to the head of the line.

Branding

While you are developing your relationships and building your portfolio/Web site, you need to develop a look and feel for your company.

As a photographer, you have to pay special attention to your image. Everything you do should exude good taste. You are selling yourself. Your unique selling proposition (USP) is your skill. To reflect your work and skill, you need to create a branded image, including business cards, logo, letterhead, and envelopes. Your brand image should be tasteful. You can hire a designer if you like. I did the design for my own branding, but I have skills in graphic design as well.

Whoever designs your brand should convey who you are and what your artistic approach is. Presenting a cohesive branding package that carries through on invoices, letterhead, DVD labels, and envelopes shows clients that you are a detail-oriented and well-put-together businessperson. I can't stress enough that how you come across to your clients is half the battle. Always put your best foot forward.

Neatness and spelling count in the business world. Typos and sloppy business practices are noticed, so if you have trouble in this area, hire someone to do it for you.

Getting Started

How do you get started? There are so many ways to approach your career. Location is a huge factor. If you are in a major city you will have more prospects. If you live in remote area you might have to market yourself and sell an entirely different host of services. I will detail a few options, but there are so many ways to monetize food photography. If you are just starting out and can take advantage of not having large financial and personal obligations, I recommend working as an assistant for an established photographer. (Just please don't email me for a job. I get 20 solicitations a week.) Learning under an established photographer teaches you a great deal. You can treat this as being a paid apprentice. You can earn a good living as a photo assistant, especially if you learn how to handle the technical aspects of a professional food shoot. The position is called a digital tech, and as such you are responsible for setting and maintaining the digital work flow. Photography today is so high-tech it requires a lot of detail and file management. On bigger jobs, I hire a photo assistant and digital tech.

Assisting is hard work and sometimes thankless, but it's an invaluable learning experience. I was a little older than most assistants when I started, but I was a very hard worker. I didn't just learn how to shoot; I also learned the business aspects of how to run a studio. Learn from as many people as you can. How I would approach an assignment is different from how another food photographer would. It's never a bad thing to have different perspectives. If you assist, learn from the photographer; chances are he is where he is because he knows his trade.

For you who are a bit older and have life entanglements, you can begin by shooting for stock assignments, sell artwork online or in person on weekends, and shoot food assignments on weekends or evenings for local businesses. Once you have a steady income, you can transition fully into professional food photography. It can take years, or you could just get a lucky break. There is no way to tell.

Restaurants are a great place to learn and get paid. Barter if you like. Get in the habit of completing an assignment from beginning to end.

There are other revenue streams you can tap into if you get creative. Creating a food blog and selling ads when the traffic builds up is a longer return on investment, but if you do a good job you can make money. With a little research, you can earn a living.

Do not fall for e-book scams, get-rich-quick scams, or online claims of outrageous paydays. There are people out there trolling for people to splash down cash for the "Secret to Success." It's called hard work and taking amazing photographs of food. That's how to succeed.

You do not have to quit your day job to make money as a food photographer. You should get your business established no matter what level of the business you are trying to penetrate. You can then write off all expenses from your business. The IRS allows you to run at a loss for a few years while you establish yourself. If you have a regular job and have taxes withheld from your pay, most likely you'll get a tax refund. If you start to earn income from photography, it will affect how much of your money you get back. In some cases you will owe taxes instead. By exploiting all of your tax deductions, you can offset any additional income, so keep books on your business. On the flip side, you can offset your losses through a secondary business.

Dealing with Clients

Doing business requires that you deal with clients. Clients come in all shapes and sizes. Learning how to handle individual personalities is an art. Schmoozing with clients, accommodating their requests, and assuring them the end result will be fantastic are all part of the vendor/client relationship. Clients are people just like you and have anxieties just like you. When dealing with clients, always project confidence. If something goes wrong, don't sweat it. Solve the problem but never show fear. They will quickly forget the problem if you solve it.

Not all clients are going to treat you well. If a job goes badly through no fault of your own, sometimes it's best to walk away. I had a job where the client did not like my work after boxing me into a creative direction I objected to. After a lot of unpleasant exchanges, I decided not to work for that client if they ever called again. And sure enough, I received a call for another job. I simply told the client I was booked. Every time they called after that I was busy. Eventually they got the hint and moved on.

This is a fun job and should not be ruined by people who are negative and who treat you poorly. Some people think that paying you entitles them to abuse you. That is not true. Always maintain your professionalism, but do not put up with abuse. Life is too short.

Regarding dealing with clients, I will say one last thing. If you mess up, own up to the mistake and make it right. A client may not be happy, but if you own your own mistakes, they will respect you. You may get another chance if you rectify a mistake, but if you try to deflect blame, your phone will never ring again from that client.

Sometimes you will do everything right, and the client will still request a reshoot. If the client was on the set or approving shots offsite as you went along, then he must pay for the reshoot. If you messed up, you should not bill the client for your mistakes. Sometimes it's good business to share the expense of a reshoot by charging for your fixed costs and not charging your fee when doing a reshoot. It's very political, and you will have to gauge the client and the situation before you offer that. The photography business is about relationships. It's much easier to service an existing client than it is to find a new one. Treat your clients well, and they will trust you and repeat their business.

These days, clients have options to attend a photo shoot or work remotely. Working remotely slows down any job because the client is not in the room making decisions. It adds time to your day. Insist on getting written approvals via email in case the client is absent. You can't get into a he said/she said argument if you have written proof that a photograph was signed off on. Also make the client aware that you will not be able to produce as many shots in a day if he is not available. I had a situation where the art director was in another city and his client was in a third city. We had an Internet exchange system set up where they could view my monitor on their desktops. My art director was approving shots quickly, but his client was slowing up the process. He kept going into meetings. Our productivity was severely limited because the client had final approval.

The Last Word

In summary, the business of photography requires as much of your time as the actual shooting does. Learning how to do business is an integral part of having a successful career in food photography. But do not let the business aspect interfere with your creativity. Even if you work commercially, you should still make time for personal assignments. The entire reason you started taking food photographs was to express yourself. I am always looking for interesting ways to create art and express myself through my work. I shoot other types of photos, but I keep coming back to food, even in my personal work. Many photographers turn their passion into a career only to discover that it has become a job. I have not had a job in twenty years. My passion for food photography remains strong because I shoot for myself, challenge myself, and don't rest on my laurels. I never take my clients for granted, and I am always coming up with ideas. I earn a nice living doing what I love.

I will emphasize that it takes a lot of effort to be in business. I work long hours sometimes, shooting all day and then doing post-production and attending to business details in the evening. Sometimes I have long stretches between assignments. I have learned over the years to enjoy my free time. It took me a long time to be able to take time for myself without feeling like I was neglecting my business. Taking time off is essential to my creative process. Every business has its cycles. You should always be looking for business, especially when you are busy. The biggest mistake I made in business was working for one big client and not prospecting for new ones aggressively. When the client pulled back because its budget shrank, it really was noticeable. You should have multiple revenue streams so if one client leaves you can replace it and not notice the impact. Losing a large client at the wrong time can put you out of business.

Balancing Commerce and Art

As a commercial food photographer, you are not just a hired gun. You are an artist. Photography is a powerful medium with which you can make artistic statements. It's a good idea to come up with self-assignments to keep your creative juices flowing. Whether you shoot mostly in the studio or take to the streets, you can come up with interesting assignments with a little thought.

As a commercial photographer, you are a camera for hire. When you are shooting for someone else, you are a spoke in the wheel of the creative process. Because your outcome is influenced by others, it does not entirely belong to you. The only way to create work that is unfiltered is by continuing to shoot self-assignments. These self-projects help you keep your ideas fresh. It's hard to explain the freedom you experience when you shoot for yourself until you are fully immersed in food photography. If you are photographing these types of assignments at the moment, continue to do so. There is a certain thrill associated with shooting commercial jobs. It's a rush to get paid a lot of money to do something you love. If you become successful as a commercial food photographer, you wind up shooting for clients. When it comes to creating your own work, it's easy to fall into the trap of only shooting when you are hired to do so. The importance of continuing to shoot your own material cannot be stressed enough.

Self-assignments move you forward in your evolution as a photographer. This is where you take most of the risks. You workshop your new ideas, lighting, and direction before you mix them into your paid assignments. Often, self-assignments are more challenging because you own the entire process. With self-assignments, your work is unfiltered. If you don't execute the assignment, everything falls on your shoulders. There's no art director to blame here. Just you. Remaining relevant as an artist will help you in your commercial endeavors.

You can also turn your art photography into a nice profit. Some photographers never do commercial photography; instead, they choose art photography as a pursuit. My goal is to eventually move from commercial photography into an art career.

Self-Assignments

Here are some of the self-assignments I have given myself over the years. These are some of my favorite images. It's a matter of pride to do something interesting and relevant. When shooting self-assignments, sometimes I just shoot one or two images, and other times I shoot 100 images in a series. Not every subject warrants a series. When you can develop an idea into a larger theme, it's always fun. Sometimes I take to the streets instead of confining myself to the studio. Other times I restrict myself to using only one lens or renting a lens I do not own. It's important to mix it up to gain fresh perspectives. If you always shoot with soft light, try shooting with no diffusion. If you only shoot with a macro lens, use a wide angle lens. You will improve your skills quickly by stretching outside of your comfort zone.

Series 1-Frozen Foods

The idea for this first series came to me entirely by accident. I was experimenting in the studio with different types of images. I did not like the direction I was heading in and abandoned the idea. Since I was committed to shooting for the day, I was determined not to come up empty handed. I was rummaging around my kitchen when I opened the freezer. I noticed there were boxes of frozen vegetables left over from a shoot. The boxed vegetables were months old. I opened the first box of frozen corn and was blown away by the amount of ice that had accumulated inside the box. I started shooting. Before I knew it, a series was born, and I experimented with different ideas along that theme. I played with freezing subjects with dry ice, freezing vegetables in cans, and freezing vegetables in shapes. The ideas kept flowing until I had about 100 shots. Lately I have been printing this series on canvas. Here are some of the ones I think stand out.

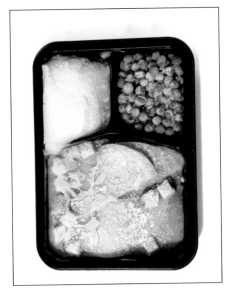

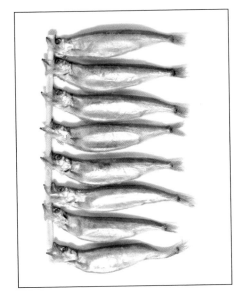

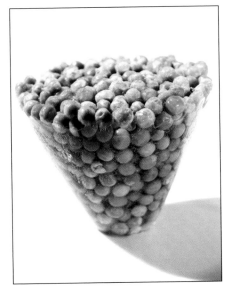

Series 2-Study in Peeps

The second series is a study in peeps. Peeps are made of marshmallow and coated in colored sugar and originally shaped to resemble a small bird. They come in different shapes now, like bunnies, but something about the chick-shaped ones intrigues me. Because peeps are a seasonal item, they only show up in stores around Easter time. People go crazy for peeps, and they have a cult following. This series evolved from a different series about candy. I had photographed the original image and wanted to make a statement on being different. All the peeps are the same color except one. People loved this image, and I always wanted to explore peeps further with a larger photo essay. One day I could not resist buying half the store's stock of peeps. I let them sit in my studio for a while until inspiration struck one day. I started noticing that the peeps, which are segregated by color, could be used to promote a message of social conscience. Would one color of peeps be prejudice against a different color of peep? When I started arranging them on set, it struck me that some peeps were quietly judging their fellow peeps. The peep is devoid of emotion, and I tried to express that through my photography. Here is where the series took me.

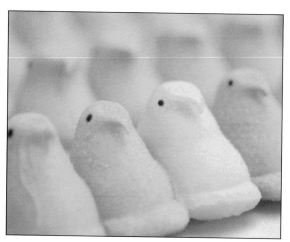
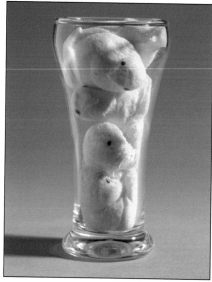

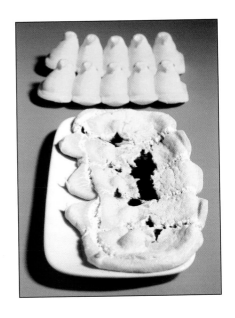

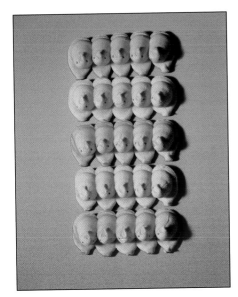

Series 3-Chinatown

In this last series, I went out to do some street photography. My office is close to Chinatown in lower Manhattan. One evening I set out early and walked over to Chinatown to see what I could find. The food of Chinatown was what I wanted to highlight. I came away with a nice series that is a bit different from my studio work. Opportunities to shoot food outside the studio exist at every turn; you just have to open your eyes and stretch your imagination. There are so many places you can practice street photography: different ethnic centers in cities, working farms, vineyards, county fairs, street fairs, picnics, parks, festivals. If you think about it, you can come up with many options.

Street photography is great fun and does not require the aid of a food stylist. It also doesn't require you to prepare the food. Walking around with a tripod can be cumbersome, however. I have a street tripod. There is also a cool gadget called a monopod. A monopod has one leg that usually telescopes like a tripod leg with a head attached that the camera mounts to. Although not as sturdy as a tripod, it does keep the camera stable. It's not recommended for very long exposures, but it's better than hand holding. There are also other alternatives you can explore by doing a little research.

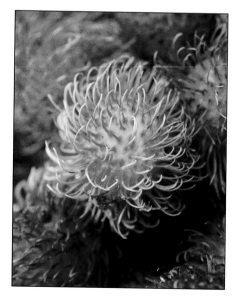 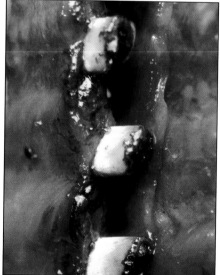

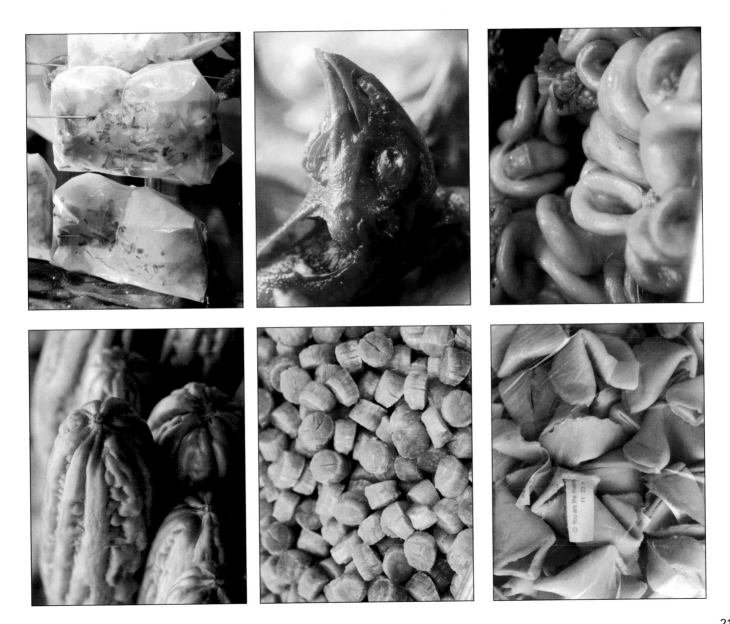

Standalone Art

The next few examples were not intended for a series. Sometimes you just have an idea that intrigues you. Some involve more than one image but are not quite worthy of a series. Often times I take a photograph and get stuck. A few months or years later, something may spark an idea that will bring it to a new direction. The photos in a series should be able to stand alone or in a group. Here are some examples of individual thoughts that turned into one or two photos.

Colt-45

The first shot is specific to New York. I was walking to my studio one day and noticed a can of Colt 45 in a bag that had been run over by a truck. You are not allowed to walk around with open containers in NYC, so it is common to see people drinking out of paper bags. As long as the drink is concealed in the bag you won't get a ticket. I loved this find and had to photograph it. I moved the can up a little to peek out of the bag, but otherwise it looks as I found it. This shot is reminiscent of Irving Penn, one of my photo icons.

Red

I was asked to contribute a photograph to an art book called *Red*. As the name suggests, the photograph had to contain only red elements. Being a food photographer, I wanted to shoot a food image. I went to Dylan's Candy Bar in NY, a giant candy supermarket, and walked out with a dozen wax lips. I shot the two images that follow. The one with the bowl was my final submission. The second idea, which I loved, was inspired by my wife, Sasha Graham. She was a 1990s actress who starred in independent horror films. She loves vampires. I used a blowtorch to slightly melt the lips, which reminded me of a vampire's kiss as well as *The Rocky Horror Picture Show*.

This next image was inspired by Jackson Pollock, an American painter best known for his abstract expressionism. The photograph contains all manner of condiments and food stuff I rummaged out of my kitchen.

I had wanted to explore the theme of this image for a long time and really had a lot of fun making a huge mess. Like Pollock, I wanted the image to be both abstract and textural. Pollock would interweave objects like screws, keys, and other hardware objects into his images to give them dimension. In this case, I used nuts, spices, and other food-related morsels to create the image and give it texture. I now have it printed on canvas.

Stages of a Bubble

In this panel of four images, called Stages of a Bubble, I wanted to show the sensuality of bubble gum. The image is laced with sexual nuance for you to draw your own conclusions.

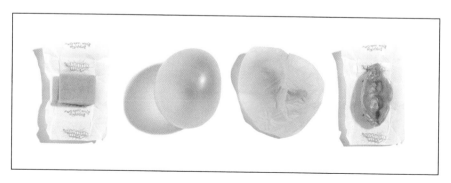

Random Thoughts

These last images are just fun. Feel free to assign meaning to them as you like.

As you can see, there is an endless well from which you can draw artistic inspiration. Whether your desire is to create art specifically, as a photographer you are an artist first. The opportunity to express yourself artistically is limited only by your imagination and dedication. Creating art images is fun and can lead to countless new ideas. Have fun challenging yourself, and don't be afraid to experiment. If you don't succeed, try something different. The world is open to you, and it's up to you to explore it.

EXERCISE #1

In the studio, create a series of your own drawing inspiration from what you have just read. Examine the work you have done previously, and see if there are any ideas that warrant an art series The idea here is to get creative. Come up with a central point or theme you would like to develop into an artistic statement; then see if you can create a series around that statement.

EXERCISE #2

Develop an art series outside the studio. Visit an ethnically diverse area where food is prominent. You can do an exercise called one hundred steps if you like. One hundred steps is a fun, easy photo exercise. Simply go to the area where you are looking to shoot. Find a subject to photograph, and then take one hundred steps. After you take one hundred steps, look around and see if there is another image to take.

The Last Word

When I first started compiling my thoughts for this book, I decided to tell two stories. The first story was to teach the art of food photography. I wanted to help build a strong foundation based on my knowledge as a photographer, not just a food photographer. To be a successful food photographer, you must learn the principles and rules of photography. Shooting with a digital camera does not excuse you from learning photographic theory. With a strong foundation in photographic theory, you can create any photo you desire. Hopefully I have explained the basic theory of photography and how it applies to food photography in an easily understandable manner. I hope you learned and enjoyed taking photographs in a fun but enlightening way.

It is my sincere wish that you succeed in whatever objectives you set out for yourself. Whether you take food photographs for a personal food blog that you want to make spectacular or you want to shoot high-end commercial food assignments like I do, I hope this book has helped you. When I was learning photography, I drew from many sources in search of photographic knowledge. I took correspondence courses, examined photo magazines, and studied master photographers' works—all in search of how to take a photograph and then how to make it better. When I encountered complex photographic ideas, I would study them continuously until I understood them. You can read theory all you like, but there is no substitute for shooting actual photos. You can read about how it's done, or you can actually do it. Your experience is what will propel you forward. This book is not intended to be the definitive authority on food photography, but it should be one of many sources. Learn from your own experimentation.

The second story I wanted to tell was that of my journey as a professional food photographer. By sharing my experience, I tried to humanize the experience for you. Many books of this nature are a bit dry. Perhaps I have succeeded in telling a more interesting story for you. I am not the last word on any of the techniques that we covered. I have merely tried to convey how I figured out solutions to photographic problems, evolved as a photographer, and succeeded professionally. I remember when the task seemed enormous and the dream seemed impossible. I remember looking at my portfolio and seeing all the work that was ahead. I remember almost giving up on more than one occasion. I have failed at assignments, been fired by clients for no reason, and been fired for good reason. Every step along the way, I was forced to examine my work and see if it measured up to not only my clients' expectations but to my own expectations. The path has not been easy, but it's been well worth it for me. I hope you enjoyed taking the journey with me. It's been an interesting process writing this book.

If I had to distill the lessons of my career into a few bite-size morsels, here is what I would say:

Do:

- ❖ Do use a tripod.
- ❖ Do use a macro lens.
- ❖ Do learn the fundamentals of photography and apply them to food.
- ❖ Do perform all the exercises in this book.
- ❖ Do get up close and personal to food when shooting.
- ❖ Do learn how to light with both natural and artificial light.
- ❖ Do follow your artistic vision.
- ❖ Do practice your craft regularly.
- ❖ Do have fun learning.
- ❖ Do challenge yourself.
- ❖ Do learn all the rules of photography.
- ❖ Do break all the rules of photography.

Do Not:

- ❖ Do not show your work unless it's finished.
- ❖ Do not be afraid to take bad photographs.
- ❖ Do not make excuses why you can't shoot regularly.
- ❖ Do not go into business until you are ready.
- ❖ Do not use the flash on your camera as a main light.
- ❖ Do not buy equipment you don't need.
- ❖ Do not forget to market yourself.
- ❖ Do not forget to ask questions.
- ❖ Do not be afraid to make choices.
- ❖ Do not turn food photography into a job. Make it a career.
- ❖ Do not forget why you wanted to be a food photographer in the first place.
- ❖ Do not give up if this is your dream.

May you be inspired to follow your dreams whatever they might be. I followed mine, never gave up, and kept moving forward. I have had major setbacks along the way, but I have never lost my desire to succeed as a food photographer. Today I get paid to do what I love. I wish the same for you. Whatever path you choose, make sure you enjoy yourself. Life is too short not to live your dreams.

Lastly, I have set up a website at www.moredigitalfoodphotography.com. I would love to see some of your work. Feel free to reach out to me via the site. I am looking forward to hearing from you.

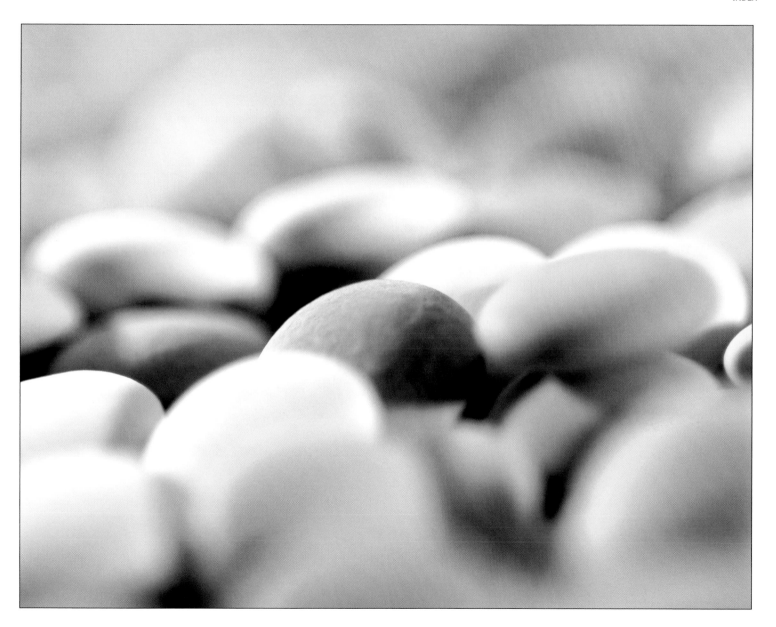

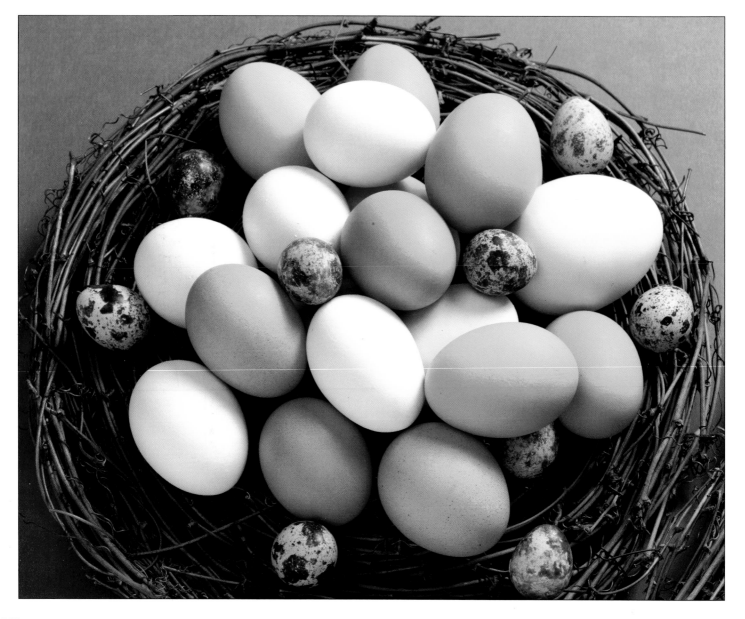